OLIVE WHITE GARVEY

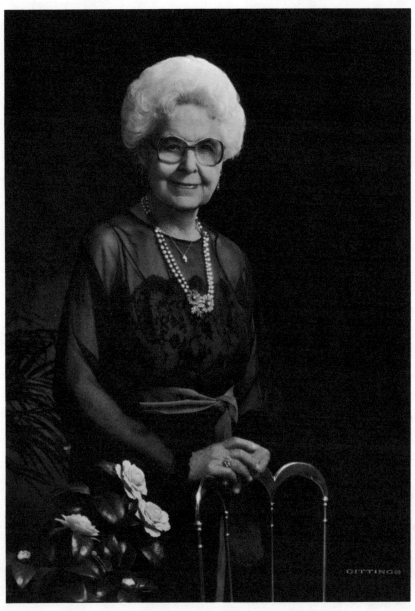

Olive White Garvey, Chairman of the Board, Garvey, Inc.

THE CENTER

FOR ENTREPRENEURSHIP & SMALL BUSINESS MANAGEMENT

**Presented To
The Libraries In Kansas**

In Honor Of

**OLIVE WHITE GARVEY
Chairman of the Board
Garvey, Inc.**

**An outstanding corporate
executive, humanitarian
and philanthropist.**

Professor Fran Jabara
Founder and Director

COLLEGE OF BUSINESS ADMINISTRATION • WICHITA STATE UNIVERSITY

WSU
BUSINESS HERITAGE
SERIES

WSU
──── ⊒BUSINESS HERITAGE⊑ ────
SERIES

The Center for Entrepreneurship
Advisory Board, 1985

Fred Berry
Wichita

Richard Boushka
Wichita

Frank Carney
Wichita

Ron Christy
Wichita

Jamie Coulter
Wichita

Jack DeBoer
Wichita

Martin K. Eby, Jr.
Wichita

Larry Fleming
Wichita

Fran D. Jabara, Director
 Center for Entrepreneurship

Lawrence Jones
Wichita

Norman Klein
Denver, Colorado

Dean Richie
Wichita

Douglas Sharp, Dean
 College of Business

Don Slawson
Wichita

OLIVE WHITE GARVEY

HUMANITARIAN, CORPORATE EXECUTIVE, UNCOMMON CITIZEN

by
Billy M. Jones

Center for Entrepreneurship
College of Business Administration
Wichita State University

ABOUT THE AUTHOR

Billy M. Jones is an endowed professor in the College of Business Administration at Wichita State University, holding the Chair in Entrepreneurship and Small Business Management. He is the general editor of the Business Heritage Series and the author of six of its volumes, including *L.E. Phillips: Banker, Oilman, Civic Leader; J.A. Mull, Jr.: Independent Oilman; Dane Gray Hansen: Titan of Northwest Kansas; The Chandlers of Kansas: A Banking Family; Magic With Sand: A History of AFG Industries;* and *Henry A. Bubb: Capitol Federal Savings and Loan.*

Copyright © 1985
Center for Entrepreneurship
Wichita State University

Manufactured in the United States of America.

ISBN: 0-86546-066-3

INTRODUCTION

Success, it has been said, is not a destination but a journey. From 1915 until 1959, Ray Hugh Garvey, a Washburn University graduate, reached one plateau after another on his way toward becoming, along with other notable achievements, "the largest grain elevator operator in the world." Starting in Colby, Kansas, as a small town lawyer, he began his journey toward success with an investment of only $500. To many of his contemporaries, Ray was a business genius whose grit and computerized memory allowed him to visualize and take advantage of opportunities well in advance of his competitors. Ultimately, he reigned over a vast grain empire which included tens of thousands of acres under tillage and a network of massive elevators with a combined storage capacity of more than 200 million bushels which he called "castles on the plains."

His story truly is remarkable and would have been so even had it ended with his death in 1959. But it did not, for Ray Garvey is survived not only by his business empire but also by a strong and intelligent family who have never regarded his journey as being over. Because of their persistent efforts, the Garvey name today remains synonymous with success—and Ray's achievements as the prototype of what individuals can accomplish through determination, education, and hard work. His story continues to resound dramatically throughout the midcontinent region and the world whenever there is a mention of wheat, grain elevators, oil, banking, home and commercial building, and philanthropy.

Since 1959, the recognized leader of the Garvey clan and their business activities has been Olive White Garvey, herself a Washburn graduate whom Ray married in 1916. Theirs was an enviable marriage, for as the years passed they grew together and ever closer in every category important to marriage partners. Each pursued individual interests and needs but unselfishly—and fortuitously—opened their world to the other. Olive emerged

wise in the ways of business and well informed about the Garvey enterprises with the result that at age 65 she was prepared to assume the leadership of both family and business when tragedy struck down her husband in 1959.

Because the Garvey businesses faced serious problems at the time, some observers feared she might be incapable of managing them without Ray, but they had not properly assessed her strength and determination. She skillfully and with unassuming flair guided the Garvey enterprises through the unsettled and troubled period in the early years after 1959, and thereafter, with her children and their spouses as catalysts and co-workers, tied up loose ends and moved on to new and phenomenal achievements by 1985—with prospects for even greater things to come.

Olive gave dynamic leadership to the businesses and not only divided the responsibility for appropriate parts of the enterprises to their four children, but eventually transferred the ownership to them also. She hurdled numerous obstacles before reaching her goal, but that plan, finalized in 1972, now is in place. Today the Garvey children and their families own and operate separate businesses.

Olive White Garvey at age 92 remains active in all family business affairs and still goes to her office several days each week, but in recent years she has devoted increasing amounts of time to interests of social and civic significance to her. As one journalist has stated with justification, "She is content with all she surveys." This is her story, and it may be even more unique than her husband's.

AUTHOR'S ACKNOWLEDGEMENTS. The author is indebted to many people for their assistance during the preparation of this manuscript. First, genuine gratitude is expressed to all of the Garvey children and their spouses—Ruth and Bernerd Fink; Willard and Jean Garvey; James and Shirley Garvey; and Olivia and George Lincoln—who gave unselfishly of their time and carefully scrutinized the finished document for factual accuracy.

Other members of the family, such as Elliot and Daphne White and Oliver Hughes, were very helpful as were business associates

of Mrs. Garvey such as Robert Page, Clifford Allison, Eric Jager, Henry Dock, and Edmee Cermak. There were others, professionals such as Arthur Kincade, Jordan Haines, Dale Critser, Hugh Riordan, James Baird, Terry Johnson, and Richard Felix, who took time from crowded schedules to provide much needed information. A simple thank you seems inadequate but is nonetheless heartfelt.

And of course there is Olive White Garvey. Writing about one who is an accomplished author and who has told her own story with great eloquence is a challenging experience. It has been exceptionally rewarding to work with her during the preparation of this manuscript. Our interview sessions, though gratefully informal, nonetheless were quite lengthy, but her stamina always exceeded mine. She insisted upon being as factual as possible and continually stressed the importance of researching and verifying all details and of being totally objective about them. No author ever had greater cooperation.

Two exceptional student assistants, Mrs. Connie Jennings and Mrs. Malerie Turner, worked tirelessly in helping to assemble data and in transcribing the audiotapes used in drafting the manuscript, and in turn have served as skillful critics of the finished product. Additionally, the staff members at both the Ablah Library at Wichita State University and the Wichita Public Library should know of my continuing gratitude for the professional consideration they always give to my research requests.

Finally, my special dedicatory thanks go a person patterned in Olive Garvey's mold—to Doris Hudson Jones, my companion and most patient supporter for more than three decades, whose success in bearing and fashioning the lives of our four well-loved sons far exceeds anything I shall ever accomplish.

Wichita, Kansas
April, 1985

Billy M. Jones

CONTENTS

ILLUSTRATIONS

OLIVE WHITE GARVEY

1
JULY 15, 1983
A TIME FOR REMEMBERING

The refreshing showers of countless summers have fallen on the rolling countryside of what is now North Hillside Street in Wichita, Kansas, but the mid-morning drizzle which blanketed the area on July 15, 1983, hardly was welcomed by the several hundred, specially invited patrons and friends who gathered to witness the formal dedication of the Olive White Garvey Center for the Improvement of Human Functioning. It was obvious, however, that no one felt overly inconvenienced, for the misty atmosphere was punctuated with gaity and animated conversation as the guests crowded beneath shared umbrellas and make-shift shelters, awaiting the start of a program which, interestingly enough, had been announced as "Skybreaking 1983."[1]

They had come not just to help launch a new health research complex, important though the facility was for Wichita; their presence also was an expression of personal affection and respect for Olive White Garvey, a prominent businesswoman/philanthropist who was observing her 90th birthday. The Center's director, Dr. Hugh D. Riordan, purposely had scheduled "Skybreaking 1983" on that July day as a means of paying special recognition to Mrs. Garvey for her initiating and sustaining support during the planning and construction of the Center which bears her name.[2]

To provide a forum for the birthday tribute, he had persuaded her to make a brief welcoming address, and as she was introduced and arose to deliver her remarks, the entire assemblage stood and joined in singing traditional birthday greetings to her. Although known for her great poise and graceful dignity, she nonetheless was moved by the gesture. However much she might

have wished it otherwise, there was but one conclusion that could be drawn: the day belonged as much to Olive Garvey as it did to the Center.

Understandably, she took a few moments to arrange her notes and to "clear her throat" before launching into the brief assignment, but her words flowed thereafter in comfortable, well-chosen rhetoric, making the welcome she extended seem all the more thoughtful. And, the warm praise she accorded Riordan and his associates for their research and treatment of a wide range of human sufferings set a receptive atmosphere for a dedication program which also featured short addresses by nationally and internationally recognized experts in the field of science and medicine.[3]

Although the ceremony was lengthy, she enjoyed the occasion immensely, and more than once was observed to nod at and exchange acknowledging smiles with those she recognized in the audience. She noted a number of cherished friends with whom she had spent many happy hours in the course of almost six decades' residence in Wichita. There also were dignitaries from a wide range of political, civic, and educational organizations with whom she had worked to improve the quality of life and to increase the opportunities of personal fulfillment for the various constituencies they served. Present also was a host of important business executives and associates with whom she had dealt in providing executive leadership for the family enterprises since the tragic death in 1959 of her husband, Ray Hugh Garvey.

But most importantly, numerous relatives were scattered throughout the various seating sections, including almost every member of her immediate family, which by total count then numbered four children, 18 grandchildren, and 26 great-grandchildren. Many of them, unknown to her, had traveled long distances not only to attend the dedication but also to share a surprise birthday weekend with her, and she had learned of their presence only after arriving at the Center that morning. That surprise was but one of many she would encounter in what would unfold as a memorable weekend of happy experiences.

Obviously, July 15 had not been planned as a "this is your life" spectacular, but as the day progressed, it quickly developed into

an analogous adventure in nostalgia for Olive White Garvey. Even the heavens contributed a spirit-lifting dimension to the occasion, for the morning drizzle stopped just minutes before thousands of colorful balloons were released in a "skybreaking" finale to the dedication program. Then, as preparations were being made to serve an informal, post-ceremony luncheon, friends and admirers formed a long line as they awaited their opportunity to extend personal greetings to Mrs. Garvey.

It was a time for remembering, for most of her fondest memories are associated with people and places in her native Kansas. With each handshake or friendly embrace, a segment of her life literally passed in review—engendering thoughts of Arkansas City where she was born in 1893; of Topeka where she spent much of her youth and early adulthood; of Augusta where she taught school following her graduation in 1914 from Washburn College; of Colby where she and her husband started their life together in 1916; and of Wichita, her home since 1928 and focal point of a vast business empire fashioned by her late husband. She received her well-wishers warmly, and with her amazing memory was able to greet most of them by their first names, including her great-grandchildren whom she then chided with, "Why didn't you let me know you were coming?"

"We wanted to surprise you," was the standard response, leaving the impression that the primary reason for their presence was to attend the dedication of the new Center named in her honor—which "just happened to fall on her birthday." Like pied pipers, they played a mesmerizing melody; she believed them, and the Garvey family settled into what seemed to be a routine luncheon together at tables reserved in the Center's unfinished administration building. Only later did she learn that they "had ganged up on me" and were shielding her from the truth, inviting her, as Ralph Waldo Emerson wrote, to:

> *"Pass in, pass in," the angels say,*
> *"Into the upper doors,*
> *Nor count compartments of the floors,*
> *But mount to paradise*
> *By the stairway of surprise."*[4]

With area hotels bulging with Garveys, it seems incredible that Olive did not recognize that she was being led to her own stairway of surprise, but a web of partial truths had been carefully woven to conceal true intentions. A party, it was alleged, had been planned for Saturday afternoon for two of her great-grandchildren (Donna and Deanna Cochener whose birthdays were approaching). Still unknown to Olive, the out-of-towners had stayed over another day to turn the Saturday celebration into a belated birthday party. The adults (including grandmother) were advised that they might wish to delay their arrival at the party until the smaller children had had their fun, and Olivia Lincoln, Mrs. Garvey's younger daughter and houseguest for the weekend, was assigned the task of making certain that her mother followed such a plan.[5]

The plotting worked to perfection. Her stairway of surprise led to the lower level in Bruce and Nancy Cochener's Wichita home where wall to-wall kinsmen were waiting to shower gifts and affection on their beloved matriarch—and she "mounted to paradise" in complete innocence. That it was a total surprise was poignantly captured in a photograph, snapped at the precise moment she realized the party was in her honor. Stripped for an instant of her emotional defenses, her face flushed with mixture of incredulity, gratitude, and joy. And in a typical Olive Garvey response, she smilingly and half-audibly uttered, "Oh my word!"[6]

Thus, July 16, 1983, became a heartwarming extension to a memorable weekend, truly an adventure in happiness for a proud great-grandmother who always has placed her family ahead of any other consideration. That they had returned her love in such a special and appreciative way was the greatest gift they could have given her. She visited with everyone present, and laughed with and doted over the younger members of her brood. Fittingly, as she moved about, a photographer recorded the entire event, snapping enough posed and impromptu pictures "to fill a complete scrapbook" with the happy faces of those who surrounded her that day. Topping the collection is a treasured, full-color family portrait of the 66 in attendance.

But, there was "icing for the cake." Later in the evening, a birthday dinner was held at Crestview Country Club, and var-

ious members present offered tributes. Capping the ceremony, Elliot Hill White, Olive's only brother, spoke briefly and stated that he and his wife Daphne had just returned from England and were impressed with the great dignity which Queen Elizabeth added to that society. "People everywhere should have a queen," he concluded, "and our family is very fortunate to have one of its own. Ours is Olive."[7]

There was an unspoken aura which hovered over the occasion—the memory of Ray Hugh Garvey. Although he could not be pictured with the family, his spirit pervaded the hearts and minds of everyone in the portrait. It was his name that provided family identity; his genius which had produced the foundations for the abundant legacy all of them shared; and his wife and life's companion who had provided the inspiration and leadership for the extension and enrichment of that legacy until the torch of responsibility was passed to their children.

Thus, the gathering also became a time for remembering Ray Garvey. It was an easy task, for his story is well known and is a source of deep pride to all of them.[8] Although he once stated that he had been forced into every business he ever undertook, Ray was a man of vision—an incurable entrepreneur—who always was searching for an unmet need. His career began in Colby, a small rural community in northwest Kansas, where he established a law practice in 1915 following his graduation from Washburn College. He subsequently discovered new opportunities for business growth both there and in Wichita (to which he moved in 1928). Within four decades he had accumulated assets which by some estimates had made him the wealthiest man in Kansas.

His portfolio by 1959 included extensive real estate holdings, massive farm operations, a gas service and supply company, an investment company, Petroleum, Inc. (the largest independent oil production company in Kansas), and a network of grain elevators which made him the owner/operator of the largest total storage capacity of any existing company or group in the world. Among these elevators, which included those at Lincoln, Nebraska, and other locations, were four of the world's largest—at Wichita (43 million bushels), at Topeka (40 million), at Salina (34 million), and at Fort Worth (20-plus million).

Garvey had shouldered an enormous debt in building the grain storage complex, but the financial strength of his empire was such that he was able to handle the indebtedness with short-term loan agreements. Thus, it was a matter of great satisfaction when the first of the elevator facilities became entirely clear of debt, and Ray and two members of his staff embarked on a pleasurable mission on June 30, 1959, to celebrate the event, traveling to Salina where they "burned the mortgage" of the Salina elevator. Unfortunately, the day became one of both triumph and tragedy, for on the return trip, on the highway near McPherson, Ray met with a fatal accident.

His death occasioned some apprehension about the future of his vast business operations inasmuch as it was well known that he personally made the decisions and gave direction to all management functions for his companies. Although he had begun to give some thought to partitioning his elevator empire into four divisions with operating centers in Kansas (Wichita and Topeka), Texas (Fort Worth), and Nebraska (Lincoln), fate intervened before the plan was implemented.

Some observers feared the worst—citing that without his genius and first-hand knowledge, the Garvey empire most likely was imperiled; or perhaps, as history so often has recorded in cases of inherited wealth, that sibling rivalry might prove the undoing of his business creation. Time would reveal that Garvey's unanticipated departure was indeed a tragic loss and that overlapping interests, some of them serious, between the children remained unsettled for a time, but the passage of years also would prove that Ray's remarkable legacy to his family was much too strong to presage the dissolution of his holdings— or to allow (as an age-old axiom contends) "shirtsleeves to shirtsleeves in three generations" to occur.[9]

Garvey left four talented children whose inheritance included not only his penchant for hard work, aggressive initiative, and responsible stewardship, but also his devotion to family, country, and conservative economic principles. Their personal and philosophical foundations were so solid that individual differences and goals always have found common threads to bind them securely in mutual and deferential respect for each other's inter-

ests. But most importantly, Ray left them with another extremely valuable asset: his wife, Olive White Garvey, whose inherent intelligence, soft-spoken wisdom, and emotional strength have proven virtually indispensable to both family and the Garvey enterprises in the years since the fatal accident. The story of her accomplishments is unique in the annals of corporate leadership and business success.

At the age of 65, Olive Garvey's life changed dramatically when she assumed the executive leadership of the Garvey enterprises. She definitely would have wished it otherwise. Nevertheless, she accepted her new responsibilities unhesitatingly, and the poise with which she moved from living room to board room and the wisdom she invoked in assuming the essential administrative responsibilities of the various businesses at such a critical stage were magnificently effective. There was never the hint of arrogance, never an omniscient or an omnipotent attitude, never the slightest evidence of selfishness in her behavior. To her, there merely was a job to be done—to carry on the work her husband had begun, and eventually, to divide the responsiblity for future management of his businesses with her children. She is not one to leave a task unfinished.[10]

Although she regards herself as "just an ordinary human being," she confesses that the challenges she has faced have been unique, and no doubt the happy events of the weekend which began on July 15, 1983, reminded her repeatedly of all her yesterdays as she moved among friends, business associates, and family. She has just cause to be proud of her numerous accomplishments; moreover, her experiences present a challenging case study for aspiring professionals—especially for women—who seek to fashion their own development by studying the factors which influence and shape the careers of successful corporate executives.

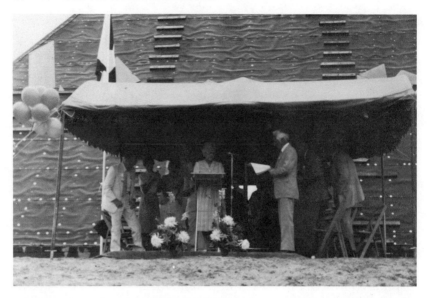

Above: Mrs. Garvey delivered the welcoming remarks at the dedication ceremonies of the Olive White Garvey Center for the Improvement of Human Functioning, July 15, 1983. Below: Daphne White (right), Olive's sister-in-law, and Olivia Garvey Lincoln (center) were among the numerous family members who attended the ceremony.

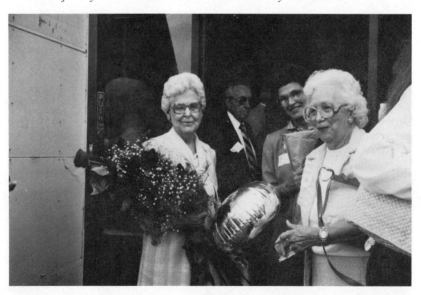

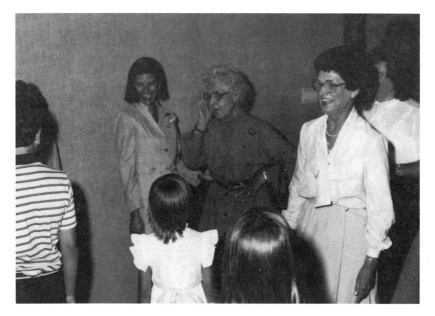

Above: Caught off guard by the surprise birthday party in her honor, Olive responded, "Oh my word!" Below: Ten of her 30 great grandchildren share a 90th birthday cake with Olive.

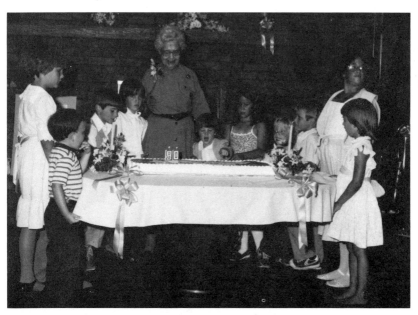

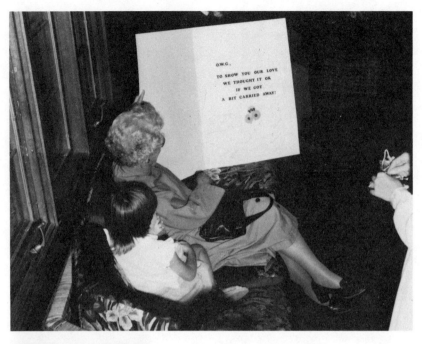

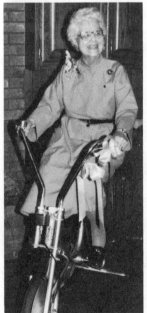

Above: Olive reads the 90th birthday card from loved ones who "got carried away!" Left: One of the birthday gifts she received was this exercise bicycle.

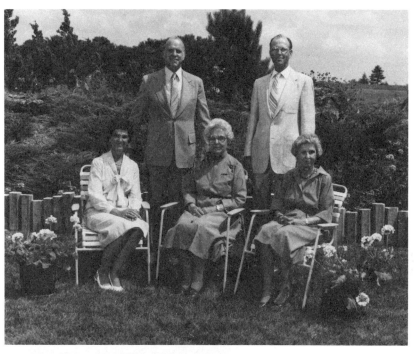

Above: Mrs. Garvey and her children, July 16, 1983. Seated L to R: Olivia, Olive, Ruth; standing, Willard, James. Left: Elliot and Daphne White. Elliot is Olive's brother.

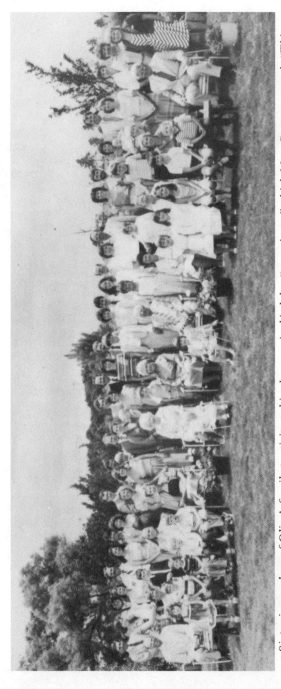

Sixty-six members of Olive's family participated in the surprise birthday "conspiracy," which Mrs. Garvey termed: "This is happiness."

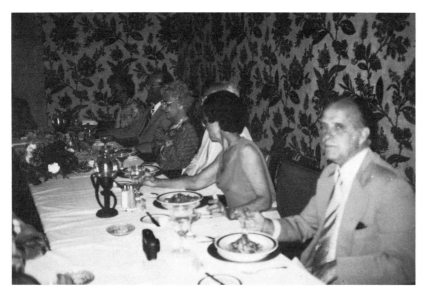

Above: Head table of the birthday dinner celebration at the Crestview Country Club. Seated L to R: Ruth Garvey Fink, James Garvey, Mrs. Garvey, Elliot White, Olivia Garvey Lincoln, Willard Garvey. Below: Robert and Marjorie Page shared Olive's birthday dinner celebration. Page, President of Garvey, Inc., is Mrs. Garvey's long-time business associate.

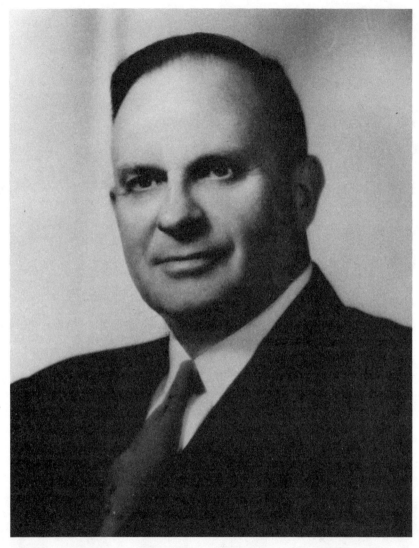

Ray Hugh Garvey, 1893-1959, founder of the Garvey enterprises.

2

THE EARLY INFLUENCES

The lines are fallen unto me in pleasant places;
yea, I have a goodly heritage.

<div align="right">Psalms 16:7</div>

Olive Garvey would be the first to acknowledge that she has a goodly heritage. Her ancestral lines stretch from England to colonial Virginia in the 17th century and into North Carolina by the beginning of the 18th. Her pioneering forebears, like countless others during that era, preferred to seek new opportunities in wilderness America rather than to endure political and religious oppression in their homeland, and their legacy—the spirit of facing adversities maturely, of searching for new challenges, and of developing God-given talents to the fullest—has been an enduring family asset.[1]

Many families, however, can point with pride to similar heritages, and as important as a proud background undoubtedly is, history has shown that an individual's determination to succeed involves far more than a favorable inheritance. Achieving one's full potential and the richness of life (success or failure) is measured in personal terms and depends to an even greater extent upon how any such advantage is utilized in developing basic character, personal characteristics, talents, and methodology in dealing with life's opportunities and challenges. Mrs. Garvey's life is an interesting verification of that analogy.

Olive was born to Oliver and Caroline Hill White on July 15, 1893, in Arkansas City, Kansas, at a time when the United States had reached a turning point in its history, and the city of her birth would play a significant role as this dramatic change was taking place. Soon after winning independence from England

at the close of the 18th century, America entered an age of expansionism, and eager homesteaders surged westward over the Appalachian Mountains, across the fertile Mississippi Valley, and onto seeming limitless plains. The plains, however, were not unlimited, and in less than a century, most of the more arable lands from coast to coast and from the Great Lakes to the Rio Grande were settled, thanks in large measure to waves of hopeful European immigrants.

By the time of Olive's birth, the frontier was fast closing, leaving only the unoccupied Indian lands in Oklahoma as the last major homesteading opportunity for landless farmers, and Arkansas City, because of its favorable location on the northern edge of the Indian Territory, enjoyed almost a decade of unprecedented activity as an assembly point and supply center for tens of thousands of future Oklahomans who arrived in anticipation of the starting dates for the various "rushes" into the unoccupied lands and who, in the events which followed, helped close America's last frontier.[2]

The build-up for these land rushes was just beginning when Oliver White moved his family from Indiana to Arkansas City in 1887, and he may have chosen the town over others in the region because he recognized its superior business opportunities, not only in supplying the needs of a growing number of itinerant homesteaders but also those of the established farming community in the area. Thus, he joined with Henry H. Hill, his brother-in-law, in forming what became a profitable implement and supply firm known as White, Hill & Company.

For more than a decade, the Whites made their residence in Arkansas City. Served by the Atchison, Topeka and Santa Fe Railroad, the town was a thriving little city, almost as big then as it is in mid-1980. It had nice homes on wide, graveled, and shady streets; and there were two nice hotels, good schools, a number of churches, several blocks of good business buildings, a thriving bank, an active newspaper, and a range of professional people. As Olive's mother once remarked, Arkansas City "had some better amenities than Indiana."

Oliver White had come to Arkansas City after years of residence in Indiana, but he was a native North Carolinian, having

been born to Josiah Thomas and Elizabeth Wilson White on October 9, 1852, near the town of Belvidere. Josiah, a farmer and owner of a mobile lumber mill, was a descendant of a long line of English land owners who emigrated to Virginia and later moved to the Albermarle Sound area in Perquimans County in the northeastern corner of North Carolina. The lands his ancestors chose were rich and heavily wooded, but they also were low lying and swampy, perennially plagued with much feared miasmatic fogs and malaria which produced "racking chills and fevers" of such severity that quinine became a dietary staple and death an all-too-frequent visitor. The area came to be designated as "The Dismal Swamp."[3]

Three generations of Whites struggled against this environment, raised their families, and lived out their lives in Perquimans County. Those bearing a direct line to Oliver White (Olive's father) were: Josiah, born June 1, 1750, to William and Margaret Scott White; and David, born June 5, 1783, to Josiah and Sarah Newby White. Eventually, the rigors of the Dismal Swamp and the lure of more healthful and arable lands in the west persuaded David's son (and Olive's grandfather), Josiah Thomas White, to break the pattern and leave North Carolina. In 1858, he moved his family to Milford in Wayne County, Indiana. Oliver then was six years old.

Grandfather Josiah Thomas, whom Olive remembers as a "neat, dapper little man," was born on April 3, 1824, and was raised in strict adherence to Quaker teachings.[4] Throughout his youth, he was devoted to his church and, as all other Quakers did, used the pronouns "thee" and "thou" in his speech habits. Moreover, he was a loyal son and worked long hours alongside his father in helping to provide family needs. As he matured, he was aware that it was unacceptable to marry outside the faith; therefore he chose a woman of similar religious background, Elizabeth Wilson of Pasquotank County, North Carolina, to be his wife. They were married in Pasquotank County on January 21, 1846, but made their home in Perquimans County near Belvidere.

Thus Quakerism, a heritage which formed the moral and ethical foundations of many of America's colonizers, extends deeply into Olive's ancestry on both the paternal and maternal sides.

Indeed, she had the example of grandparents who lived wholly by its tenets, and Olive's Grandmother Elizabeth never wore anything but the simple clothing (without ornaments or jewelry of any type) and headcoverings which distinguished Quaker women.[5]

Founded in 17th century England by George Fox and nurtured through the periodic persecution and imprisonment of its stalwarts, the Quakers (known officially as the Society of Friends but first called Quakers by their detractors) were but one of many groups which despaired of British intolerance and sought religious freedom in the colonies. In many ways, early Quakerism was Christianity in one of its simplest forms, but in some ways it also was remarkably progressive for its day. Women had equal standing and respect with men; education, including college training, was encouraged for both boys and girls.

Seventeenth century Quakers disdained worldliness, rejected all artificialities, and placed ultimate faith in strict observance of peaceful ways as the proper method of promoting an orderly society. Their goal was to exemplify their faith by example, not precept. Honesty and integrity were demanded of everyone, especially from their leaders who were expected to guide them quietly but forcefully in preserving the purity of their religious and social environment. Dancing, smoking, and drinking were forbidden, and persons known to have leanings "out of unity" were expunged from the Meeting rolls.

The Society at times was regarded as clannish because of the "holier than thou" attitude their neighbors ascribed to them. However, Quakers were, in practical affairs, anything but "other worldly." They were thrifty property owners who sought to manage their farms well, and many were gifted businessmen, some of the best merchants in colonial Philadelphia being members of the sect. They became involved in their communities and assumed leadership roles in civic and educational functions. The overriding characteristic in all of their activities was the belief that a Quaker's life was a sacred trust given by God to be lived in purity and "right thinking." Certainly Josiah and Elizabeth White enjoyed extensive involvements as well as happiness and tranquility—and the respect of their family—of a type which comes

only from leading lives that are consistent and in harmony with professed ideologies.

Josiah never wavered from the tenets of Quakerism. Much of his attention was devoted to the Society, its Sunday Meetings, and its educational program. As a farmer and mill operator, he built a reputation as a man of integrity and as a scrupulously honest and hard working individual who sometimes engaged in real estate and other financial transactions. He carried a small notebook in which he recorded daily activities, including appropriate scriptural references to what he was doing or thinking. Josiah was a busy man, but he always found time to assist other Quaker communities, traveling at least once to North Carolina and another time to Kansas in the interest of the Society.

Elizabeth complemented her husband well. They were compatible intellectually and emotionally, and shared a mutually firm commitment to their religious beliefs. Pictures of her reveal a strikingly handsome face with expressions which suggest a woman of great poise and contentment. Family and church were inseparable parts of her life; she was known to be a loving, almost overly solicitous mother as well as a devout, almost indefatigable Meeting worker. Indeed, she was designated in the sect as a leader with "a Minute" and often participated in larger gatherings where neighboring groups assembled in what were known as Quarterly or Yearly Meetings.

Large families were characteristic of the times, and a total of nine children, three sons and six daughters, were born to Josiah and Elizabeth, some of them (including Oliver) in North Carolina, others after their move to Indiana. Three of them died early in life, one of them being Oliver's twin sister. The surviving children grew up in a large white, two-story house of wood construction which the family named "Brookdale," and all of them pursued separate interests upon reaching majority.[6]

Oliver enrolled for his college preparatory education at West Town Academy in faraway Germantown, Pennsylvania, and later matriculated at the even-more-distant Haverford College, an institution founded near Philadelphia in 1833 by the Society of Friends. However, a serious bout with rheumatic fever interrupted his studies, and he finally returned to Indiana and later

enrolled at Earlham College (another Society institution established in 1847 at Richmond, Indiana) in order to be nearer his home. Health and scholastic interruptions combined to make his progress burdensome at times, but he managed to complete some of his college studies and to enjoy the friendly social life at Earlham.[7]

Although plagued with recurring rheumatism, Oliver was an energetic youngster with a sturdy medium build, curly black hair, and picture-blue eyes which seemed early to focus on Caroline (Carrie) Hill, a winsome if rather small lass with shiny, knee-length black hair and brown eyes. As they became better acquainted, they developed respect and deep affection for each other.

The strict environment at Earlham, which forbade frequent social contacts, posed some problems to their budding romance, but they managed to see each other often enough to explore interests and backgrounds. They did not know that they possessed a common ancestor in the person of Thomas Jordan II of Virginia. Thomas and his wife, Margaret, had ten sons, among them Joseph and Joshua. Carrie's Henley forebears descended from Joseph, and Oliver's White family line reached back to Josiah. Had they known they were cousins, though remote, they might have been allowed to see each other more often, for Earlham permitted greater visitation privileges between relatives.

Much earlier than the Whites, the Hill family had joined the western migrations to Indiana, settling around the turn of the 19th century in Hancock County, where Samuel Benjamin (Olive's maternal grandfather) was born on February 22, 1832, to William and Charity Hawkins Hill. The Hill-Hawkins family roots also extend well beyond colonial America to blood lines which are connected directly with English and French kings, including one as ancient as Charlemagne, the ubiquitous ninth-century Emperor of the Holy Roman Empire. This proud heritage was extended to their son, Samuel Benjamin, and it was subsequently enriched in 1852 through his marriage to Mary Henley of Rush County, Indiana, whose father, not surprisingly, also had roots in the Dismal Swamp area of North Carolina.

The Henley-Hills were more sophisticated than the Whites.

Mary Henley, who was the daughter of a banker, had been reared in a large home by a family who could afford more than the normal amenities. She had a strict sense of social proprieties which she imparted to her children, and always saw to it that they dressed well. Thus, when Carrie was born to Samuel and Mary on September 15, 1857, some of the outward symbols of Quakerism were disappearing.

Carrie idolized her father, and when Olive knew him, he was a portly gentleman with white hair and a medium white beard. A typical Hill, Samuel Benjamin left the impression of being somewhat stolid, and he enjoyed having people think he was more stern than he actually was. But, it was characteristic of the Hill family to be quiet and to speak only when they had something to say. His grandchildren, however, knew him to be a "very kindly person" who always had "a twinkle in his eye." He was a prosperous gentleman farmer who raised a variety of crops and made some of the finest maple syrup in his community, and his two-story home was "an imposing brick" structure "set well back from the intersection of the crossroads which bordered the farm." The Hill children attended Prairie View School, which was located across the road to the south, and later went to Earlham College.

Regrettably, Olive was never to know her maternal grandmother, for Mary died while Carrie was a student at Earlham College; indeed Carrie, like Oliver, her husband-to-be, was obliged to take time away from her studies. First her mother died, then her older brother Franklin, who was teaching the Prairie View School, succumbed to typhoid fever. Carrie left school and finished Franklin's school term; however, she was able to rejoin her class and finish at the top of it. Her father married Mary Hadley who bore him a son, Rowland, and after her death a few years later, Samuel was married a third time to Elizabeth Jarrett, a lovely and typically Quaker gentlewoman who endeared herself to the family as a congenial, supportive wife and devoted surrogate to Samuel's five children—three daughters (one of them Carrie) and two sons.

Carrie was devoted to her family and would have been the last to behave in a manner which might bring embarrassment to them. She was a young woman of good breeding—of genteel character,

sweeping curiosity, and innate intellect—qualities which un-
questionably were the result of centuries of cultivation and re-
finement by her ancestors before becoming integral to her
consciousness.

Such was the woman Oliver came to know at Earlham College.
Shortly before poor health forced him to again halt further col-
lege studies, they became engaged. Carrie again taught the Prai-
rie View School for a year, and they then proceeded to fulfill the
customary obligations expected by the Quaker Meeting for mar-
riage. After publishing their betrothal at regular Meetings on
three consecutive Sundays, they found total acceptance of their
intentions and were permitted to exchange vows at her father's
home on December 30, 1880, in the presence of family and
friends.

Shortly after their wedding, Oliver took his wife back to North
Carolina where he reentered the lumber milling business which
his father previously had pursued. He soon regretted the deci-
sion. For a year, he attempted to balance his growing business
assets against the perils of the Dismal Swamp, but when malaria
claimed his first child, a son born during the year, he despaired
of raising a family in such an unhealthy environment, sold his
business, and returned to Indiana where he bought a small farm
across the road from Samuel Hill's homestead.

They moved into a little white cottage next to Prairie View
School and resumed a life in pleasant and familiar surround-
ings. Five happy years followed, during which time two daugh-
ters, Mary Elizabeth (1883) and Ione (1886) were born to Carrie
and Oliver, but the lure of business opportunities in the West
made sharp inroads into Oliver's consciousness, as it already had
for his sister and her husband, William Jenkins, who recently
had moved their family to Arkansas City. Oliver made a brief
exploratory visit to the region in 1887, and after analyzing sev-
eral communities, he chose Arkansas City as well. Thus, twice in
less than a decade, Oliver had left Indiana as an itinerant entre-
preneur in search of opportunity, but his quest in Kansas was
imminently more successful than his sojourn in North Carolina.
In Arkansas City, he became a prosperous implement dealer, built
a two story home on South B Street, and within six years became

the father of two additional daughters, Florence Ruth (1888) and Olive Hill (1893).

Those six years in Arkansas City were an exciting time in which to live. People from all parts of the nation surged into Kansas border towns such as Kiowa, Honeywell, Caldwell, and Winfield, but Arkansas City became the unmistakable gateway city to the "promised land." Arriving in every possible type of conveyance and living for the most part in clusters in and around the cities, the human tidal wave proved as bothersome to the towns' social and civic structures as it was profitable to their businesses. Upwards of 70,000 hopeful settlers converged on Arkansas City (which had a permanent population of only a few hundred people) after the first of the authorized land rushes into the Indian Territory was announced for April 22, 1889.[8]

As best they could, Oliver and his fellow merchants met the needs of the migrants, and watched as history was being made in April of 1889 when, in a single mighty convulsion, their city reverted to normal size as hordes of people (forever thereafter to be known as the '89ers) raced past the starting lines to join the rush into the Unassigned Lands.

Oliver also resisted the urge to make the runs in 1891 and 1892 when additional Indian lands were opened to settlement, but he was too much the businessman to reject such opportunities indefinitely. Accordingly, when the Cherokee Outlet, or Strip (a belt of land embracing six present-day Oklahoma counties bordering on south Kansas), was made available for settlement in 1893, he and his brother-in-law Will Jenkins decided to make the run. Oliver laid claim to some city lots in the Newkirk townsite; Will staked out a quarter section of land in an adjoining section. Oliver later sold his lots, but his experiences became an historic extension to the lore of the White family heritage.[9]

Olive was but three months old when her father filed his claims in the Newkirk township. The White's residence in Arkansas City continued without interruption, at least for a time, and it was there that Olive's earliest memories developed. Her first recollection was the celebration of her third birthday at which she received a large doll, but her strongest awareness was the fact that it was a family affair—that her entire world consisted of an

attentive mother and father and three older sisters. A comforting feeling of security pervades her remembrance of that event, for it was the beginning of a continuum of youthful experiences which consistently confirmed that affection and respect were the cornerstones of life in the White household. And she was aware that as the baby of the family, she invariably received a larger share of the attention given out by both parents and sisters.

Carrie and Oliver approached family development seriously, the foundations for which were a firm belief that their marriage was indissoluble and that consistent effort was required not only to make it succeed for their own sake but also to fashion a stable homelife for their children's happiness. Whatever adjustments they had been required to make during the early years of their marriage were firmly in place by the time Olive was born; the White's household was one of pleasant relationships, predictable activities, and proper attitudes. Their children were taught the importance of obedience, good manners, and consideration of others, as well as the value of assuming a personal responsibility for their own well-being, including orderly bedrooms and clean, freshly ironed dresses.

Olive enjoyed a classic childhood. By the time her earliest memories began, she had the advantage of being at home alone with her mother during the week days, inasmuch as her older sisters already were in school. They did everything together— work around the house, shop at the market, and visit the elderly or shut-ins. Olive learned to cook, sew, and do the laundry the old fashioned scrub board way, and she went along when Carrie called on friends, "complete with white gloves and calling cards." A mature and patient mother, by example and positive instruction, took the time to mold a toddler into a budding young woman, and did it with such success that Olive acknowledges that her mother has been the most influential person in her life.[10]

Carrie's finer traits grew ever stronger as she matured, and she became an excellent role model for her children. She was always pleasant and not overly demonstrative in mannerisms, and her quiet, almost reserved demeanor engendered the feeling that she always had everything under control. She talked little, except when she had something to say, but when drawn into con-

versations, her quick mind and ready wit made for delightfully informed discussions. The children were conditioned to the fact that she seldom raised her voice, but they were also attuned to her soft speech. When she spoke, they listened attentively and followed her bidding to the extent that she seldom had to punish them.

Above all, Olive's mother was a highly principled woman who held personal beliefs which she had developed through "intelligent consideration, and not from prejudice." Carrie always had an open mind which was receptive to new ideas, and when she grew to feel that some of the older Quaker customs were unrealistic, she modified her habits to fit what then seemed appropriate to her so long as the change did not violate her conservative Christian principles. Thus, when Carrie and Oliver first arrived in Arkansas City and found no Quaker Meeting, they and their children became Congregationalists without losing stride in their church work or commitments.

Oliver and Carrie had a good marriage, but their children were aware that they had almost opposite temperaments. Oliver was more emotional—quicker in action and judgment, more highly opinionated, more rigid in the defense of his conclusions than Carrie. Both took their parental responsibilities seriously, but where Carrie used quiet persuasion, Oliver was more articulate and often given to long dissertations in instructing their children, a practice which Olive at times thought boring and superfluous. In retrospect, however, she has drawn great strength from his insistence on certain customs and practices, such as prayers before meals and daily Bible readings which exposed her to "all those priceless words of wisdom" which made permanent impressions "and have returned over my entire life as beacons of guidance."[11]

The Whites enjoyed many experiences as a family. Arkansas City had an Opera House which served as the center of cultural activities, and they frequently went there to attend a Lyceum entertainment series which presented a variety of lecture and musical programs and occasional local talent shows. Additionally, traveling tent shows, such as the exciting performances of the Ringling Brothers Circus, were major events in Arkansas City

and were never missed, not even the pre-show spectacular when the animals and equipment were unloaded, a routine which thrilled Olive as it has many subsequent generations of children.

There were other youthful memories: the horse-drawn ice cream wagon which made its mesmerizing rounds on hot summer days; the ice delivery wagon which dispensed free ice chips to the children along the way; and a first train ride at the age of four, which bring back happy thoughts of yesterday. Not so for the various childhood diseases, especially the dreaded scarlet fever which left entire families, including the Whites, quarantined in their homes until the maladies had run their course.

The years following the last of the major land runs into the Oklahoma Territory proved increasingly difficult for the implement business. A sharp decline in sales accompanied the departure of the migrants, and parching droughts took a heavy toll on the business normally conducted with established customers. Worse, poor economic conditions for farmers everywhere forced numerous defaults on previous credit transactions, and White, Hill & Company was not spared the recessionary effects of these developments. Their accounts receivable ledgers were laden with uncollectible debts, especially one rather large bill owed by Sam Lessert, an Osage Indian, who owned a ranch in Kay County in the Oklahoma Territory.

Oliver and Henry decided in 1899 to sell the company but to retain and divide between them some of the unpaid credit notes in the hope of collecting them at a later date.[12] Sam Lessert's account fell to Oliver, and in working toward a settlement, Sam offered a three-year lease on his ranch in lieu of the money he owed. In the spring of 1899, Oliver accepted the deal, and although the overall farming/ranching prospects seemed good to him, he found living conditions at the ranch to be marginal and also an absence of schools for the children. The only accommodation at the ranch that first summer was a "dank, moldy, mouse infested cabin" inasmuch as the main ranchhouse was still occupied by the incumbent lessee. At summer's end, according to plan, the family returned to their comfortable home in Arkansas City for the school year while Oliver managed the ranch and awaited the availability of the ranchhouse.

Thus, Olive was permitted to begin her first school year at the Second Ward School in Arkansas City under the tutelage of Miss Nellie Dean. She did well, but her father's absence and the prospects of having to move at year's end were none too comforting, especially after Ruth Parks, the first playmate her own age, moved into the house next door. During Oliver's frequent visits throughout the year, however, he and Carrie talked at length about the future and developed a plan based on the projected requirements of the family. Their ranch lease was finite and would last but for three years, not including the one which rapidly was passing. For the near term, adjustments would be made to accommodate the girls' schooling, but once the lease expired, the family would select a city which afforded the best combination of business and educational opportunities. And as their discussions progressed, Topeka emerged as the logical choice, inasmuch as it was Kansas' capital city and was blessed with good public schools as well as Washburn College.[13]

The plan was communicated openly to the girls, which had the effect of eliminating any reluctance they might have had in leaving the town for the country. But on the whole, they considered it an adventure. When spring came, they sold their house on South B Street, loaded all their household goods aboard wagons, and Carrie and her four daughters left the city to join Oliver at the ranch.

There were complications upon arrival. For a time, the Whites were obliged to share the ranchhouse with the family of Albert Penrose whom Oliver had employed to assist with routine farm/ranch and household operations and with whom he had shared the main house during most of the previous year. The overcrowded home forced upon all of them an uneasy accommodation until the Penroses experienced unresolvable marital problems and left the ranch, after which the Whites had the house to themselves.

Inasmuch as there were no schools in the area, Mary, as planned, returned at summer's end to Arkansas City where she lived with a friend while completing her senior year in high school. Carrie undertook to educate the other girls at home, Ione having reached the eighth grade, Florence the sixth, and Olive the second. Al-

though this effort complicated Carrie's other responsibilities, she handled it in stride. She had the advantage not only of having received a strong classical, advanced education herself but also of having taught school at Prairie View before leaving Indiana. With this solid foundation, she introduced Ione to Latin, Florence to algebra, and managed to cover the other subjects by utilizing individually prepared lesson plans obtained from a publishing company which specialized in educational programs.

The older sisters made good progress, but as time would tell, the results were not entirely satisfactory in Olive's case. However, the flexible schedule allowed time to enjoy to the fullest a variety of other important experiences. Life in rural remoteness enhanced family interdependence. They read numerous books as well as the current magazines (particularly *The Youth's Companion*), and they played games, the favorite being "Authors."

Carrie, ever the wise mother and master family psychologist, carefully encouraged the individual interests for her daughters, assigning Olive, for example, the exclusive use of a large closet beneath the staircase which became a youthful fantasyland where she "managed a hotel" for the numerous dolls she had collected. Oliver supplied each of them with a horse and allowed them freedom to roam the entire ranch at their leisure.

Olive and her sisters also assumed modest responsibilites in the essential chores at the ranch, being occasionally pressed into service as field hands whenever the corn fields needed weeding. They also were assigned the duty of riding and making minor repairs to the fences around the pastures. In some places it was necessary to build double lines of wire, several yards apart, to protect livestock from tick-laden Texas cattle which were driven northward to graze on the Oklahoma grasslands during the winter months and placed in adjoining pastures. When supplies had to be fetched from the Kaw Agency, Ione and Florence rode their horses to the little village which consisted of a post office, a grocery store, an imposing Indian Boarding School with large stone buildings (including a church), the Indian agent's home, and a cluster of Indian houses. Inasmuch as the agent came from Arkansas City, his daughters were friends of the older sisters, and they visited back and forth. Occasionally, all of the girls attended

the Sunday School which was taught in the pretty stone church by the teachers of the Indian School.

Trips to the village exposed them to the unique environment of their new homeland. Although Indians were the more numerous ethnic group, they were regarded with no more apprehension than the white settlers. The elderly still wore blankets, and the youngsters dressed much the same as the white children. Young braves riding on the roads were common sights.

But an unusual incident did result from an encounter between two young braves and Ione and Florence during one of their trips to the Kay Agency. After playfully heckling the unescorted ladies and receiving a cold reception, the braves seized the bridles of the girls' horses and led them until the group neared the Agency, after which the Indians dropped the reins and sped away. Two frightened young ladies returned home with their story, and two equally concerned parents took steps to prevent a recurrence of the incident by placing limitations on their freedom. To Olive, the episode was a first exposure to the facts of life which all young ladies face, but she reacted with an indifference befitting her youth and inexperience. She could not understand their concern, for from her observations, Indians not only were peaceful but also indolent, made so (she would surmise later in life) by federal policies which encouraged a reliance, indeed a dependence, upon government largess.

As their second year in Kay County approached, it was felt that Ione, now ready for high school, should attend a real school. Moreover, Mary had graduated from Arkansas City High School in the spring of 1901 and was ready to begin her college training. Thus, Oliver and Carrie sent both of them to Topeka, Mary to enter Washburn College, Ione to enroll at Washburn Academy—they becoming the first of the family to locate in that city. For Olive and Florence, the ensuing year was somewhat lonelier without Ione, but both had adjusted well to life in Kay County. With Carrie they went fishing on the Arkansas River, gathered walnuts until their hands turned black, churned butter—and studied their lessons. A cousin, Harold Hill, visited them in the summer, and they played "Authors" with cards so tattered that they had to be placed in large books; otherwise their backs would

have been as easily distinguished as their fronts. They also enjoyed their pets and rode horses. In the fall, they watched as Oliver and his farmhands butchered hogs and prepared the meat for curing. They were involved in a raft of meaningful, growing-up activities, and in retrospect, Olive remembers the entire ranch experience as "wonderful, more fun than a picnic, one of the memorable high spots of my life."

As enjoyable as life in the country had become, one occasion during the year heightened Olive's anticipation about the impending move to Topeka. Mary and Ione came home at Christmastime, bubbling over with exciting tales of their school activities, of fresh academic interests, of new friends, and of budding youthful romances. As Olive listened, it initiated an interest in Washburn, which persisted throughout her life. Such thoughts made the winter pass faster, and by the time the spring rains swelled area rivers to overflowing, a new element added expediency to family planning.

Although it was concealed from the children for a time, Carrie was expecting a new baby which was due to arrive in October. Even though the ranch lease had another year to run, this new situation indicated that an earlier than planned move to Topeka was desirable. Two children were already enrolled in school there, and Florence was now ready to enter high school. Accordingly, Oliver made a special trip to Topeka, rented a house at 1105 Western Avenue, and moved his wife and children back to Kansas.

Carrie barely had time to get the girls settled and enrolled in school before the baby came. Its arrival—a boy born on October 30, 1902—was an event of great moment. Oliver was overjoyed, having almost despaired of having a son. The name Oliver had been reserved for such an event, but when his fourth daughter arrived, the name had been surrendered. With the name thus preempted, the new son was christened Elliot Hill, which pleased the girls because they "thought the name distinctive and pretty."

Unlike his sisters, Elliot would know only Topeka as a home during his youth. He was too young to remember that his family released their rented house, stored their furniture, and rejoined Oliver at the ranch for the final summer of his lease, but Elliot was to hear of the grandeurs of Kay County many times from

Olive who has always felt those experiences were some of the more meaningful of her life, having "brought me closer to nature by allowing me to know life in the unique way that rural people know it." She has never lost her appreciation for the farmers of the world, for she recognizes that they are a prime example of man's basic obligation to himself as well as to the economic system under which he lives: they either "produce or starve"— precisely the code by which the Whites had subsisted in the Oklahoma Territory at the turn of the century.

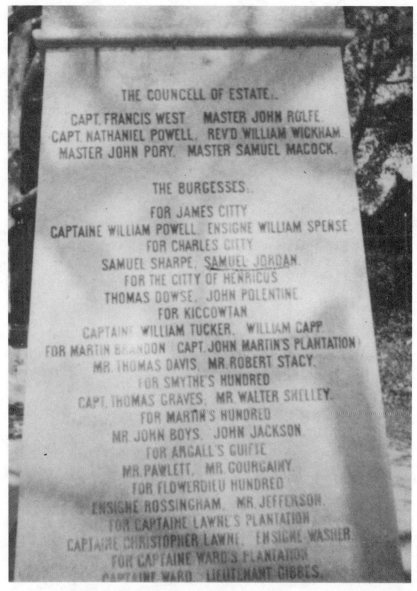

Plaque commemorating the first House of Burgesses in Virginia in 1619, lists one of Olive's forebears, Samuel Jordan.

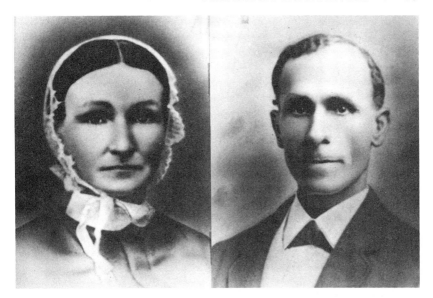

Above: Elizabeth Wilson White (1825-1879) and Josiah Thomas White (1824 1913), Olive's paternal grandparents. Below: Samuel Hill (1832-1911) and Mary Henley Hill (1831-1873), Olive's maternal grandparents.

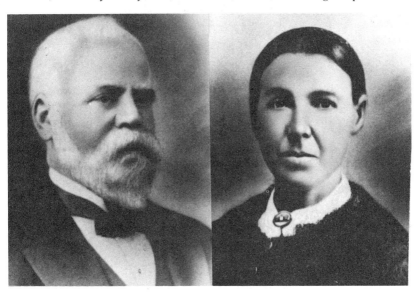

Oliver Holmes White, Olive's father, in 1878.

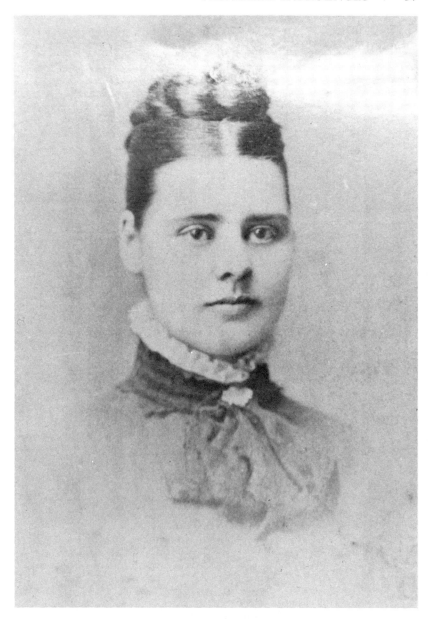

Caroline Hill White, Olive's mother, in 1878.

Above: 914 South B Street, home of the Oliver Whites in Arkansas City, Kansas. Standing L to R: Henry Hill, Oliver White, Caroline White (tending daughter Florence); seated, Mrs. Henry Hill (holding son Harold), Ione White, Mary White. Below: White-Hill & Company, Arkansas City, Kansas, as it appeared in 1889.

Olive Hill White, born July 15, 1893.

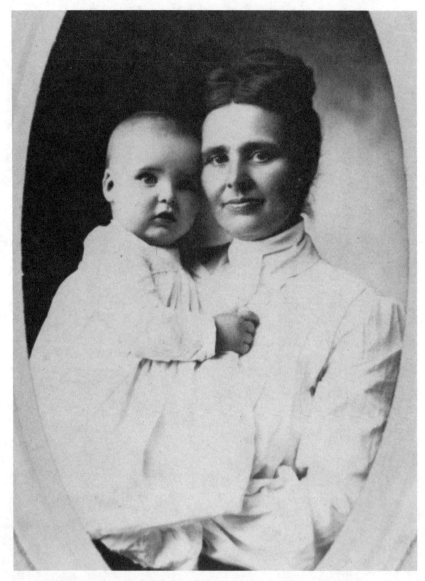

Elliot with his mother, Caroline (Carrie) White (1903).

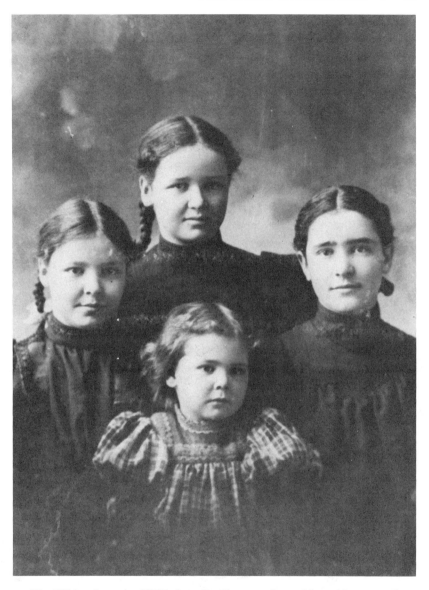

The White sisters in 1896. L to R: Florence, Ione, Mary, (foreground) Olive.

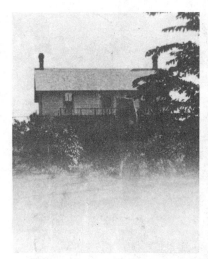

Above left: The White's ranch home in Kaw County, Oklahoma, 1899-1902. Above right: "Mrs. Grace Olive Hill White Taylor," the play name Olive adopted in managing a hotel for her dolls at the ranch home. Below: Olive feeding the chickens at the Kaw County Ranch.

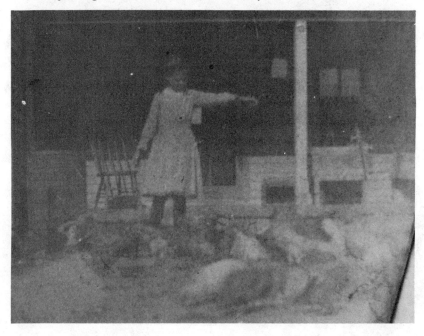

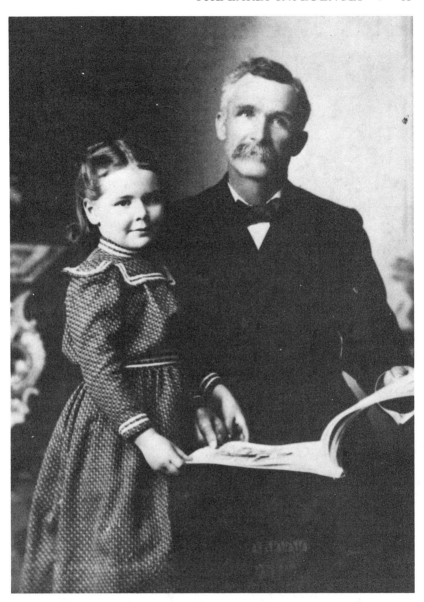

Olive with her father, Oliver Holmes White, in 1898.

3

THE FORMATIVE YEARS

Type of the wise who soar, but never roam,
True to the kindred points of heaven and home!
William Wordsworth, 1827

Olive's life as a farmer's daughter finally came to a close when Oliver returned his family to Topeka in the fall of 1903. Her father bought a house at 2021 West Street, conveniently located with respect to both Washburn and the public schools his children would attend. It was a large two-story, wood-frame structure with eight rooms and a wide porch which extended along two sides, and for its day, the house was spacious and comfortable, even though it had no furnace or indoor plumbling. After getting his family settled in their new home, Oliver searched for business opportunities and eventually decided to purchase, with an old Arkansas City friend, William Axtell, the Topeka Transfer and Storage Company.[1]

Oliver would remain president of the company until his death in 1931, during which time he not only developed TTSC into one of Kansas' leading transfer companies but also became known for numerous civic activities, including the YMCA and the Rotary Club. Not surprisingly, he was a pillar in the Central Congregational Church which he regarded, along with his home and his children's education, as the cornerstone of life's commitments and obligations, and the example he set left an indelible imprint on the character of his progeny.

After moving to Topeka, Olive quickly lost her youthful, country innocence, although her assimilation into a "more worldly environment" at first was difficult. The older girls in the neighborhood soon discovered her naivete and frequently enjoyed

44

telling her preposterous stories which she accepted as fact, only to learn later that she had been made the butt of yet another of their tricks or jokes. Their early advantage of greater sophistication was equalized in time, and she soon made friends with her schoolmates, one of whom had a collection of dolls rivaling the one she had amassed. Together they spent countless hours in playtime fun. During later afternoons, most of the neighborhood youngsters gathered under the corner streetlamp, as Olive remembers, "to play the popular hide-and-seek and other games of the era which sent them scurrying gleefully over fences and down alleys well into the early evening hours. Young people in those days created their own recreation, and it usually was characterized by wholesome, highly imaginative fun."[2]

Olive had attended Polk School during the 1902 school year, but when the family moved into the house on West Street, she enrolled at Euclid School where she would remain until the eighth grade. When she first entered the Topeka schools in 1902, Olive was given an examination to determine the grade level at which she would begin. To her utter disappointment and embarrassment, she was placed in a class at Polk which was a half grade behind her age group. "In effect," she recalls, "that put me a year behind them and really rankled me, and it made me wish I had spent more time with my books [at the ranch] and less with my ponies." In a few weeks, she was advanced half a year, and she eventually made up all her deficiencies and rejoined her age group when that class entered the eighth grade at Polk, to which it was sent because Euclid was not large enough to accommodate eight grades. And by the time Olive entered Topeka High School, which then combined grades nine through twelve, she was "straight with the world."

Meantime, Olive's other sisters followed Mary in attending Washburn College, Ione after finishing Washburn Academy in 1904, Florence after graduating from Topeka High in 1907. They were good students and enjoyed their college years immensely. Interestingly, they entered the College exactly three years apart, and each of them ultimately became engaged during her junior year to a college student whom she later would marry. Moreover, inasmuch as it was the custom of the day for a young man to

finish his education and/or become established professionally before taking a wife, each of Olive's sisters, upon obtaining her degree, entered the teaching profession until her husband-to-be graduated and felt prepared to take on family responsibilities. It was a pattern that Olive also would follow.

Mary graduated from Washburn in 1906 and two years later married Harrison (Harry) Maynard who received his undergraduate degree from Washburn and finished his advanced studies at the Union Theological Seminary in New York. Mary taught botany at Centralia and Onaga High schools until Harry completed his theological degree and was ordained in 1908 at the Central Congregational Church in Topeka, after which they were married at her parents' home. Maynard then accepted an appointment from the American Board of Foreign Missions and took his young wife to Turkey for what became their first career assignment in "over thirty eventful years of devotion to an alien people."[3]

Ione continued the pattern, becoming engaged in her junior year to John Hughes, whom she first met while they were students together at the Washburn Academy. Their long courtship was interrupted by Hughes' periodic need to drop from school in order to earn sufficient money to complete his college training. Thus, Ione graduated a year before John and accepted a teaching position at The Academy in Eureka, Kansas. They finally were married in 1909 after Hughes finished his coursework and became principal of Fort Scott High School. Later, he held the superintendencies of the Chanute and Independence schools, and eventually capped a distinguished career as superintendent of the El Dorado system where he formed the first junior college in Kansas.[4]

Florence became a freshman at Washburn during Ione's senior year. An avid reader of English literature (especially Charles Dickens), she often memorized long passages from preferred poems which she recited so frequently that Olive could recite many of the same pieces. She also doted on her little brother Elliot, whom she frequently took to the Washburn campus where he met some of the professors who one day would teach him.[5] And inevitably, she met Stacy Guild, a chemistry major from Bern,

Kansas, who later studied medicine at the University of Michigan. Graduating in 1911, Florence taught in the Pittsburg and Seneca schools until her marriage to Stacy in 1914, after which they moved to Ann Arbor, Michigan, where Dr. Guild began a long and distinguished career as a medical educator, ultimately becoming the head of the Department of the Inner Ear which was established at Johns Hopkins University by the DuPont family.[6]

The opportunity to share the experiences of older sisters was of inestimable benefit to Olive. She adopted the pattern they established of finishing college and of waiting for their future mates to become established professionally before proceeding to marriage. At the time it was expected that her sisters, like all girls of good families, should be "very proper young ladies," even though they were outgoing and fun-loving in their social graces. When gentlemen friends called for their dates, often they were not ready (to be waiting might seem too eager), and as the younger sister, Olive was expected to receive and entertain them until "Cinderella" came down the stairs. She enjoyed the duty immensely and behaved so precociously at times that she later marveled that some of the young men ever called again.

In that day, dressing was not a casual consideration. To be properly attired, one donned a woven shirt, a tightly laced corset, ruffled muslim drawers which covered the knees, heavy stockings, petticoats, dresses, hats, and gloves. And it was expected that the parents would meet every young man the first time he called.

These were accepted concepts for Olive and reflected the remarkably happy and stable homelife she enjoyed. What Olive came to appreciate most about her parents was that they placed great trust in their children, respected (indeed encouraged) their individuality, and taught them by example to think rationally and act prudently in every decision that affected their lives. They were not expected to be carbon copies of each other or to pursue undesirable interests for the sake of pleasing their parents.

All of these advantages formed an enviable heritage for Olive and no doubt were highly influential in helping shape her life, but heritage alone cannot explain why she developed as she did. From her earliest days as a schoolgirl, she displayed most of the

characteristics by which she would be known in later life, and especially after she became a highly visible and successful businesswoman. In short, she was born as she is, a person with an inner compulsion to cause things to happen, to devise some project, or to organize and run an activity—and to see it through to completion. Even as a youth, she had the instincts of a natural leader, and she early experienced a susceptibility to dependent people; someone always wanted her to decide something for them. She could have denied these instincts and refused the responsibilities inherent in them, but such was not consistent with her conscience or consciousness.[7]

Throughout her years in public schools, Olive used her budding talents in a range of activities, talents which grew stronger and more recognizable with each passing year. For example, in elementary school she helped organize, with some of her friends, several "literary clubs" which served as a forum for sharing the stories and poetry they wrote, so interesting to Olive that she would pursue it throughout her life. In high school, she was instrumental in organizing a high school Y.W.C.A. Club and became its first president. She became very familiar with "Robert's Rules" which she used effectively in both high school and college while holding many offices and helping to manage numerous projects.

Successful leadership, she discovered as time passed, "depends on knowing people and how to get along with them." Moreover, she learned that every project must be monitored to its conclusion, and that the best way to cure complainers is to put them in charge of an activity— "everyone performs better if he thinks it is his own idea." Olive also developed an early sensitivity to the conditions around her as well as an ability to sense all sides of many situations. As a result, she became an excellent mediator in "touchy" situations and a confidant to many who faced difficulties. Although she always demonstrated a great deal of empathy toward those with problems, she did not waste time "feeling sorry for people because they must be willing to help themselves." Her goal became that of trying to think of ways to help them do it, an early attribute (along with many others) which carried over as a life mission.

Of equal significance is the fact that in every activity in which she became involved, she always had a "sense of time" (or time table) in her consciousness which operated according to the demands but which remained flexible to accommodate unforeseen events. "There always have been so many interesting and necessary things to do," she reflects, "that time to do them is at a premium. It should never be wasted."[8]

Although Olive was born with what she describes as "a contrary mind," she never has been one to argue or force anyone to accept her point of view. Rather, if people hold strong opinions contrary to hers on the appropriate way of doing a thing, she regards them with respect but tries to find some pleasant but effective way of demonstrating that she is right. Little wonder that her classmates (and those who would work or associate with her in various activities in later years) returned her respect and developed a reliance on her ability to organize and lead them successfully toward a desired goal.

Thus, her years at Euclid, Polk, and Topeka High schools were involved, happy, and profitable. She formed numerous lasting friendships, among them Lillian Stone, Wilma Shoemacher, and Catherine Stanley (with whom she attended Sunday School), and in time she became "best friends" with Caroline Lovewell and Hazel Parkinson. They called themselves "The Triumvirate" and spent much time together, including numerous overnight slumber parties at each other's homes.[9]

There were no social clubs in high school, although the various grades were organized into classes which then were further divided into separate groups for boys and girls. Each held parties, mostly in private homes, but not necessarily for dating purposes. Consequently, groups of the opposite sex were invited to "just visit," play games, and enjoy refreshments. Sometimes Olive was escorted to such parties by a boy, such as Robert Whitcomb, an exceptionally bright lad who was a year younger than she, but most often she went with her girlfriends. Frequently, special invitations were extended to two of their favorite instructors—Grace McKnight, a Latin teacher, and John Hoener, director of the manual training program—who served as usually required chaperones. And interestingly, because Grace and John

later were married, Olive's class took no little delight in claiming a Cupid's role in the matter.

Formal social activities were limited. The junior and senior classes staged only one major function each year, but they were properly chaperoned, banquet-type affairs at which there was no dancing. There were the usual competitive high school sports programs for boys (none for young ladies), but inasmuch as they held little attraction for Olive, she seldom went to the games. As a college freshmen, however, she would become involved in the interclass (intramural) sports activities and actually participated on the freshman girl's basketball team. Her school interests were much more attuned to subjects like English and mathmematics— and just learning in general, except for foreign languages which were her nemesis because "they must be learned through rote memorization rather than logic." For both Olive and her teachers, three years of Latin, one of German, and one of French, were sufficient to indicate that she would never become a linguist.

The years in public schools have a special significance to Olive. In retrospect, she appreciates most the discipline which pervaded every activity, including classroom study. The close cooperation between home and school reinforced a "study hard and behave, or expect to be punished" environment. Teachers taught not only the subjects their students were supposed to learn but also a "respect for law, morals, and country." Parents generally had a low tolerance for their children's inattention to school work or poor conduct, and sanctions imposed by school authorities normally were matched by appropriate penalties at home— all of which, Olive firmly believes, creates an orderly and disciplined atmosphere in which learning can take place, and habits and character develop. She attributes her interest in and use of English form and composition (both written and verbal) to the "thorough grounding" she received under such strict tutelage by her high school teachers.

Having rejoined her age group in the eighth grade, Olive entered high school with a momentum which caused her to exceed annual requirements expected for each grade. Whether she enjoyed the challenge of a heavier scholastic load or merely was demonstrating a latent impatience to put her adolescence be-

hind her, the net result was that by the end of her junior year, she had amassed almost enough credits to graduate. Whatever her reasons, she chose to complete English history and algebra through home-study courses, and after taking and passing examinations in both subjects administered at Washburn Academy, she was granted permission to enroll in 1910 at Washburn College under a "special student" classification, in what was Florence's senior year. By accelerating her own matriculation, Olive gained her niche in the family pattern. It would not be the only similarity she would experience.

Her years at Washburn began with expediency. She was aware of the advantages that had been hers in growing up in the state's capitol. Many of her classmates were from rural or small town backgrounds and had not been exposed to the more sophisticated urban environment of Topeka.

She had grown up in a city which bustled as Kansas' seat of government. There always was great activity during legislative sessions and an infusion of new life into an already thriving business community. As a reflection of its growing urbanization, Topeka boasted of paved streets, a public street car system, a small but increasing number of automobiles, telephones of the old turn-crank variety, an expanding and dependable sewage system, electrical and natural gas services to most homes, and several movie houses which featured the latest Mary Pickford films and others. There were vaudeville theatres and a downtown Grand Opera House which afforded inexpensive balcony seating for Olive and her classmates at such memorable performances, she recalls, as Marlowe and Southern in the *Merchant of Venice* and Maude Adams in the original company of *Peter Pan.*

And significantly, Washburn students enjoyed another important advantage: town-gown relationships were excellent. Although the campus remained relatively isolated from other city activities, students were shown great consideration by Topeka residents who provided employment and other assistance because they regarded the College as one of the city's greatest assets.

It was against this backdrop that Olive began her college experiences in the fall of 1910. Her first social activity at Washburn, a traditional get-acquainted mixer for freshman students, was

sponsored jointly by the College YMCA and YWCA organizations. By custom, drawings were held to match boys with girls as refreshment partners, and fate took a hand in the pairings. During the early mingling, Olive met many young men and already had become friendly with Paul Rouse; however, another freshman from Phillipsburg, Ray Hugh Garvey, drew her name for supper. They enjoyed refreshments together, but when Ray asked for the privilege of walking her home, she had to tell him that she already had accepted Paul's invitation. Nonetheless, a first contact had been made between two freshmen who were destined to spend their lives together.

Four eventful years lay ahead at Washburn. Olive spread her wings and enjoyed "unaccustomed popularity," dating some young men slightly older than she was for a time. She thought it wonderful to have sufficient invitations "to guarantee a full and interesting schedule," and although her dating pattern varied from several partners to one, she managed to avoid permanent commitments until Ray emerged late in their sophomore year as the dominant personality in her emotional life. Thereafter, they were recognized as steadies or, in the campus terminology of that day, "as having a case."

They often were seen having sodas at a drug store near the campus, and like most love-struck young men, Ray invariably prolonged his frequent visits at the White residence until the last streetcar had already departed for the evening. Obviously, he did not resent the enforced three-mile walk home (where he had to arise at 4:00 a.m. to carry newspapers), for he persisted until Olive consented to make their commitment official by becoming engaged on January 19, 1913, thus making her the fourth sister to make such a decision in her junior year in college. Thereafter, Ray demonstrated his sentimental tendencies by celebrating the 19th of every month, which he called "lunaversaries," by giving her a box of candy or some other gift until their marriage three and a half years later.

Even though her social life was brisk, Olive had other interests which she pursued avidly, especially her academic work. She chose English as a major and was particularly devoted to the study of literature and composition with Miss Charlotte Leavitt and Dr.

Duncan L. McEachron; mathematics under Dr. Frank Harsh-barger; science from Dr. Ira Cardiff; ladies' physical education from Miss Pearl LeCompt; history under Dr. Arthur M. Hyde and Dr. Kirkpatrick; psychology from Dr. William Reisner; and sociology under Dr. Daniel Moses Fisk. Many of her teachers also had taught her sisters, and Olive had been forewarned of the eccentricities by which some of them were identified. Harshbarger, for example, was known as a colorful, jovial character who entertained while he taught. Hyde was a quiet, retiring man with a soft voice who was a prototype of the absent-minded professor. He once returned home from the grocery without his son and his perambulator. He was shy by nature, and his middle name being May, students often surreptitiously referred to him as "Arthur May Hyde if he wishes."

Olive regarded both Harshbarger and Hyde as excellent teachers, as she did Dr. Reisner in psychology and Dr. Fisk in sociology. Reisner was a fine young professor who later moved on to Columbia University, and Olive felt she learned as much from his class as any she had at Washburn—useful things which have remained with her all her life. Fisk was "another character" who lectured more than most instructors, but his students were struck by the fact that they seldom forgot what he said. Olive certainly was impressed. She regarded his theories as being well thought out and found his explanations of them to be quite helpful "in just every day living." Years later, she based her book, *Produce or Starve?* on his design of human progress. Such were the influences of her college professors.

Most of Olive's extracurricular activites complemented her interests in academic subjects. She was an active leader in the Alethian Literary Society, and was a member in 1912 of the first Kansas college Women's Debate team when the Washburn women met the Ottawa University women's team on the subject, "Resolved: That Immigrants Should Be Required to Pass a Literacy Test." She performed with a group known as The Thespians in a festival which featured ethnic dances done in costumes obtained from New York, and she also had a role, along with Ray, in the Senior Class Play which she managed, as she remembers, to perform "without undue embarrassment." Like Florence be-

fore her, she also pledged Kappa Kappa Chi Sorority which later became Delta Gamma.

Olive was never one to be idle or "just mark time" between activities. During summer vacations, she often worked at the To-peka Transfer and Storage Company for her father, serving as a relief clerk and bill collector for vacationing office girls on his staff. She and her group of girl friends also arranged picnics and lawn socials, and even spent whole days hiking in the country-side, after boarding a morning train to reach a favored spot near one of the small towns in the area. Between her junior and senior years, Olive spent two weeks in Colorado at a YWCA summer conference, but despite the excitement derived from her first visit to the Rocky Mountains, she was eager to return to Topeka, to which the numerous letters she exchanged with Ray certainly attest. In addition to these experiences, Olive spent some time each summer making her own clothes and in sharing activities with her friends until the autumn would bid them return to a campus routine—where their future was in the making.[10]

Ray also was an involved and industrious young man. Prior to his enrollment at Washburn, he began planting wheat each fall and harvesting it in the summer, and with the profits from his first summer's work, he invested in a run-down *Topeka Capital* newspaper route in North Topeka. He bought a bicycle, built up his subscribers' list, then bought a second route which he rented out. He earned his way through college by this means, and when he graduated, he sold his equipment and paper routes for $500—which became the capital on which he started his business career. Ray also made good progress in his school work and enjoyed a normal social life as well as an interest in college athletics despite his demanding, after-hours work schedule.

As a prelaw major, he was highly interested and involved in debating. He belonged to the Alpha Gamma Fraternity and had the reputation of being its best prepared and most aggressive debater and represented Washburn in several intercollegiate de-bates. In 1911, he entered the Intercollegiate Oratorical Contest in Kansas, and after winning the Washburn competition, he pro-ceeded to capture second place at the state level. He won the State Prohibition Speech Contest in 1913. Ray also was an athlete

who enjoyed long distance running. At various trackmeets, he won numerous races at distances of both one and two miles, and he set a state record in the two mile run which stood for many years. Olive shared many of these experiences with him as a spectator.

All too soon, Olive's college days dwindled down to a precious few. Her junior year had been busy, for in addition to having to devote much time to her studies, she was involved in other college projects, in most of which she assumed a leadership role. So also was Ray. He served as business manager of the college annual, and Olive also was on the staff. Their senior years were equally involved. Ray was elected president of his class and served as one of the business managers for the college newspaper, the *Washburn Review*. He was honored for his work by being selected for Sagamore, an honorary leadership group. Olive won recognition for her achievements by being elected to Tau Delta Pi (later to be known as Phi Kappa Phi), an honorary scholastic society.[11]

Just as it had for her sisters, graduation to Olive meant starting a new life, and inasmuch as Ray had yet another year of study before he would complete his law degree, she secured a position for the fall of 1914 as a teacher in the Augusta, Kansas, schools. Located in Butler County, Augusta was enjoying a brisk business boom, brought on by the discovery of oil and the heavy demand for petroleum products by the European nations involved in World War I. Workers had invaded the city, absorbing most of the available housing, but fortunately, Olive was able to secure a room (which she shared with Eleanor Neiman, another first year teacher and recent graduate of Kansas State in Manhattan) in the home of the Johnson family whose daughter Nan also taught in the Augusta schools.[12]

Olive found her work stimulating. She regularly taught "all the English courses and one in physiology," and she also was asked to teach journalism during her second year. Additionally, she coached the debate team, helped in play productions, and served as chaperone for other school functions. For these duties she was paid $75 per month the first year, $20 of which had to be earmarked for room and board at the Johnson residence. Her sal-

ary was increased to $80 for the second year, and her room and board to $24. Thus, besides saving for her trousseau as well as for the summer months when she would not be teaching, she also began painting china—which consumed most of the surplus.[13]

Days and evenings usually were filled with school-related activities, except for Tuesday nights when she, Eleanor, and Nan "hurried through dinner and rushed down to the cinema to see the latest episode of the *Perils of Pauline* or some equally gruesome spectacle." Inasmuch as it was well known that she was engaged, she had the proper sense (as well as good breeding) to accept invitations to various functions only from men considered to be fully informed escorts. Even when Ray came to a nearby town on a work-related assignment and stayed over for the weekend in Augusta, they were circumspect, knowing that rural communities often are critical of conduct, especially of those who teach their children.

There were few automobiles in Augusta, but regular train service was maintained between the city and Wichita. A passenger train left Augusta at 7:30 a.m., and a freight train with a caboose returned about 6:00 p.m. Occasionally, the girls made shopping trips to Wichita. They infrequently stayed overnight at the Eaton Hotel when a Broadway troupe happened to be performing at the old Crawford Theatre. Olive once took her entire Shakespeare class there for a special matinee performance of *Hamlet* which starred Forbes Roberson, a famous British thespian of his day.

Surprisingly, there were few periods of visitation between Ray and Olive before and after he finished his law degree at Washburn in 1915. Upon graduating, he left immediately for home to harvest his crop and then made his first trip to Colorado. Upon his return, he stopped at Colby where he opened his legal practice. Cash flow (which came slowly) and distance precluded frequent personal contacts; thus out of necessity, no marriage plans developed. However, they overworked the postal service, and Olive "collected a trunk full of very interesting letters" which kept close contact while Ray was struggling to develop his practice.

Ray's legal fees at first were few and small, and the part-time City Clerk's job he held in Colby paid him only $15 per month.

However, there were more encouraging developments. Using the $500 he had realized from his Topeka paper routes, Ray invested, at the invitation of Judge A.A. Kendall with whom he shared an office, in a small but productive farm which also had good prospects for long term equity growth. He received a substantial amount of bank stock in lieu of professional fees after negotiating the sale of a financial institution. Finally, he was appointed City Attorney for Colby in the spring of 1916 with a princely salary of $75 per month in "regular cash money," a windfall which set wedding plans in motion.[14]

Olive and Ray were married on July 8, 1916, at her parents' home in Topeka. The ceremony was solemnized by the Reverend Harry Maynard, her oldest sister's husband, who was enjoying his first sabbatical since entering the mission field. The date chosen was only a week before Olive's 23rd birthday, and inasmuch as Ray already had reached that age in January, she was able to say (with a twinkle in her eye) that she was marrying "an older man." It was but one of the endearing anecdotes which survive that happy event, for Ray countered her affectionate teasing by claiming that he had saved his bride from starvation, reminding her that she once had said, in a pique of frustration over some insignificant incident which most teachers have experienced, that she would rather starve than continue her teaching career. But Olive had the last word, claiming in equally good humor that he had married her for her money by pointing to the fact that she had "a whole $55 left in my bank account" on their wedding day.

Their wedding was a heartwarming, intimate, and unifying experience for the entire family, and the beginning of a most successful marriage. Olive glided through a catered, post-ceremony luncheon, then carefully packed her specially tailored wedding dress among other essential belongings, and joined her husband aboard the Rock Island "Jersey" that afternoon for the first leg of a trip to their new home in Colby, a town she had never seen. They stopped briefly in Phillipsburg for a weekend visit with Ray's parents, then reboarded the "hot, gritty Jersey" for a 90-mile ride westward to "the small red wooden station" in

Thomas County bearing the name Colby in bold letters on its
side.[15]

The train ride was their honeymoon, there being neither time
nor money available for a more elaborate one, but like most new-
lyweds in similar circumstances, they had no feelings of being
deprived of anything significant. The memories of that honey-
moon ride, which remain vivid in Olive's mind after more than
six decades, have been described by her as follows:

> ...As we bumped along the uneven rails, inhaling the acrid cin-
> ders from the open windows, shifting uncomfortably on the
> straight, plush-covered seats, the landscape which passed before
> our eyes was a contour of limitless open prairie, broken only by
> occasional undulations where shallow stream beds, usually dry
> [and] relieved by occasional cottonwood trees which diminished
> in size, each mile west, varied the flat ground.
>
> The countryside was done in earth tones. The wheat fields
> were a ripe tan, but the stand light enough for the gray-brown
> of the soil to show through. And where it had already been har-
> vested, the sparse stubble was pale beige. There was an occa-
> sional corn field where the young stalks showed green, and the
> various grasses and weeds...supplied multiple hues of green blades
> and ochre plumes and seeds. The prevailing cover was buffalo
> grass with a muted gray-green sheen, often broken by areas of
> gray-brown soil.
>
> There were occasional farm houses, universally small, often
> unpainted, surrounded by small farm buildings, sometimes fences
> still harboring dust piles, some boasting a small garden near the
> windmill, and sometimes one or two scraggly trees.[16]

Such was the setting of Olive's home-to-be for the next 12 years.
Although northwest Kansas was new to her, it was not to her
husband, for he had spent all of his pre-college days in the re-
gion and had continued his wheat-raising activities there during
each of his years at Washburn. Olive was aware that Ray felt "at
home"in northwest Kansas; he knew the land and its people, and
his professional fortunes there already were on the rise. There
was never a doubt in either of their minds that Colby was the
right place to begin their marriage.

Above: Early residence (1903-1911) of the White family at 2021 West Street in Topeka, showing Oliver White with his son, Elliot. Below: Brother and sisters at the West Street residence. Olive is first on left.

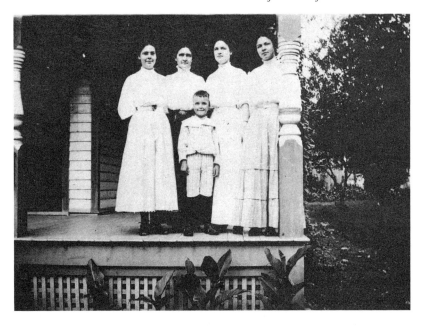

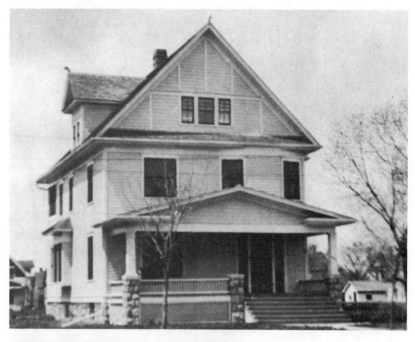

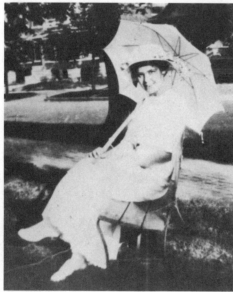

Above: Later residence at 1327 Lane Street in Topeka. Below: Olive, pictured with parasol.

Left: Olive as a freshman at Washburn College, photo taken in 1910.

Right: Ray Hugh Garvey, shown in 1912, first met Olive when he drew her name and won the honor of sharing refreshments with her at the Freshman Mixer at Washburn College.

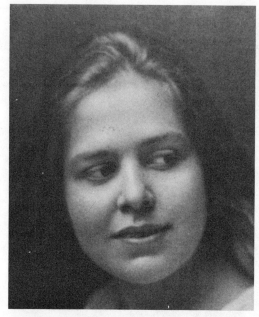

Left: The Art Teacher posed Olive to depict the Franz Hals painting of "La Bohemienne." Below left: Ray and Olive engaging in "campusology" at Washburn College. Below right: By the end of their sophomore year at Washburn, Olive and Ray "had a case" and eventually announced their engagement during the following school year. They are pictured here in 1914 in the backyard of the White's Lane Street residence in Topeka.

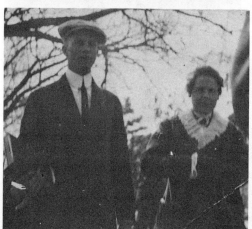

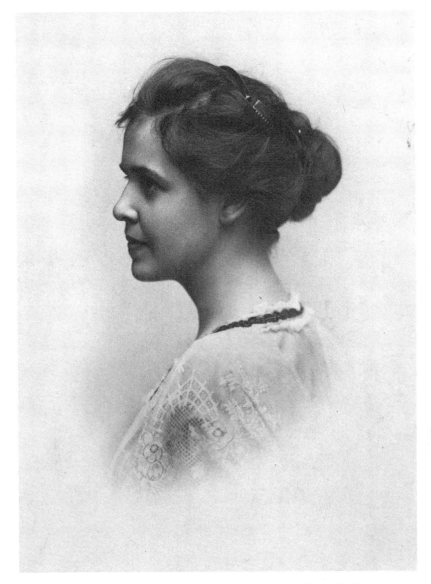

Olive in 1914, the year of her graduation from Washburn College.

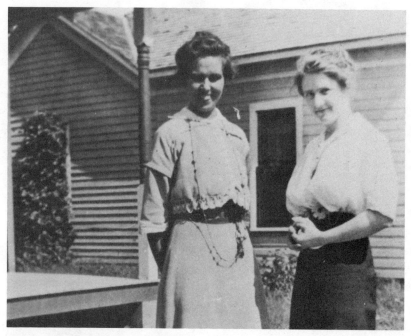

Above: Olive with Nan Johnson, in whose home she lived while teaching (1914-1916) at Augusta (Kansas) High School. Left: Auto riding was both a novelty and a form of recreation in Augusta. Olive is shown in rear seat, first on left.

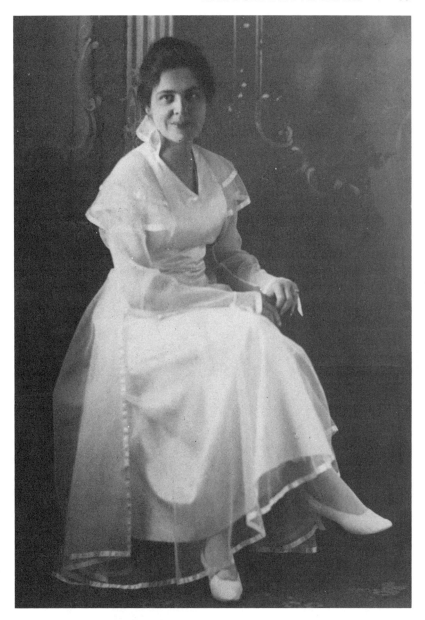

Olive's wedding portrait. She and Ray were married on July 8, 1916, at her parents' home in Topeka.

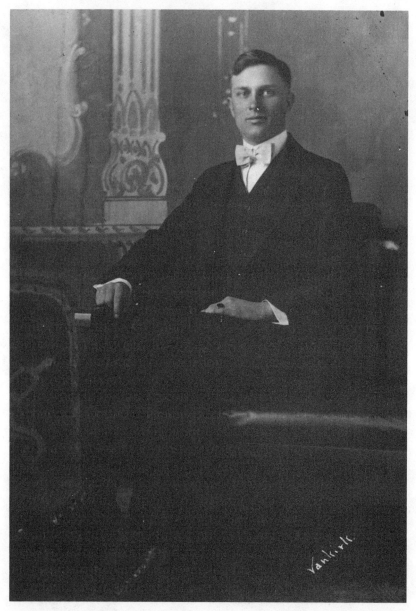

Wedding portrait of Ray Hugh Garvey. The young couple moved imme-diately to Colby in northwest Kansas.

4

OLIVE AND RAY:
THE COLBY YEARS

Paradise itself were dim
And joyless, if not shared with him.
Thomas Moore, 1817

"Feelings and attitudes," Olive has said, "flow from one generation to another. It is inescapable; they are inbred as a part of our character." When Olive and Ray married, they were two distinct personalities, having come from equally distinct backgrounds. Olive's heritage was the more conventional and embraced a more orderly plan of doing things; Ray's, on the other hand, reflected the flexibility of the frontier where every man was his own master, independent of others. They were entirely compatible on ethical issues and shared similar beliefs on politics, religion, and economics. They also were avid readers and interested in public affairs. But their methods were different.[1]

Both of them had aggressive, arbitrary minds, but hers was more unemotional and methodical than his. Ray never followed a set schedule and was impulsive, a direct actionist with "a one track mind" when absorbed in a project. He had confidence in his own actions (as did she) and gave little attention to what other people thought about them. Anything he thought pretentious was held in great contempt, and Olive, who maintains a reserved deference toward the actions of others, occasionally accused him of being an inverted snob.

Ray indeed was a product of the frontier, his grandparents, Obadiah and Mary Sutherland (Polly) Garvey, having moved to Phillips County, Kansas, from Indiana in 1879 with several of

67

their unmarried children. Among their neighbors in Kansas were Peter and Catherine Stickney Post, another pioneering family who had preceded them by a year and whose daughter Jannetta Jane (Nettie as she was known) later married the Garvey's youngest son, Seth Homer. Seth had attended Valparaiso Normal, taught school in Indiana, and then secured a country school in Phillips County, Kansas. Nettie had been a student in his first class.

Seth and Nettie Garvey made their first home in a semidugout on her father's homestead. Seth became both farmer and schoolteacher, and Nettie bore him four children—daughters Della and Grace, son Ray Hugh, and a baby who died in infancy. There were difficult times at first, but by the time Ray was nearing school age, Seth had acquired a quarter section of rolling land on Big Creek where he eventually built a six room house and ample operations buildings to complement his farming activities. The year was 1898, which corresponded to the time when Olive still lived in Arkansas City and was preparing to enter the first grade.

From infancy, Ray was a wiry, scrawny, rather nervous lad who was seldom still when he was awake, causing some to muse that he probably "was born running." When he started to Dog Neck School where his father taught, he rarely walked the two miles to the school with his sisters but chose instead to run the entire distance, perhaps explaining his later successes as a trackman in college.

As he grew older, Ray's assistance on the farm increased, but he always managed to find time to pursue personal interests. He loved to read from his father's modest library of books and magazines, devouring in their entirety the Bible and all of Shakespeare's works as well as every book available on history. And occasionally, a "dime novel" would come his way via his sisters. These he read clandestinely. He and his sisters often played games about comparative knowledge of history and geography. While attending high school, Ray roomed with his grandmother in Phillipsburg, and in order to help defray his maintenance expenses, he found part-time jobs polishing shoes at the hotel and serving as an errand boy for Frank and Mamie Boyd, owners of the *Phillipsburg County Post*. He was a good student with a quick mind and fluid speech, and he finished the high school's four-

year sequence in three, becoming known in the process, according to the class history, as "a phenomenon in argumentation" in the debating society, a reputation which would follow him after he enrolled at Washburn.[2]

Attending college was his goal, and in order to accumulate some money to enter Washburn in 1910, he accepted an appointment for the 1909 school year at Silver Light School, approximately 12 miles west of Phillipsburg, at a salary of $35 per month. The previous summer, he also rented land from a neighbor and planted a wheat crop, and the income from this harvest along with his school earnings enabled him to embark on his college studies.

Such was the drive and initiative of the young man with whom Olive shared refreshments at the freshman mixer at Washburn in 1910—and with whom she now had chosen to share her life in Colby. From the beginning, she respected her husband's energy and drive and felt it a part of her obligation to encourage and support, and show appreciation, for his hard work. She worked equally hard to provide a happy home environment, in a multitude of duties no less difficult or important to their happiness and livelihood than those he shouldered. And they enjoyed a remarkable willingness and need to communicate—an attitude of total sharing, of openness and congeniality, and of reciprocal affection and appreciation. They had a good life in Colby.

Colby in 1916 had a population of approximately 700, down somewhat from earlier years because of a prolonged drought which had taken its toll not only upon the town but also the number of farming operations in Thomas County and the surrounding areas. The return of moisture after 1911 gradually restored agricultural productivity, but there still were manifold vestiges of the earlier dry years with which to contend. Houses and buildings had mounds of soil heaped around their foundations and along adjacent fence rows. Worse, housecleaning was an unending chore, for strong Kansas winds "whistled while housewives worked," bringing in fresh supplies of dust to replace what had been removed the day before. Happily however, intermittent rains and increasing wartime demands for wheat by 1917 had occa-

sioned a new flurry of land speculation, resulting in a modest population growth and a revival of business opportunties.

Ray's business interests and his election as County Attorney in 1917 gave him enough security to take an economic breather in which to sort out what was most important in his life. Moreover, his marriage to Olive, which was his first priority, gave him a companion who understood his need for freedom to explore all options in determining which opportunities might lead them to even greater security and ultimate prosperity.[3]

His elected position was not overly demanding but left much to be desired. As Olive remembers, "He found his few cases both uninteresting and disturbing; the sordid ones were distasteful, the sad ones depressing because he had a tender heart." Only eleven cases were adjudicated during the two years he served, leaving ample time to pursue other aspects of his legal practice. He handled title and transfer work for the Kendall Land Company, and although the fees for his professional services were small (averaging no more than three dollars per filing), their number nonetheless was increasing—as were his frustrations over the contrast between his meager fees for examining abstracts and the much larger commissions land agents received, which oftentimes amounted to $100 or more per sale.

His work in the land records office revealed that large portions of Thomas County farmlands had been owned for decades by eastern speculators who, because of the prolonged drouth, either had leased them at low rates for grazing purposes or had virtually abandoned them. Ray began the practice of addressing penny postcards to the owners, offering to become their sales agent, and to his surprise, many eagerly accepted the opportunity to have the young lawyer represent them. He was an immediate success. Soon, his revenues from sales were many times greater than his combined income from all other sources, and he began to make investments of his own in Thomas County farmlands with some of his earnings. Only his commitments to Kendall and his duties as County Attorney kept him from pursuing the role of realtor on a fulltime basis.

His term in office expired in the spring of 1918, and he chose not to stand for reelection. Instead, patriot that he was and with

his nation by then involved in World War I, Ray felt an obligation to join the armed services, and he applied for admission into the U.S. Army Air Corps, a decision fully discussed with Olive and one in which she resolutely, if reluctantly, concurred. He was called to St. Louis and given aptitude tests, but the Armistice was signed in November before his papers were processed. Back in Colby, Ray promptly made another dramatic decision: he altered his career objectives, electing to discontinue his law practice to become a partner with Judge A.A. Kendall in the land business.[4]

It was a decision of great moment, the type which entrepreneurs relish and which only they understand. Ray had caught a glimpse of the future, of what "might be" if he seized an opportunity whose time had come. Like a few of his risk-taking counterparts, he could see a little farther down the economic road than most of his contemporaries. Agriculture had reached a stage of development where rising world demand for farm products was rekindling a boom in land sales. Kansas already had become a leading grain-producing state, but there still were untold acres yet to be brought under cultivation which could increase its productive capacity. Equally significant, he recognized also that the agrarian world was poised on the threshold of new and evolutionary changes in both technique and technology which not only would further improve the average yield per acre but also would dramatically raise the value of farmlands.

Thus Ray, who frequently would say in later years that he had been forced into every business endeavor he ever undertook, gave up the security of a law practice and a budding political career to accept the challenge of his convictions. He became a hard-driving land salesman who earned the reputation of being a persuasive, creative, and scrupulously honest broker—reviving, in the process, the defunct *Thomas County Cat*, the first newspaper published in Colby, and using it to extol the advantages of the region. Numerous out-of-state purchasers, some of them longtime Nebraska acquaintances of Judge Kendall, were attracted to the Colby area. As a result, wheat production in the County soared until, regrettably, postwar grain prices plunged in 1920 to near depression levels.

Many of the new farmers thereafter faced bankruptcy and foreclosure, leaving the Kendall Land Company and its partners holding many unrecoverable mortgages. Such bad fortune to some might have presaged failure, but to Ray Hugh Garvey it signaled another opportunity to put his genius to work—to be "forced into yet another business activity." Adversity, he reasoned, was the traveling companion of opportunity; he was determined to stay the course.

Shortly thereafter, an aging Judge Kendall chose to dissolve their partnership, dividing equally with Ray their assets and liabilities. Ray received ownership or options on approximately 13,000 acres, and inasmuch as land sales had virtually ceased, there were taxes as well as interest on bank notes to be paid. Thus he improvised, renting some of his acres to neighbors and ultimately deciding to become a "custom farmer" himself—a wheat grower as well as a realtor. He traveled widely throughout the region, surveying the better farming techniques and hoping to discover something better than the traditional "break-and sow" method then in vogue.

At McDonald, Kansas, he was introduced by Asa Payne to a technique known as "summer-fallow tillage," a relatively new method developed by Payne and adopted by the State Agricultural College. The process—deep plowing a field during the summer but allowing it to lay fallow and accumulate a year's moisture before planting the next summer—increased crop yield fourfold. With summer-fallow tillage (and a deep admiration for Asa Payne), Ray launched successfully into the wheat growing business on the acreage he held or subsequently would acquire. In 1921, he established a separate farming company, administered by Claude Schnellbacher (a Kansas Aggie student and another summer-fallow tillage devotee who was a first-rate farmer), which utilized the newly developed tractors.

Throughout the twenties, Ray managed to survive the vacillations of an unstable agricultural economy. Olive watched as he spent increasing hours in the fields in a general supervisory mode, cataloging in his computer-like mind even the smallest of details which bore on his enterprises. At times, he must have thought he was aboard a roller coaster which made frequent stops in the

pits, but he was never dissuaded from continuing his operations or discouraged from acquiring new acreage whenever the economics of a land transaction seemed right.

He bought a particularly desirable section of flat, fertile land adjoining Halford. This he gave to Olive for her future security. He thought it a better medium than an insurance policy. And he assigned her its management. Olive was content with her present support and was not overly appreciative of having to make her own tax return. But the value of such a practice was incalculable, a fact she would not fully realize until Ray's tragic death many years later.[5]

Ray fundamentally was a teacher who set out to teach Olive about business, although she felt she had a little more knowledge in the field than he gave her credit for. He seldom told her things he thought would not interest her, but he nonetheless sought to acquaint her with details he thought important for her to know. His vehicle was the property he gave her, his technique the actual handling of the financial details regarding them. Her methods were more conservative than his; where he felt debt leveraging to be a prudent business risk, she systematically assigned surplus revenues to early debt retirement until she held title to her properties outright.

In 1924, Ray branched out into an enterprise related to his farm operations. With some 20,000 acres under tillage, it had been necessary to assemble a large fleet of farm implements which required maintenance, service, and fuel. The failure in that year of the Western Trails Company of Wichita, which previously had accommodated these needs, threatened to complicate the Garvey farm enterprises, and to help salvage the best of a bad situation, Ray "was forced" to buy the franchise. He renamed it the Service Oil Company, reopened a few service stations in the area, and began providing tank-wagon delivery, not for his use alone but also for others who were dependent upon such services. Again, he had seen "a little farther down the economic road"; the dealership proved to be a prudent investment, for after Ray established an efficient management system, Service Oil began to show a profit and, as Ray would later reveal, actually did so well over the years that it "kept the Garvey agricultural ship afloat" during

the decade of the thirties when most American farmers were devastated by the Great Drought.

He and Olive shared an openness for discussing all activities, business as well as domestic, which made for lively and informed exchanges between them. Although he kept her generally informed about his business operations, he was not given to making regular reports. In the main, it was unnecessary for rural people, because by experience they understand economics and cooperation without the need for conscious verbal communications. Nonetheless, their relaxed, oftentimes lighthearted, but totally respectful conversations were as much a product of Ray's heritage as they had been hers. In their youth, both had experienced similar cooperative interactions between their parents—which Olive believes was a product of their own agrarian upbringing.[6]

Mrs. Garvey particularly feels that rural families develop a unique understanding of the value of sharing and caring about each other's interests; not only does such conversational intimacy build interpersonal strengths and reinforce family solidarity but it also provides what some sociologists refer to as a welcome escape from human loneliness within isolated or confined environments. Ray also subscribed to that philosophy, and supper table discussions early became an important communications medium, serving as a type of informal family forum which became an expected and enjoyed (indeed lively) experience for all the family after their children were old enough to participate.

From those youthful days in Oklahoma when she "managed a hotel" for her doll collection in a private ranchhouse closet, Olive had accepted the ultimate end of matrimony as the creation of a family, and when their first child, Ruth Caroline, was born on April 26, 1917, an important new world opened to her. There were complications in Ruth's birth. She was breech born and suffered slight damage to the nerves in one of her arms, and as soon as it was practical, Olive took the baby to Topeka for special treatments. Fortunately, the arm responded to therapy, and mother and child returned to Colby within a few weeks.

In their absence, Ray had taken steps to improve his family's living conditions. The small rented house they had occupied since

moving to Colby had electricity but no indoor running water, and they often had discussed the possibility of buying a larger home with more conveniences. Inspired by those discussions and eager to provide a better environment for his family, Ray not only bought a two-story house from a local druggist (who was building a new home) before Olive returned from Topeka but also had developed plans to have it moved to a residential lot he had purchased on the west side of town.

It was not exactly the type of house Olive "had in mind," but once the structure was relocated, she welcomed the opportunity to have her own furniture and make an attractive home. Ray immediately added an additional bedroom and bath and subsequently installed new floors, woodwork, and a furnace. The house would remain their residence until 1928.

There was a "crop" of babies in 1917 in Colby. Several women with whom Olive had become initially acquainted also were pregnant, and all had babies within a two or three month period. Motherhood was an expected, important, and welcomed condition, but her ambitions embraced far more than being a housewife who tended only to domestic chores. In addition to a natural desire to socialize with the other young mothers, she had strong, unfulfilled interests in literature and wanted to write, and she also felt a growing determination to have a greater involvement in community activities.[7]

Most forms of social entertainment centered around the home, although there was a movie house which offered relaxed diversion. The ladies shared a variety of activities, including a Sewing Club and eventually daytime bridge parties which were preceded by luncheons. Also, she and Ray were invited to join the Whist Club which met bimonthly at members' homes.

There also were two women's clubs in Colby which were devoted to literary appreciation. Mrs. Kendall immediately invited her to join the Leisure Hour Club which consisted almost exclusively of female members of the pioneering families. The intellectual stimulation she derived from associating with "those wonderful and intelligent women" gave her an outlet for her own well-cultivated interest in literature. The ladies produced their own programs and once undertook the study of "The Frogs," a

Greek drama by Euripides. They also presented papers for discussion and performed dramatizations complete with scripts and costumes. Olive also was invited in later years to become a charter member of the Colby chapter of P.E.O., a national, non-collegiate "sisterhood."[8]

Olive was instrumental in forming the Civic League, an organization which was dedicated to the improvement of Colby. Numerous fund-raising events were staged and the money used to establish the Colby Community Library as well as to beautify and provide maintenance for the Colby Cemetery. Even more ambitious was a project which called for draining a low-lying, somewhat swampy area on the north side of town known as Fike's Grove and developing it into a city park, but the endeavor was much too costly for their organization to undertake without the assistance of the City Council. Unfortunately, the needed assistance was withheld because elected officials doubted that the area could be permanently drained. Nonetheless, the Civic League had planted the idea for what eventually would become known as Fike Park. Two decades later, a well-designed recreational area was developed on the site, which included drives, walks, a swimming pool, and (of all things) a City Hall.

Meanwhile, the Garvey family grew. The acceptance of birth control was new, and young wives were very conscious of its social overtones. Two children were the popular norm, although one was preferred. "Had nature not known better," Olive has said, "there probably would have been only two little Garveys. But Ray was more enthusiastic about large families, especially after the first ones won him over." Ruth was almost three before a second Garvey baby was in the offing. As its arrival approached, Olive became apprehensive about her experiences with Ruth's birth, and not wishing to face similar problems without proper medical attention, she traveled in the summer of 1920 to a hospital in Colorado Springs, Colorado, where Willard White was born. Happily, there were no complications during the delivery, but the hyperactivity of the new baby signaled to everyone that another Garvey malechild "had been born running." Two and a half years later, Olive's motherly duties multiplied again when yet another son, James Sutherland, made the Garvey

household even livelier by also "hitting the ground running" in the winter of 1922.

Three years would pass before Olivia Rae, the last of their brood, would arrive in the spring of 1926, and during those years, the form and substance of Olive's life developed in predictable fashion. The solid influences of heritage and home, especially the examples set by her parents, were indelible in her attitudes and behavior. She allowed only those things to become routinized which by necessity had to be observed regularly and orderly, but in all other matters, she encouraged an atmosphere of individuality in expressions and activities. Her children were influenced, as she had been, to do what was expected of them as a matter of course, and they generally wanted to respond in a correct fashion because they knew their parents desired rather than demanded it. Punishment for improper behavior was rare, but when needed, Olive administered it swiftly and without harshness—and always with a view toward developing the same "correct thinking" which had characterized her own rearing.

Routine matters of discipline were Olive's responsibility, not because Ray sought to avoid it but because his indulgence was conditioned by the fact that he seldom was at home during the day. She accepted as unchangeable the work schedule he maintained—rising early in the morning, eating breakfast, and eagerly setting off for a new day. His parting words were: "Goodbye children; I am off to do what I laughingly call 'my work'." His long hours caused him occasionally to miss the evening meal, but the rest of the family was present and "washed" for the affair, even in his absence.

At times, Ray felt a tinge of conscience about his work schedule. He once remarked to a prospective real estate client as they drove past his house, "That's my widow and orphans there in the front yard," implying incorrectly that he was but a parttime participant in family matters, but those who knew the Garveys understood that such remarks subtly expressed his sincere admiration for Olive's support of his business efforts and her tolerance of the time he felt he needed to spend at them.

In all other mutual activities, however, Olive and Ray were constant companions. They were regular in attending the Pres-

byterian Church (inasmuch as there was not a Congregationalist group in Colby) and saw to it that their children experienced spiritual instruction in Sunday School. And, they were frequent participants in most of the social and cultural activities in the city, including the social groups. Olive and the children often accompanied Ray on his rounds of the farms.

Despite the elongated work days, it was evident that the Garveys otherwise sought a balanced life for themselves and their youngsters. As a family, they enjoyed frequent outings and picnics under lone trees on the open prairie. One of Ray's jokes was that whenever Olive saw a tree (which was not often), she invariably suggested that they have a picnic. And, whenever it was appropriate, they traveled by overnight train to Topeka or to more distant destinations in one of the various automobiles Ray owned. Ray once drove them to Ann Arbor, Michigan, to visit Olive's sister Florence and her husband, Dr. Stacy Guild, and almost every summer, the Garveys made weeklong trips into the mountains in Colorado.

All such trips were memorable, even when Ray occasionally found it necessary to cut them short because of business demands, and they were educationally broadening, especially when the children were exposed to new learning experiences, as they were during a visit in the summer of 1927 to Topeka when Olive and her three older children made almost daily trips to the Topeka YWCA to receive swimming instructions. "I learned very little more than how to float," she recalls, "but the children began what was for all of them a lifetime sport."[9]

There is a memorable footnote to the story. The summer experience was blunted by the fact that the children knew there was no comparable facility in Colby in which to continue their newfound interest; indeed, there was not even a river with sufficient water depths to accommodate erstwhile swimmers. However, during their absence, a farmer who owned a stock pond north of the city had enlarged and deepened it into a community "swimming hole," and a host of citizens rushed out to use it. For a time, no one complained about the unkept banks which sported weeds and grasses to water's edge, but by midsummer, the undergrowth teemed with redbugs' (chiggers') larvae which in-

flicted untold misery upon those who came into contact with them. Undaunted, the three older Garvey children joined the watery pilgrimmage upon their first day back in Colby—and with painful results. After a single, funfilled afternoon, their little bodies bore large red welts which itched cruelly for weeks thereafter despite Olive's efforts to provide them relief. They had no desire to repeat the ordeal, and postponed indefinitely their aquatic interests.[10]

Perhaps that footnote speeded consideration of an even more profound postscript to the history of the Garveys in Colby. As parents, Olive and Ray were sensitive to the needs of their maturing children, needs which Olive increasingly felt could not be accommodated in Colby, delightful though their life had been there and convenient though the city was as a focal point for Ray's enterprises. Perhaps Olive also was influenced by the experiences of her own childhood. Her parents had made a similar decision to move from Kay County, Oklahoma, to Topeka in order to provide their children with greater opportunities for cultural and educational development. In a sense, it was history repeating itself.

As college graduates, both Ray and Olive knew the importance of an education, and their children's progress always had been monitored with great interest. After Ruth entered the first grade, Olive had become active in the local Parent-Teacher Association, serving one term as president of the organization, and she had a continuous involvement with her children in numerous functions during school terms. Her concern was aroused not from any dissatisfaction with their achievements, nor from any disenchantment with their life in Colby, a city which she regarded as "the best small town between Topeka and Denver"; rather, it arose from a growing sense of urgency to provide her children with an exposure to such expanded opportunities as a larger city could offer.

Chiggers and a community swimming hole added symbolism to her reasoning and strength to her lobbying efforts for a change of residence. However, the reasons for her persistence in discussing relocation were no more logical than those which Ray offered in defense of his reluctance to leave the area. Northwest

Kansas was the land of his heritage, Colby the center of his growing empire. To him and his farm operations, time was the most valuable asset, distance the most obvious liability; any dramatic change in location would add significant complications to his ability to provide effective management and supervision for the expanding Garvey enterprises.

Still, it was characteristic of their relationship to respect each other's point of view, and eventually they began systematically to survey the advantages of several larger communities. They always had enjoyed the mountains, and there were some marvelous memories of a week-long holiday experience in 1926 when Olive accompanied Ray to the National Rotary Convention in Denver. Not surprisingly, Colorado drew early attention, and Ray developed a preference for Colorado Springs because of its relative proximity to his Kansas holdings.

Their searchings contributed new dimensions to their discussions and added depth to their visions of the future. They knew that any change must provide not only a larger arena for their children's development but also a bigger stage on which Ray could exercise his unique business genius. Surveying new cities had occasioned investigations of fresh economic opportunities and again had aroused Ray's natural entrepreneurial instincts.[11]

Colorado Springs, to their regret, offered few encouraging prospects at the time, and after months of looking and reflecting upon the various advantages other locations offered, Wichita emerged as the more logical choice. They were native Kansans, they reasoned, with deep family ties as well as significant land holdings in the state, and Wichita was equally as close as Colorado Springs to Ray's enterprises and much more attuned to high plains farming and wheat production than any of the other cities they visited. Even more significantly, Wichita was emerging as the queen city of the midcontinent region with sufficient business potential to arouse Ray's enthusiasm for the move.

The approach of the new school year in 1928 provided the impetus for reaching a final decision. Wichita it would be, and Olive was assigned the task of locating suitable lodging for the family. In August, she and Willard, her older son, made the trip to Wichita, and with the help of realtors, Olive selected a rental

property at 416 North Clifton, an older brick dwelling which was spacious enough to accommodate a six-member family in comfortable style.

When the Topeka Transfer and Storage vans arrived to transport their household goods to their new home, the impending departure was not viewed without regrets. The children had many happy memories which symbolized their life in rural northwest Kansas, such as playing in the dusty, unpaved streets of Colby or the scoldings they received (and the fun they had) after gleefully plunging into the turgid, pollywog infested waterholes across the street from their home. They also held nostalgic thoughts about those numerous family picnics, the long rides into the countryside in their trusty Model T Ford, the joys of learning to ride the horse Ray bought them, and even their performance as tumbleweeds in a skit Olive wrote for the Sunday School during which they sang memorable songs such as, "I am a little prairie flower, growing wilder by the hour; no one cares to cultivate me; I am as wild as wild can be!"[12]

There also was one physical reminder, the only near-tragedy which marred an otherwise happy childhood for the Garvey children in Colby, an accident which cost four-year-old James the tip of a finger when he innocently thrust his hand into the gears of the washing machine while a busy Olive was not watching. Fortunately, the damage was minimal and not in anyway disabling, but thereafter, James wore a short finger on his left hand, Olive a tear in her heart, to remind them of yesterday in northwest Kansas.[13]

They had enjoyed a good life in Colby, and even though very valued friends of more than a decade had to be left behind, the decision to move had been too long in the making to occasion serious doubts about its appropriateness. By August of 1928, excitement for the new adventure was rising—about what they believed (and fully expected) they would find in the way of new experiences in Wichita.

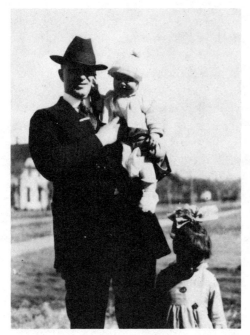

Left: Ray Hugh Garvey with children, Willard and Ruth, as photographed in Colby in 1921. Below: Because his work frequently kept him away from home, Ray Garvey referred to this photo as "my widow and orphans." Shown in 1921 are Olive with Ruth and Willard.

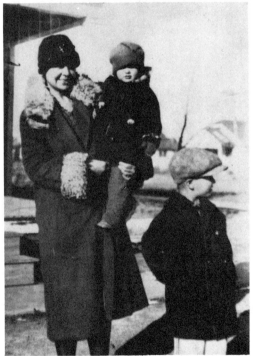

Above: The Garvey's spacious home in Colby. Left: Olive and her two sons, Willard and James, in 1924.

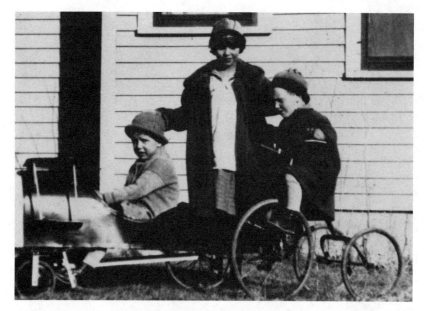

*Above: The Garvey children at play in Colby. Below: Olive, holding Oli-
via, and her "little Indians" in 1927.*

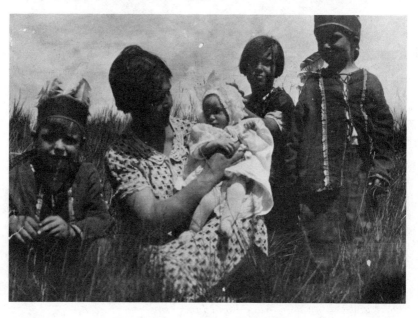

The Spirit of 1930

The spirit of 1930 is the spirit of Protest, the spirit of Criticism. This is usually the case in a declining commodity market. Raskob has employed Shouse to try to embarrass the Hoover administration. Reed was no sooner elected Governor than the State Journal crowd began to knock his administration. We are making another instaliment payment on the war and the medicine is not easy to take. In South America, it took the form of revolution; in Kansas, we voted for Brinkley.

Even here in Thomas County which is in the most prosperous part of the State in spite of low commodity values, we hear criticism of nearly everyone who is trying to do anything constructive.

Criticism of the Foster Farms which have been converted from a dust blown desert into a garden spot; criticism of Lauterbach, Alexander and Riedel for owning or operating a chain of land extending from Bennett, Colorado to Colby, Kansas. It is not charged that they do not farm it well but it is sufficient that they own or farm more han a quarter section; criticism of Schnellbacher, Geiger and Garvey for farming a portion of their holdings, most of which they couldn't get decently farmed, otherwise; criticism of the Wheat Farming Company which has bought 10,000 acres of Thomas County land which was under foreclosure or was in distress, and which they are farming well; Democratic criticism of Roy Leak for operating a chain of eight or ten quarter sections near Mingo and Republican criticism of Representative Woofter for operating a chain of twenty or twenty-five quarter sections north of Colby. The pup that these and other gentlemen have laboriously raised has turned around to bite its mother and a legislator from an eastern county, it is said, now proposes to introduce a bill in the Kansas Legislature to prohibit any man or corporation from farming more than one-half section of land.

In the meantime, we have some choice farms to sell at a low price on reasonable terms to those who would like to farm a bit.

Garvey Land Co.

(This is first of a series of advertisements on the Spirit of 1930)

Ray Garvey editorialized in some hard hitting, common sense rhetoric along with his sales offerings in this Garvey Land Co. advertisement in 1930.

Olive and Ray in Colby.

5

THE GARVEY CHILDREN

In her tongue is the law of kindness.
She looketh well to the ways of her household,
and eateth not the bread of idleness.
Her children arise up, and call her blessed.
Proverbs 31:26-28

Moving from Colby to Wichita involved sacrifices. The added distance increased the time Ray would spend in commuting to his farming activities and frequently caused him to be absent from home, a condition that was felt by the entire family. Fortunately it came at a time when there was a natural break in Ruth's school career, and the boys were too young to be greatly affected. Willard was the only one with any regrets; there was a very alluring little blond girl in the second grade whom he vowed one day "to come back and marry."

Excitement notwithstanding, the Garvey children made the transition from Colby to Wichita with relative ease because there were no radical changes in family routine. Ray continued his massive involvement in business activities, provided well for his family, and routinely continued to encourage and participate in the roundtable discussions at dinner when he was at home. His frequent absences caused a delay in his and Olive's participation as a couple in community and social events, but they made up for it later. Olive adjusted to these conditions, carried on the responsibilities in daily household functionings which contributed immeasurably to the children's stability, made new friends, and found ways to satisfy her need for personal and community involvements outside the home.

In the early days after the move to Wichita—before perma-

nent friendships were established—Olive helped minimize their temporary feelings of estrangement by leaving them no room to doubt, even for a moment, that "my children were my first priority."Although the role was nothing new to her children, she made a special effort to reach out to them in their moments of need. Years later, after all of them had reached adulthood, the Garvey children would point to her sustaining concern as one of the most influential factors in their adolescent development.

The move to Wichita was everything Olive hoped it would be, for she quickly became impressed with the city's social, cultural, and educational environment. She discovered that the Wichita she had visited infrequently when she taught in the Augusta school system had begun to shed the last vestiges of its overgrown cowtown status and was becoming a thoroughly modernized metropolis with every convenience and activity then available to cities of its size: good schools from elementary through the college level, a greater number of shops and markets, an exposure to a wider variety of cultural programs, and more appealing opportunities for extracurricular and recreational activities for her children—not the least of which was a YMCA with an indoor swimming pool.[1]

Happily, the availability of the YMCA and the start of a new school year speeded the children's adjustment. Ruth entered the seventh grade at Roosevelt Junior High School; her brothers went to College Hill Elementary School, Willard enrolling in the third grade, James in the first. They made friends easily, and their time promptly came to be filled with studying and sharing after-school activities with new acquaintances. Like most youngsters, they conveniently put the past behind them, eagerly reached out for the happinesses of the present, and wisely began to build a solid foundation of security based on new experiences and personal relationships.

The Garvey children were fortunate to have intelligent parents who wisely treated their children as individuals with separate personalities and differing needs. Each was given special time and attention as well as encouragement in his or her area of interest, whether academic or extracurricular, with no distinction as to gender. Discussions at the dinner table and other

times were stimulating and included constructive suggestions, occasional admonitions, and always expressions of confidence in their ability to handle whatever challenges they faced.

All children have problems from time to time, but Olive, ever calm in demeanor, sensed those moments when one of hers needed attention and usually took time to talk over the issue at hand quietly and privately with the individual concerned. Always approachable and never vindictive, she helped them deal with unpleasant situations, proposed changes in behavior and attitude, and suggested new solutions or directions which enabled them, as Ruth has said, "to face reality as contrasted to wishful thinking, disappointments being counteracted with a view to future fulfillment. Deferred gratification, though seldom mentioned, frequently was the result."

Her children's friends always were welcome in the Garvey home; parties were encouraged, even if planned on short notice, and a gracious Olive always demonstrated a genuine interest in making them feel "at home" not only through her culinary skills but also by utilizing her creative talents in making the parties original and fun-filled. All who were in her home during those early years still cherish their friendship with her.

Her creativity knew few bounds whether in party giving, home decorating, dressmaking, costume designing, poster making, or whatever the assignment or medium, and she was capable of executing the results by herself—always with originality and artistic flair. As Ruth has said, "No household task was beneath her, and there are few she hasn't undertaken: upholstering, refinishing furniture, draperies, repairs to home and electric appliances and outlets." She merely analyzed the challenge, took immediate action, and performed it capably and well. Her daughters' clothes frequently were her creations. With an eye to current fashion, she often saw a costume and, perhaps with adjustments, cut it without a pattern and finished it beautifully, often within a very short time frame. "She kept an attractive, nice home," Ruth concludes, "always in presentable condition, doing most of the work herself—which she continues to this day."[2]

Teachers also were invited to dinner at the Garvey home, and no extracurricular school activity at which parents were ex-

pected went unattended. There is the delightful story of her involvement in the P.T.A. organization at A.A. Hyde Elementary School while James was a student there. It was the custom to assign a canary to the class having the largest number of mothers in attendance at each of the meetings. James' room won the privilege of caring for it several times, and his teacher usually appointed James to care for it. However, on one occasion when he came home from school, he met his mother coming down the stairs and asked where she was going. Upon being informed that she was on her way to the P.T.A. meeting, James stretched his arms across the stairway and remarked, "Oh no you're not. I'll have to feed that blasted canary again."

Inasmuch as both Olive and Ray had grown up during a period when children's help at home was a necessity, they recognized its value and expected a minimum of chores from their own children. They believed children needed adequate time to play, both with members of their own age group as well as with family, and they frequently set aside time during evenings and Sunday afternoons for games all of them could enjoy. It was their way of remaining close to their children and of stressing a balanced regimen of activities and responsibilities. Such sensitivity and concern were powerfully influential in shaping the lives of their children.

Ruth, for example, was almost twelve at the time of the move to Wichita and, in Olive's judgment, overly deferential to her parent's wishes. "She always was an obedient child and a very good girl," Olive has said, "almost too good for her own good. She was very opinionated and normally would stand strongly by her convictions until she came into our presence. Perhaps she felt that disagreement would be regarded as disrespect, for she always quietly accepted and supported our interpretations in all matters."[3]

Because they wanted her to develop confidence in her own abilities, Olive and Ray tried "to stay out of her way as much as possible," and often refused (as unobstrusively as possible) to express an opinion about any decision they felt she should make. To help build her self confidence, they gave Ruth an allowance early in her high school years and permitted her to spend it in

any way she chose, with the understanding that she would use some of it to select and buy her own clothing.

By imposing no artificial time schedule on her study periods and no social curfews (provided she told them what she was doing and what time she expected to return), they entrusted her with the responsibility to exercise discretion. The trust granted by her parents, later extended also to her younger brothers and sister, was reciprocated. Mutual trust between Olive and Ray and their children have been basic and continuous.

Ruth was a good student with a quick mind and, for the most part, managed her time well and proved herself trustworthy. She was elected to honor societies in junior and senior high schools and was involved in extracurricular activities. Through the influence of Miss Lucile Hildinger, a wonderful woman and teacher, she developed an interest in journalism and was editor of the *Messenger*, the East High School newspaper. This experience stimulated her desire to pursue journalism as a career.

Olive's first thought was to urge Ruth to go away to college, feeling that she would mature better were she independent of parental direction, and Ruth applied for and received a scholarship to a woman's college. However her father, whom she later realized was devoting every effort to retrench in order to weather the depression, to retain those employees he could, and to help the rest find other jobs, suggested to Ruth that if she would remain at home for the first two years, he would try to make it possible for her to go away to finish her college.

Enrolled at the University of Wichita, Ruth pledged Alpha Tau Sigma, a local sorority (later Delta Gamma), and became involved in activities on campus. She chose courses in the liberal arts consisting of history, English, and political science, being advised of their importance for a journalistic career. Gifford Booth, business manager of *The Sunflower*, the University newspaper, offered her the opportunity to sell advertising for the paper, and upon his graduation, she succeeded him as business manager at the beginning of her junior year. These involvements kept her bound for three years, at the end of which time she was chosen as the 1937 recipient of the American Association of University Women's annual "Outstanding Junior Woman" award.

On the matter of finishing school away from home, her parents finally prevailed. Advised by her father that to choose an institution in another part of the country—on either coast or at least across the Mississippi—would help prevent her from becoming provincial, she chose the University of Illinois whose department of political science (her major) was strong. She pledged Delta Gamma, to which her mother belonged and in which she would become more heavily involved within a few years after graduation.

In 1938, there were few job openings for fledgling journalists. Reporters worked very long hours at low salaries, and most of them, with the exception of those on women's pages, were men. Ruth's father suggested that a small town newspaper could be interesting and profitable, and that he would help her acquire one if she were interested. He held the conviction that those with the ability should not expect people to employ them; rather, they should create jobs for themselves and, subsequently, for others who cannot. Preferring life in a larger community, Ruth declined the offer and worked for a time for the Better Business Bureau of the Wichita Chamber of Commerce just "for experience," hoping that it would develop into a permanent position, which unfortunately it did not. For a few weeks, she worked as an assistant to Jane Evans, the society editor of the *Wichita Beacon*, also without pay. When she suggested to the managing editor that she would like lunch money, he told her he did not need her anymore.

Olive then suggested that she move to Topeka to live with her widowed grandmother who was living alone following the graduation of another of her granddaughters from Washburn College. In Topeka, Ruth was employed for a year in the sales department of the telephone company, at the end of which she spent her week's vacation as Topeka Alumnae Chapter delegate to the Delta Gamma convention at Mackinac Island where the decision was made to establish a chapter at the University of Kansas. Ruth was invited to be the colonizer.

Inasmuch as it was a volunteer job, accepting the assignment would mean a return to financial dependence upon her parents whose blessings she sought. She received them without reser-

vation. Her father advised Ruth that if she hoped to be an effective organizer, she must become a catalyst. He explained the term: "to create a chemical compound, a catalyst is the agent necessary to effect it. When the catalyst is removed, the compound is in place, and the catalyst is not missed. In establishing the new chapter, you are the catalyst."

Olive has said, with a mother's pride, "One of Ruth's most admirable character traits is her tenacity. She never does a job half heartedly. She throws herself wholeheartedly into any responsibility she accepts and doesn't stop until it is finished, no matter how long it takes." For over a year, Ruth did precisely that—and accomplished the mission within her father's admonition, although it is doubtful if the sorority will ever forget the work she did. Conditions were quite favorable for the colonizing effort, for a recent University regulation had directed that all sororities were to absorb their members within a single, officially designated house and close all annexes which many had acquired to accommodate overflow membership. Eliminating the annexes placed severe limitations on taking new pledges, thus leaving many quality candidates without opportunties to gain an affiliation—and opening the doors for a successful colonizing effort for Delta Gamma.

In addition to Ruth, a colonizing committee of four alumnae was appointed, two from Kansas City and two from Wichita, one of whom was Olive White Garvey. An obvious priority was housing, and a study was begun to develop a proper house either by building or purchasing an existing facility. The committee, working with Lawrence alumnae, located a well-situated, well-built fraternity house that was facing foreclosure by a Lawrence bank which held the mortgage.

Olive was designated to negotiate the purchase just prior to the spring arrival of the national officers who were to install the new chapter. Convinced that the fledgling chapter should start on a sound financial base unhampered by overwhelming debt, she moved quickly, offering to purchase the bank's liability in the property contingent upon an acceptance of the deal prior to the installation banquet. She received confirmation by telephone during the installation dinner, and her announcement of its ac-

ceptance during the program elicited "exciting applause beyond the capacity of a sound-meter." Moreover, her successful negotiation stands as the best purchase value in Delta Gamma housing annals, an achievement in 1940 which demonstrated her superior business acumen.

In the course of her assignment, Ruth took post-graduate courses and met Richard Lloyd Cochener, a senior engineering student from Kansas City, in a class they shared. Soon a romance of serious dimensions blossomed. Dick graduated in January of 1941 and left Kansas to accept employment with General Electric in New York, and they continued to correspond and visit whenever they could. Within the year, as Ruth's organizational tasks were nearing completion and as the winds of World War II blew their disruptive gales, they announced their intentions to be married. The ceremony took place in the Garvey home on February 17, 1942, only two months after Pearl Harbor was attacked.[4]

Dick drew numerous wartime assignments with General Electric, about which Ruth was permitted to know very little at the time, but she later learned that some of his work was related directly to the Manhattan Project which developed the first atomic bomb. They lived successively in Schenectady, Philadelphia, and Denver. In 1947, Cochener resigned his position to join his father-in-law in the grain business. Together, they formed the C and G Grain Company and built elevators in several eastern Colorado farming communities.

When in 1949 it was determined to build the first terminal facility at Topeka, Dick went to Topeka to supervise its construction. Upon completion he established an office, moved his family to Topeka, and became managing partner of the Topeka terminal elevator. It filled to capacity upon completion. Within a year it was beset with problems of major proportions. The elevator was located on the north bank of the Kaw River, and following weeks of torrential rains, all of Topeka, including the elevator, was threatened with flooding. Volunteers rushed into action, many coming from long distances, to help in sandbagging activities. Willard, an excellent swimmer, came from Wichita, and made repeated dives along and under the dikes near the

elevator in an effort to plug gaps in them, but on July 13, 1951, the dikes finally broke, subjecting Topeka to its worst flooding since 1903.

As Ruth recalls, "Cleaning up after a flood has no equal. Homes and businesses in North Topeka, faced with a task of major proportions, were greatly assisted by a tremendous outpouring of help from numerous individuals who volunteered both machinery and personal labor, including the Mennonites who unselfishly left their fields in a tireless effort to restore the damage." Federal assistance was proffered, but Dick, as chairman of the Topeka Chamber of Commerce Flood Control Committee, campaigned against those seeking federal funds, feeling as did the United States Chamber of Commerce, that each community should care for its own needs. Unfortunately, he was outvoted, and the results were as he predicted: immediately upon the infusion of federal money, all labor and equipment costs tripled.[5]

The C and G Grain Company (actually a partnership arrangement between Olive, Ray, Dick, and the four Garvey children) was hard hit by the flood. Inasmuch as the operation had been financed through local banks, Dick visited the presidents of the banks and, in compliance with Ray's instructions, paid all the indebtedness against the Company, using monies contributed by each of the partners. Every month thereafter, each of them also contributed sufficient funds to carry the operation until the elevator was restored and grain again received.

Restoration was a complicated process, for the grain in the lower part of the flooded tanks had caked solidly, making it necessary to drill upward to the undamaged grain in order to allow it to flow downward by gravity. Removing the stench of the fermented grain, which permeated much of the community, defied all efforts until the smell was dissipated by washing down the insides of the tanks with pure Clorox, a task of no small dimensions or costs—but it worked, and the elevator was again in operation.

In the summer of 1952, Dick began to suffer symptoms which were difficult to diagnose. Surgery in May of 1953 revealed inoperable cancer in the aorta behind the heart. All avenues were explored including a trip by Olive and Ray to Sloan-Kettering

in New York where doctors examined Dick's medical records and confirmed that there was not even experimental medication for his tumor. Although Olive had conditioned her children to care for their own children independent of her, she rearranged her life to be with Ruth's family more than half the time during the last several months of Dick's illness, and Ray also came often to give Dick encouragement by talking about the business responsibilities they shared. Their presence and support helped maintain family stability during that difficult time. Dick died on January 27, 1954, one month after his thirty-fifth birthday.[6]

It was unfortunate that a partnership which had begun with such promise and a marriage which seemed to be blessed with much happiness were destined to end prematurely in tragedy. Dick and Ruth had enjoyed a grand relationship, and three children, ideally spaced three years apart, were born to them: Bruce Garvey in 1944, Diana Olive in 1947, and Caroline Alice who arrived in 1950 shortly before the Cocheners moved to Topeka. They had bought a beautiful home and were active in the business and social life of Topeka. But Ruth's world was decidedly different in the days following January 27, 1954.

With the encouragement of Olive and Ray, who persuaded her to take an active role in C and G Grain, and with the assistance of her brothers and sister who helped with other various needs, Ruth responded admirably to her sorrows. As Olive recalls, "Going to the office was good therapy for her, but she worried too much about it and was never really happy at being a businesswoman. Like me, she enjoyed being a housewife." Some months later, she began seeing a widower, Harry Bernerd Fink, whose wife, by sad coincidence, also had died of cancer, just one year to the day before Dick's death. They shared a few social activities and got to know each other quite well. He had two daughters, Marcia (who was 16) and Elizabeth (who at ten was six months older than Bruce).

Ruth and Bernerd were married in March of 1955. A graduate of the University of Kansas School of Business and a lifetime resident of Topeka, Fink had operated a stock feeding business for several years. A few months after their marriage, he sold his business and assumed the administration of the Topeka-based

family enterprise whose title designation later was changed to reflect his involvement—thereafter being known as the C-G-F Grain Company. Ruth, now with expanded responsibilities as a mother, happily returned to her role as a housewife, although she has remained well informed and closely involved with her husband in their grain operations, especially since the division of her late father's estate in 1972 which left the Finks with sole responsibility for the segment of the Garvey enterprises they had been operating.[7]

The course of Ruth's life, from her slight physical problem at birth to the tragedy of Dick Cochener and resurgent happiness with Bernerd Fink, was an important learning experience. It confirmed Olive's understanding that responsibility to one's family lasts to the end. The need for family support had been more crucial and demanded more expertise during these three sad years than at any other time in her life. Those who now ask how she made the transition from housewife to corporate executive at age 65 are prone to minimize (or even to dismiss) the complexities of running an efficient and people-sensitive household as having little influence or carryover value in the business world. But Olive knows better.

"More or less," she has said, "I have been managing my home as a business from the very start. It has always been necessary to plan and be conversant with things which must be handled before they get out of hand. It takes a lot of organizational work, and I discovered quite early that nothing happens or succeeds unless you follow through to the bitter end. In a very real sense, a household is an economic unit, and the raising of children correspondingly can be regarded as a continuous in-service training program and a problem-solving responsibility for those who manage it. Everyone knows that my husband was a genius with a tremendous business mind and a faculty for knowing what was going on and for keeping everything under his thumb so that he could give proper direction to it. Although a home and a business do not enjoy a perfect analogy, it takes the same attention to detail, the same awareness and decisiveness to manage each of them efficiently."[8]

Few can argue her analogy, especially in view of her consid-

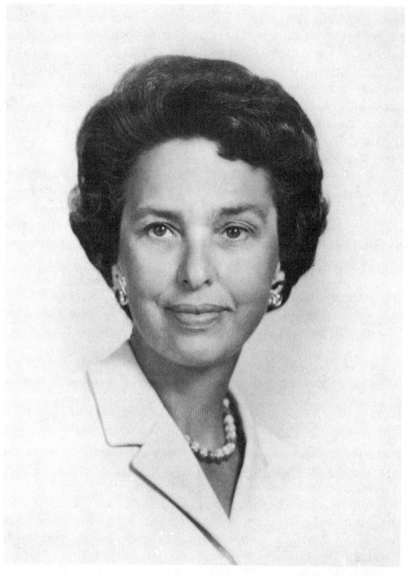

Ruth Garvey Fink. She and her husband, H. Bernerd Fink, reside in Topeka, Kansas.

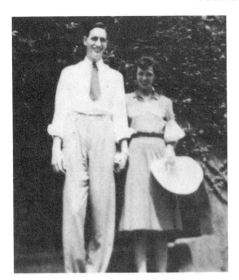

Left: Ruth Garvey and Richard Cochener met at the University of Kansas and were married in 1942. Unfortunately, Dick passed away in 1954, one month after his 35th birthday. Subsequently, she was married to H. Bernerd Fink. Below: The Cochener-Fink family in 1983, picturing Ruth and Bernerd seated third and fourth from left.

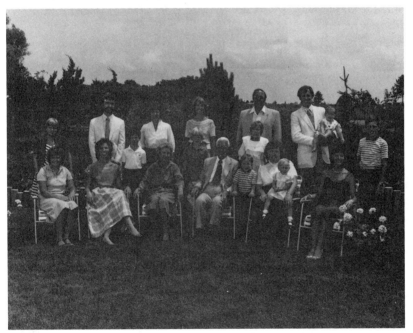

erable successes in both home and business management. Certainly it remains unchallenged by her older son, Willard, who provided her with another liberal learning experience which began even before he was born. Olive still has vivid memories of his "kicking and turning" during the last months of her pregnancy. "He was a super-active prenatal youngster," she recalls, "and I can't say he has slowed down much since he was born. As a boy, he was always busy, always doing something. Neighbors would call to tell me he was up on the roof and would be worried to death, but somehow I never worried much about it because he always knew what he was doing. I believe that if children do things they are not afraid to do, they won't get hurt—and Willard never did injure himself."9

Managing Willard's early development truly was instructional for Olive. What appeared to be an earlier-than-normal reading skill actually was the result of his busyness and penchant for memorization. When he was a lad, Ruth often read to him from her readers, and Willard not only committed entire stories to memory but also could stand up, book in hand, and recite them word for word. The practice continued even after he entered first grade until Olive and his teacher finally discovered that he actually was a poor reader; thereafter his habits were promptly adjusted to include drills in word recognition and studies in sentence structure, something that was painful to Willard because it required him to sit down.

Willard seldom was stationary. "He was a terrific competitor," Olive remembers, "and always had to be in the lead. And if that meant learning to read, then he would apply himself until he outdistanced the others. He could never stand to let anyone get ahead or take advantage of him." Once when a kindergarten classmate tried to steal his crayons, Willard promptly bit him—and received a spanking from his teacher for the indiscretion. However, Willard showed little remorse because he felt he merely was protecting his territory, and he regarded the spanking as being well worth the defense of his principles. Olive outwardly chided him for his action, but admits in confidence that she always has admired his determination "to stand up for what he believes to be right." And interestingly, the two schoolmates, the

biter and the bitten, continued to be close friends thereafter—
which, Olive believes, raises an interesting question about how
individuals (or even nations) develop respect for each other.

A family anecdote relates the origin of Willard's belief that he
"is almost always right." A Colby drugstore once staged a pro-
motional drawing by offering as a prize a foot-propelled chil-
dren's automobile. Hundreds of hopeful kids throughout the
neighborhood deposited entry stubs into a rotating basket in ea-
ger anticipation of the drawing, but Willard promptly told his
mother that he was going to win the pedicar. A dutiful Olive
counseled him about the odds of such an occurrence, hoping to
minimize the probability of his disappointment. Willard re-
mained unconvinced, and when the improbable happened—his
lone stub being drawn from the basket—he triumphantly re-
turned home and said, "Mother, I was right. I am almost always
right."

However, the expression which most correctly characterizes
Willard's youthful hyperactivity is that (like his father) "he always
had a very low tolerance for boredom." He joined the Boy Scouts
and, with his customary determination and energy, rushed
through the merit badge sequence to achieve an Eagle classifi-
cation in little more than a year. Then, Willard quickly lost in-
terest after nothing was left to be achieved, becoming only a some-
time Scout until he gradually dropped the activity altogether.[10]

His favorite sport was swimming, and Willard developed into
a champion performer despite sensitive ears which frequently
became infected from the water. When there was a span of un-
filled time, he and his friends would congregate at the YMCA
for an afternoon of fun. They camped at the YMCA-operated
Camp Hyde on the Arkansas River where longtime friends Cra-
mer Reed and Giff Booth were counselors—from which they
often returned "beet-red" after exposure to the Kansas summer
sun. And there were those overnight campouts at Matthewson's
Pasture at Central and Hydraulic streets which Olive remembers
largely because of the numerous times she was obliged to rush
out in the middle of the night to fetch both boys and equipment
when thundershowers threatened their all-night campfire vigils.

Willard had high motivation for almost every youthful expe-

rience except his school work, a fact which constituted a frustrating mystery to Olive because he obviously had the aptitude to achieve high marks. "Maybe it was because he was impatient with things that came easy for him," she muses, "or because his teachers were always throwing Ruth's excellent scholastic achievements up to him—which of course didn't go over very big with him, given his competitive nature." Until he graduated in 1937 from East High School, Willard remained virtually unchallenged but managed to pass all his courses with little study and low grades. He seemed to be challenged more by the prospects of growing up and demonstrating his independence.[11]

One expression of that need for independence became a worrisome experience for his mother. In the summer of 1937, seventeen-year-old Willard went out to northwest Kansas to work in the wheat fields, and unknown to Olive, he and David Jackman, who was spending the summer with his family at their vacation home near Glenwood Springs, had made plans to hitch hike or ride the freight trains to California once the harvest was completed. When Willard received his final paycheck, he banked all but $20 and set out to join his friend in Colorado—only to find that the Jackmans would not permit David to make the trip. Undiscouraged and without informing his parents until it was too late for them to stop him, Willard set out alone, hailing a truck to Salida, Colorado, and then hopping freights "loaded with hobos and other itinerants from the dust bowl" to Salt Lake City and beyond. It was not the best of times for a teenager to be traveling alone under such conditions.

While Olive understandably spent "some sleepless nights," Willard had the time of his life, dancing "at a dime a dance" to Glen Gray's Casa Loma Orchestra in Salt Lake City and spending the last of his $20 in the slot machines in Reno, Nevada, before hitching over the mountains to Sacramento. Broke and without access to the money he had banked in Colby, he hocked his electric razor for $5, took a room in the YMCA, and found fruit-picking jobs at 20 cents per hour in the various California orchards, living, he has said, "a page out of Steinbeck's *Grapes of Wrath* when lodging cost a dollar a week and breakfast 15 cents."

Flush with new spending money and by now in communica-

tion with home, he set out again to visit a friend in southern California, but as his resources dwindled, his grand, two-month-long adventure finally began to lose its appeal. As soon as Olive had an address, she immediately sent sufficient money and told him to buy a bus ticket home, explaining that stealing a ride was as bad as stealing money, but independent youngster that he was, he condescended to use it only out of frustration after becoming "an unkempt, dirty, smelly object" and being stranded for two days in Bakersfield, California, while hitchhiking home.

A relieved Olive gave him a prodigal son's welcome, scarcely uttering a word of criticism and becoming a willing audience for the exciting stories he told. "She was marvelous in her support," Willard has said; "it was a wonderful experience, and I think it aged me quite a bit." Olive was relieved that he had demonstrated confidence in his ability to take care of himself and discovered the motivating agent. Willard had read an article by an English author, Ian Wiley, which indicated that modern youth were so soft they could not take care of themselves. He was proving him wrong.[12]

The longterm results were gratifying. Willard entered the University of Wichita that fall with renewed motivation. For two years, he made excellent progress in his general coursework and found the study of economics to be especially challenging. With Paul Thayer, he pledged Alpha Gamma and became a fraternity brother of Clark Ahlberg who, years later, would become president of the university. He was eager to finish his degree at an out-of-state college, and after studying catalogues from Stanford, Wharton, Harvard, Yale, Chicago, and Michigan, he chose the University of Michigan because he liked its curriculum in Business Administration and because "they had the best swimming team in the country." He enrolled in the fall of 1939.

Willard was an active Wolverine. In addition to carrying a full course load, he made the swimming team, joined a fraternity, worked part-time as a waiter in a dormitory to help pay his college expenses, attended almost every major university function—and enrolled in the Army ROTC program because he felt it inevitable that the United States would be drawn into World War II. He emerged as a 20-year-old Michigan graduate in the spring

of 1941 but was ineligible to receive his Army Air Corps com-
mission until his 21st birthday. Thus, he returned to Wichita and
helped in his father's construction business while awaiting his
commission and the eventual call to active duty. The summons
arrived in November but did not become effective until January
of 1942, a few weeks after Pearl Harbor. Willard would remain
on active status until February of 1946, during which time he
rose from the rank of second lieutenant to that of major.

Before being sent overseas, Willard's first wartime duty was at
Wright-Patterson Air Force Base in Ohio. Because of his prior
experience in construction, he was assigned in the summer of
1942 as the commanding officer of a construction unit in Colum-
bus and was given a Company of Blacks with the responsibility
of converting the Columbus Fair Grounds into a materials de-
pot. His unit performed well, and he enjoyed an excellent rela-
tionship with his troops.

Sent to England in 1943, he was assigned to the Adjutant Gen-
eral's division of the 8th Air Force Headquarters at Ascot, a small
town about 30 minutes from London, and in 1944, Willard drew
many assignments in an expanded First Allied Airborne Army
headquarters which helped plan a number of campaigns on the
continent after the Normandy invasion. In fact, he was on as-
signment in Germany in May of 1945 when Berlin was on the
verge of surrendering and was ordered by his commanding of-
ficer to become one of five members of the first American staff
unit to arrive in the beleaguered city after it fell to the Russian
Army. That duty assignment later led to his appointment as Ad-
jutant General for the Potsdam Conference held in July and Au-
gust of 1945, at which the fate of Germany and the continued
conduct of the war in the Pacific were formalized in an agree-
ment between the United States, Great Britain, and Russia. He
was given, and still possesses, the first American flag to be flown
over liberated Berlin.[13]

By October, most of Willard's assignments with the Allied
Kommandatura Berlin were completed. He had sufficient ser-
vice credits to qualify for an immediate discharge, an option he
exercised in November despite the last minute promise of a pro-
motion to lieutenant colonel if he would remain on active duty

in Europe. Although he was not formally discharged until February of 1946, he was granted terminal leave and returned to Wichita in time to share the Christmas season with his family. And before he returned officially to civilian status, he considered a number of career options. He made two very important decisions about the future, the first being a resolution to join his father in the construction business as the director of Builders, Inc., and the second a determination to make Jean Kindel his life companion.

He met Jean on a blind date which was arranged by his sister Olivia when both girls were students at the University of Kansas. The daughter of George and Leota Kindel, Jean was a native Wichitan whose father was a corporate officer in the Southwestern Electrical Company. She was a graduate of North High School and briefly had attended the University of Wichita before dropping out when the war began to work in the cost accounting department of the Boeing Aircraft Company. When Willard met her, Jean had resumed her college career at the University of Kansas and was being urged by Olivia to pledge Delta Gamma. At Christmastime, Olivia arranged a party and asked (with Olive's encouragement) that Willard take Jean. That date soon was followed by a second, during which Willard asked her to marry him. At the time, she gave him no answer. Six weeks later, she said, "How about April 18?"

Their marriage, which was solemnized on that date at the Plymouth Congregational Church in Wichita, was the start of a genuine partnership which has brought them much happiness.[14] They work, recreate, travel, and do civic works together and are constant in their support of each other as well as their six children—John Kindel, born in 1947; James Willard in 1949; Ann Elizabeth in 1951; Emily Jane in 1952; Julie Rae in 1954; and Mary Lyn in 1957—all of whom have married and who collectively have presented Olive Garvey with nine of her great grandchildren.

Just as his family has grown, so also has Willard's professional development, both prior to and after the 1972 division of his late father's assets. As do his brother and two sisters, Willard now owns and provides the leadership for an independently oper-

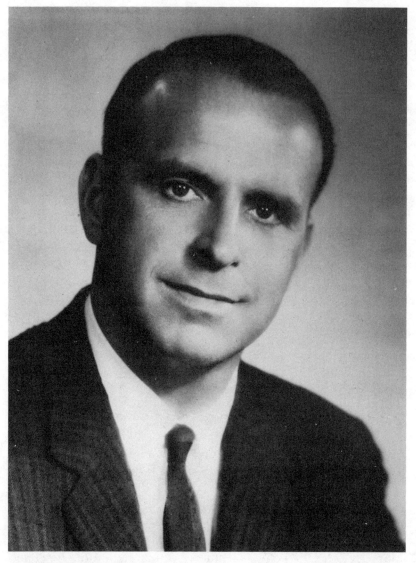

Willard White Garvey. He and his wife, the former Jean Kindel, make their home in Wichita, Kansas.

Left: Willard Garvey's military service during World War II took him to England and the Continent. He was a member of the first U.S. detachment to enter liberated Berlin in 1945. Below: The Willard Garvey family in 1983, showing Jean and Willard seated third and fourth from left.

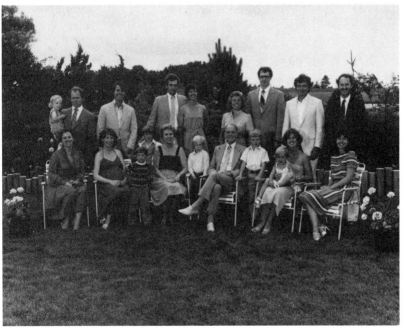

ated portion of the Garvey enterprises. His segment is based in Wichita, Ruth's in Topeka, Olivia's in Lincoln, Nebraska, and James' in Fort Worth, Texas.[15]

As the poet has written, James traveled a crooked mile or two on the road leading to Fort Worth, and he presented his mother with yet another personality as field training for the challenge she would face after 1959. "All of my children," Olive has said reflectively, "have their own personalities and their own interests. James always was a very individualistic child, quite precise in everything he did, and he loved to wear good clothes. And when he did dress up, he was the most dignified and proper in behavior of anybody in the world. But he also could be as mischievous as any of them. I remember having to spank him one time with a hairbrush, and he promptly collected all the hairbrushes in the house and cut the handles off of them."[16]

Such precocious originality was characteristic of James' youthful mentality. His mind was at work constantly, and Olive recalls that he "was forever cooking up some fantastic scheme to help someone out or to play a practical joke on them. I don't remember the details of many of them, and they would have little interest to anyone but our family, but we always thought he was hilarious. Like his father, he was a natural wit and made spontaneous comments which kept everybody in stitches all the time."

However, there is one delightful story about Olive washing his mouth out with soap because he persisted in using some bad words he had learned from his friends. James thought it "cruel and inhuman punishment," especially after he attended church one Sunday and heard the preacher use the same words over and over in his sermon. "I remember nudging my mother each time he used them," James laughs, "and asking her why she didn't go up and wash his mouth out too. That was when I learned that pastors lead charmed lives; they can say those words and not be disciplined!"

Born on December 30, 1922, in Colby, James has only limited memories of the five years the Garveys lived there. Naturally, he recalls losing the tip of his finger, the chigger bites he got while swimming in the community stock tank, and a horse-drawn road grader which leveled the unpaved streets in Colby after heavy

rains cut deep ruts into them. It was driven by a Mr. Grady, whom James called "Mr. Grader." And he also remembers playing in the pollywog-infested mud holes, sitting atop an ant hill until he was stung several times, and even the "old white plug" he always rode backwards. But he remembers most the lifelong habit he developed of rising early each morning to watch the sun come up.

"It is the best time of the day for me," he says philosophically, "for it means that you may see the rest of a new day. And the only thing that compares to it is to see the sun go down—which means that you have completed another day." As he explains it, there is no place in the world where nature stages her greatest drama—the birth and death of a new day—more impressively than in towns like Colby on the high plains of the American West, for the view is long range, unobstructed by clouds, trees, or even buildings. Dawn comes up like thunder, inspiring new vigor, and sunset is a quiet but breathtaking mixture of oranges and blues which slowly fade into peaceful and restful grays. Somehow those experiences made such a lasting impression on him that when asked what he regards as a hometown, "I always say that I am from Colby, even though I have lived most of my life in Wichita and Fort Worth."

James began his education in Wichita at College Hill Elementary and later attended A.A. Hyde Elementary, Charles A. Robinson Intermediate, and East High schools. He was a good student with marks which earned him membership in and president of the National Honor Society, and he also served as a Student Council representative of his class at East High. His days, especially after he entered high school, were crowded with extracurricular activities, the chief one being swimming, which was the center of his competitive athletic activities as it had been for his brother. "Willard always was a faster swimmer than I was," he recalls, "but high school records were not kept until I came along and made the swimming team, and as a result, I set and held for a few years thereafter the official school record in the 220 yard free style race."[17]

Additionally, James enjoyed the out-of-doors. He was close to his father and "very much like him in many ways," and he often made trips with Ray and brother Willard to the northwest Kansas

wheat fields in summertime or to the pasturelands after a winter blizzard "to help get the cattle out of snow drifts." And he and Willard were forever tinkering with soap boxes, the forerunner of modern go-carts, and "just about every old washing machine motor" they could find was installed on the noisy contraptions which they raced up and down the street on which the Garveys lived. "They always got down a hill," Olive remembers, "but seldom up."

That interest was transferred to automobiles by the time he was 14 when he bought (for $4.50 and without his father's approval) his first car, a delapidated Model T Ford with a sawed-off roof and four flat tires which he renovated with some help from Olive who repaired and resewed the tattered seats. James managed to have "a lot of fun" in the old car but now smiles wryly when he recalls that he had to sell it when police authorities "finally got wind of the fact that I didn't have a license tag on it." At 15, he bought another Model T and eventually acquired a Model A Roadster for which "my father spotted me a tank of gas a month." Olive still marvels at James' persistent enthusiasm for working on his cars. "He would stretch out under those things," she remembers, "on a hot paved area in our backyard and tinker with them every day all summer long. He was always broke, and his clothes were always filthy from the grease, but he was happy— and of course that made me happy." His car tinkering continued even beyond his college days.

Although Olive wanted him to attend school away from home because she felt he was too dependent upon his father, James would not consider it at first. He enrolled at the University of Wichita in the fall of 1940 and completed three semesters before moving on to Kansas State University at Manhattan for the spring semester of 1942. But In the fall, because he thought he would be called for military training, he reenrolled in the University of Wichita where he pursued a major in English with secondary concentrations in history and military science. By accelerating his course work, he was able to complete all but a final semester needed for graduation before his ROTC class was called to service in June of 1943.

Because of his ROTC training, James was sent to Officer Can-

didate School at Fort Knox, Kentucky, where his old-car expe-
riences resurfaced: his superiors discovered his aptitude and skills
in auto mechanics. Following his graduation, he was assigned to
a maintenance training unit where he supervised the instruction
of Army personnel destined for field duty in the armored divi-
sions, but he eventually volunteered to serve with the Armored
Force (later the Armored Command) and was assigned to a tank
battalion which then was sent to the Pacific in anticipation of the
invasion of Japan. The war ended, however, before his unit
reached the Philippines, and he served the balance of his tour
in Manila, achieving the rank of first lieutenant before returning
to the States and receiving his discharge on August 16, 1946, at
Salina, Kansas.

James then reentered the University of Wichita. He completed
his degree in 1947 and assumed the supervision of the Garvey
Farms at Eads, Colorado. In conjunction with Garvey Farms,
James assumed the management of three country elevators which
became part of Farmers Grain Company and was eventually
merged in 1959 with Garvey Elevators, Inc., along with the for-
mer C-G and G-C Elevators. His experience in agriculture and
knowledge of machine maintenance made him a very effective
manager.

James made frequent trips to Wichita on weekends where "he
sort of moped around the house and left the notion that he was
very lonely." He always had socialized and dated extensively, but
there was little social life in tiny Eads and no special young lady
in his life until Willard tried his hand at playing cupid—with un-
usual success.

Willard and the Garvey family first became acquainted with
Shirley Jean Fox through church activities after her parents, Mr.
and Mrs. Forest A. Fox, had moved from Kansas City to Wichita.
She had accepted temporary employment at the Plymouth Con-
gregational Church as a secretary for a committee Willard was
chairing in a special church campaign. They soon learned that
Shirley had attended Iowa State University and also had been
associated with the North American Aviation Center in Kansas
City. "She was a lovely girl, and we all just loved her," Olive re-
members, "and Willard thought she would be just right for James.

James Sutherland Garvey. He and his wife, the former Shirley Fox, reside in Fort Worth, Texas.

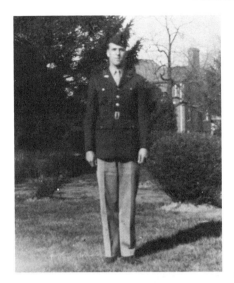

Left: James Garvey served in the U.S. Army Armored Command during World War II. His last duty assignment was in the Philippines. Below: James and Shirley Garvey (seated) and their family in 1983.

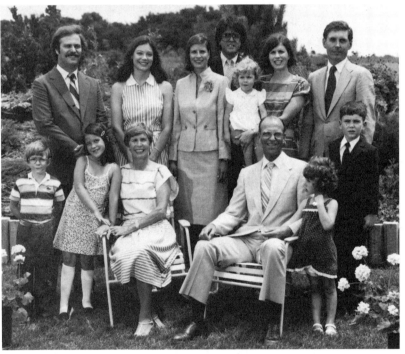

Well, the very next time James came down from Eads, Willard saw to it that he met her."The meeting was fatal for both of them. No one expected events to transpire as fast as they did, but very soon, James and Shirley were married (November 30, 1947) in the church building where the family had met her.[18]

The couple went to Eads for a few months and then to Garvey Farms headquarters in Colby where James became manager of the Garvey Ranch partnership and eventually became president of the Service Oil Company. Shirley and James entered into many social and community activities in Colby, the family attending the Presbyterian Church and James being elected an Elder in 1948. He also became a Rotarian and was elected president in 1956 of the club for which his father had served as charter president. Shirley was active in P.E.O., Junior Women's Club, and a Study Club, and as a couple they were invited to join the Whist Club and enjoyed playing bridge with many of their parents' contemporaries—as well as their own.

Their move to Colby was made all the more pleasant because Olive and Ray had lived there. Their many friends welcomed and included James and Shirley in social and civic activities, and their influcence, felt strongly then, still is evident today inasmuch as both have made efforts to keep in touch with these valued friends by visiting with them frequently. "To me," Shirley has said, "it is interesting how our family pattern has followed the one set earlier by Olive and Ray. As newlyweds, we moved to Colby, had our children there, and later moved to another city because of business opportunities—much the same as they did. And now, two of our children also have returned to western Kansas."

For 12 years, James and Shirley made their home in the city of his birth and enjoyed a wonderful life there before moving in 1959 to Fort Worth, Texas, where he owns and gives direction to his portion of the Garvey enterprises. They have three children: Janet Lee, who was born in 1948; Carol Jo in 1952; and Richard Fox in 1954. All of them now are married and collectively have contributed six great grandchildren to Olive's extensive family.[19]

After James and Shirley married in 1947, Olivia was left as the

last of the Garvey brood at home, and she was by then a senior at the University of Kansas. Although she had attended Hyde and College Hill elementary schools as well as Robinson Junior High and East High schools in much the same pattern as had her two brothers before her, she chose not to follow them to the University of Wichita, opting instead to embark on a five-year curriculum in occupational therapy. "Garv," as she was called by her schoolmates, was determined to establish herself in a profession.[20]

As the baby of the family and four years behind James in school, Olivia spent her earliest years in much the same close relationship that Olive had shared with her mother Carrie a generation earlier. As a result, Olivia had "the most happy childhood any girl could imagine." Her mother recalls that she was "a cute youngster and sort of the family pet who seemed never to receive or deserve much disciplining. She was the type of child you didn't have to punish because she always was so practical in her behavior and attitude about things."

Olivia also enjoyed a rare relationship with her brothers and sister. She became a baby swimmer, starting when she was little more than one year old, and Willard and James often took her to Riverside Park where she "almost wore out" a slippery water slide, often times starting head first and plunging into the pool at rapid speeds as her brothers urged her to greater and greater feats of daring. By the time she was three, she would attempt almost anything the boys would do, and her skills as a swimmer developed to the point where even Olive was relaxed about her water revelries. "I don't remember," Olive has said, "that she ever choked under water. She was an amazing child swimmer."[21]

The Garveys became members of the Crestview Country Club on 21st Street, and because of its excellent pool facilities as well as an expert lifeguard, Jack Davis, the family almost lived there during summer months. In fact, the children seldom took baths at home from the time school recessed in the spring until Labor Day. Again, Olivia became everyone's pet because of her daring. "Everbody would play with her and throw her around in the pool," Olive remembers, "and of course she enjoyed it. And Davis, who was good with children and occasionally staged summer water

festivals at Riverside Park, got the bright idea of featuring Olivia as a baby diver in one of the programs—only his idea didn't turn out quite like he had planned."

Olivia's role was simple enough and was given advanced publicity in the local newspapers. The stage was an old boat house with an elongated plank extending some distance from the rear of the building over the water. She was asked to walk out on the plank and, amid some fanfare, to make routine dives into the water. Everything went well until five year-old Olivia walked gracefully to her spot and peered down into the water, only to discover that it was dirty and filled with unsightly paper and other matter. "I couldn't bring myself to jump because the water was so *awful*," Olivia laughs. "Although she sort of fell in once, it was anticlimatic," Olive remarked. "Fortunately, she was young and everyone forgave her, but we have laughed a hundred times about her big flop as an aquatic performer."

There have been few such "flops" in Olivia's life. She did well in school and had numerous friends with whom she spent countless hours in fun-filled social activities. There are many good times which crowd Olivia's memory about her youth, such as the trips the family made to the Chicago World's Fair in 1933, to California in 1935, to the New York World's Fair in 1937, to Mexico in 1939, and to Florida in 1940 to watch Willard train as a member of the University of Michigan swimming team.

But there are memories with even deeper meaning. She recalls an experience during junior high school days when one of her friends returned home from school to find that her mother had died suddenly. "It was terrifying to think such a thing could happen," Olivia reflects, "and it took some time to erase the fear that something like that might happen to me. For several days, I would rush home and could never relax until Mother answered me as I walked in the door. The beautiful thing was that she never failed me; she was always there when I got home."

As Olivia grew older, her mother provided another stabilizing influence by opening their home to her schoolmates. "Mother always was more than willing to have nice parties for me and my friends," Olivia reflects—sometimes eight and ten of them gathered prior to an evening of skating or other activities they had

planned. Olive did the cooking herself, served the food, and handled most of the clean up chores after the eager youngsters had departed. "I'm sure she must have thought us ungrateful at times," Olivia muses, "but that was the way Mother wanted it. She always made my friends feel welcome, and they really enjoyed being around her."

Olivia also cherishes the example her parents set in their personal relationship; in fact, none of the children can remember that Ray and Olive ever openly displayed their emotions or aired their disagreements. In all personal matters, they maintained an aura of privacy while leaving no doubt about the deep love and respect they felt for each other. "Mother tells the story," Olivia recounts, "that Dad once remarked, after they had been married for a number of years, that they had never had a quarrel. Mother looked surprised because, as she says, she can remember a number of times when she was a bit angry over their disagreements. But inasmuch as they were not the type to 'shout or pull hair' and always resolved things in private, we children just were not aware of them."

The only time either parent appeared shocked by an event occurred on December 7, 1941, when Olivia returned home after a Sunday afternoon of "riding around with my girl friends, watching the boys, and sneaking a few cigarettes." Completely unaware of the significance of such news, she matter-of-factly mentioned that she had heard the Japanese had just attacked Pearl Harbor. Ray and Olive were resting and had not yet learned of it. "I had never seen them so shocked," she recalls, "and being the age I was and until then totally disinterested in such things, I couldn't understand why they became so concerned until I heard them discussing Willard and James who were at just the right age for military service." Thereafter, she watched as her father tried to keep her Army brothers' spirits high by initiating a series of letters to them, using the name of Muggs McGillacuddy, James' (and the family's) pet dog, as the medium through which humorous bits of news about home and concerned feelings were relayed.

When Olivia graduated from East High in 1944, Olive finally had one of her children begin college training away from home.

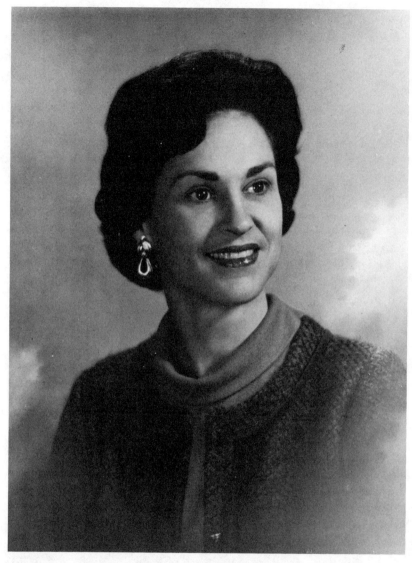

Olivia Garvey Lincoln. She and her husband, George A. Lincoln, live in Lincoln, Nebraska.

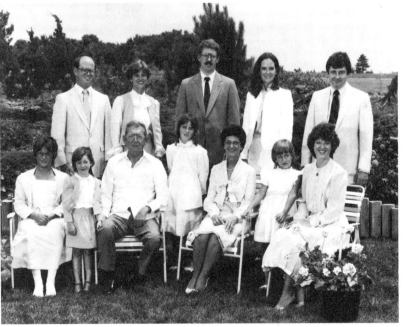

Left: Olivia Garvey enjoyed a classic childhood, in some ways similar to the one Olive had with her mother. Below: George and Olivia Lincoln, seated second and third from left, and their family in 1983.

Olivia had always wanted to do so and elected to attend the University of Kansas. Thus, she went to Lawrence, began the long process of completing the educational requirements for a professional degree, and pledged Delta Gamma, a sorority which has had a significant influence in the lives of three of the Garvey children. Interestingly, through activities related to the sorority, Ruth had met Dick Cochener, Willard had met Jean Kindel, and Olivia was destined to meet George Lincoln, her future husband.[22]

George had attended William Jewell College in Liberty, Missouri, until he was called to military service, after which he returned to Liberty to work on his father's stock farm. In the spring of 1947, he and his mother traveled to Lawrence to visit his sister who also was a member of Delta Gamma. George's sister insisted that Olivia meet her brother, and in what Olivia has characterized as a classic example of the most famous last words of all times, "I thought to myself, now why would I want to meet her brother?" They met. And the rest is history.[23]

Olivia finished her coursework in the spring of 1948 and left for Colorado to complete her final affiliations at Denver General Hospital and Fitzsimmons Army Hospital. Because their relationship had become serious, George soon moved to Denver, leaving Liberty, Missouri, in January of 1949 to accept employment with a livestock association. They had great fun together, and both enjoyed their work. Indeed, Olivia seriously considered accepting an Army commission after she finished at Fitzsimmons—which George persuaded her to decline because, as Olivia recalls, "he refused to have a second lieutenant for a wife." They were married in Wichita on November 19, 1949, in the Garvey home, and Olive's deft hand was as discernible in her daughter's wedding arrangements as Carrie's had been in hers three decades earlier.[24]

Thus, Olive had helped the last of her children reach out for independence, and Olivia, like her sister and brothers before her, was given total freedom to establish and develop her home with George wherever they wished. They remained in Denver only until June of 1950, after which they moved to Colby where George became affiliated with the Garvey Ranches. A year later, the Lincolns renovated and moved into the home on a farm Oli-

via's father had bought her several years earlier. They later built a home in Colby and remained in Colby until Ray, who had become impressed with his son-in-law's abilities, extended George the opportunity in 1959 to assume the management of the Garvey grain elevators in Lincoln, Nebraska.

For ten years, George and Olivia became "the Lincolns of Lincoln." George handled his responsibilities with skill and even branched into other business endeavors. He bought an outdoor advertising company on the West Coast and was persuaded by his associates in 1969 to move his family to northern California in order to give the business proper leadership. After a brief year of multiple obligations, George sold the company and returned to Lincoln, Nebraska, where the Lincolns since have maintained permanent residence and now give successful and independent direction to that segment of the Garvey enterprises which they own, plus others they have acquired.[25]

George has been an impressive business executive and has more than justified Ray Garvey's faith in him. As Olivia assesses it, "My father gave George the chance he needed to develop and demonstrate his good judgment and management skills, and he has proved that trust many times over." Moreover, Olivia and George have had an exceptional marriage, and their children (Georgia Rae, born in 1951; Edward Mosby in 1953; Margaret Ruth in 1954; and Ann Louise in 1957) have contributed their share of Garvey great-grandchildren—which totaled 31 by 1985.

When Olivia was 21, she was asked what her ambition in life was. Her response was simple: "to be a lady like my Mother, but I doubt that I will ever measure up to that goal." It would be difficult to convince Olive that her daughter has not done so, for her words are filled with pride when she talks about Olivia's achievements—or, for that matter, about those of any of her children. But for every kudo she extends them, she receives countless, heartfelt accolades in return. Measured by Olive Garvey's experiences, perhaps Solomon in asking, "A good woman, who can find?" provided the perfect response when he concluded: "Her children arise up and call her blessed."

6

OLIVE AND RAY:
THE WICHITA YEARS

Conduct your blooming in the noise and whip of the whirlwind.
Gwendolyn Brooks, 1968

That Olive chose in 1916 to become a homemaker rather than continue her teaching career was an inevitable stage in her life—in her words, "the next thing to do." She always had accepted the premise that if she married, she would want to have children, although she rationally kept herself from becoming overly obsessed with the idea should fate decree that she not bear any. Thus, she took what came in stride and feels very fortunate to have had "two boys and two girls, so that each can have a brother and sister." Motherhood, however, did not deter her from developing her talents in a variety of other interests.

Aspiring professionals, especially young ladies, can learn much from her example and wisdom. "Life is composed of choices," she has said, speaking from the vantage of an involved life in home, community, and business responsibilities spanning seven decades, "and no woman with career ambitions should feel that her child-rearing years are unimportant or restrictive. Where the single woman can embark on a professional goal anytime she feels amply prepared, a married woman has an entirely different set of choices, especially if she has children. I feel it is important that a mother make her children her chief responsibility so long as they need day-to-day attention and counseling. Motherhood without responsibility is reprehensible. Of course, I do not believe that care of children is the only obligation of a marriage. The husband surely deserves equal billing, and that too

122

should influence consideration of a materialistic career, even if family circumstances dictate that a wife work during the early years of her marriage.

"However, most women have their children in their twenties, and by their early forties, they are free of such individual care. If they are homebound in the intervening years, they can use their spare time to prepare for a career, if that is their desire, and most of them will have thirty or forty years ahead of them to pursue it. Each should decide such things on an individual basis and determine whether to dedicate her new freedom to the business world or to the wider family environment: charitable, educational, or cultural work."[1]

At every stage of her life, Olive has faced new choices and fresh opportunities for personal development and self expression, but most of them have come to her only because she has used initiative in reaching out for them. For example, she was a leader in many activities in both public school and college because such was her desire. She then became a teacher after she had prepared herself educationally. When she married, she made her home her most important priority; her husband and children received first consideration, and she exercised a time schedule more with them than anywhere else. She always tried to be home when the children came in from school and used her inclination to accomplish two things at once when possible, such as doing her "mending and hand-sewing while talking and listening to them." But, she had numerous other interests, as evidenced by her social and community involvements.

Life in Wichita afforded greater opportunties to cultivate these interests, and Olive became active in a number of clubs and societies. An examination of the scrapbooks she has kept throughout her life is a revelation in social involvement beyond imagination. The interest she developed in literature from her earliest days found uncommon expression at every turn in her life. She dabbled at literary creation during the Garveys' residence in Colby, but her talents blossomed in the larger Wichita community where she found many women who shared her interests in the literary arts. The list of clubs in which she was active

after she moved to Wichita includes: the Delta Gamma Sorority and the P.E.O. Sisterhood (in both of which she had previously participated); the YWCA; Twentieth Century Club; Kansas Authors' Club; Monday Afternoon Book Club; Women's Pan Hellenic Association; National Association of American Pen Women; University Club; the American Association of University of Women; the Women's Department of the Council of Churches in Wichita; and the National Society of Colonial Dames in America. And significantly, the important leadership positions to which she was elected in these clubs through the years attest unquestionably to the respect (if the word is not dependence) her peers held for her abilities.[2]

Without exception, her literary creativity found wide expression in each of these organizations, although her service was not always limited to that activity alone. She often made speeches, gave book reviews on recent publications, and wrote, directed, and/or performed in skits, pageants, and seasonal presentations for these and other civic groups. Frequently, she was asked to present her creations to such organizations as the Rotary Club, the United Church Women, the Twentieth Century Club, the University of Wichita, the Osteopathic Women's National Association (at their National Convention), the Wichita Chamber of Commerce, and the Community Chest. Additionally, she wrote plays, at special request, for the Kansas Crippled Children Society which were presented all over Kansas by a volunteer troup, and one of her creations, first presented to the Wichita Chamber of Commerce, was borrowed and used by the Los Angeles Chamber.

Olive once confessed that she was afflicted with "the pen and ink disease," but stated also that many Kansans were victims of the same incurable malady. She wrote poetry, short stories, and an occasional article for various publications, but her favorite medium was play writing. Although she cannot recall the total number of one, two, and three act plays she authored, her scrapbooks provide an impressive list of titles of stage presentations which were reported in Wichita newspapers between 1930 and 1947:[3]

"Yebo" "This Menacing Leisure"
"A Century of Womanhood" "His Mistress' Voice"
"Love's Young Dream" "Lobster Salad"
"This Psyching Age" "And Now You Know"
"Captain Washington" "Cast the First Stone"
"Marrying Off Martin" "The Well-Known Mrs. Public"
"His Old Time Sweetheart" "An Author's Nightmare"
"Spring Fever" "Mixed English"
"Knights in the Dark" "A Stitch in Time"
 "Weighing the Means"

Olive wrote for the sheer enjoyment of it but seemed pleased, if mildly self conscious, when others praised her works. She received recognition from the Kansas Authors' Club for "Knights in the Dark"; for "Mixed English" at a contest held in Parsons; and from the National League of American Pen Women for a short story entitled, "Things Just Happen," in a contest for unpublished stories. Several of her one-act plays as well as "Marrying Martin," a three-act play, were published by various dramatic publishing firms, as was "Captain Washington," which was included in an anthology about the early life of the first President of the United States. The book was issued nationally in 1931 by Dodd, Mead and Company as a salute to Washington's 200th birthday. Kudos came also from the heads of various organizations, such as C.Q. Chandler II of the Kansas Society for Crippled Children, for the plays promoting that work. And finally, she was honored by being chosen as one of 24 contributors to *Wichita People*, a book project sponsored by the Wichita Chamber of Commerce.[4]

In addition to her own writing, she sought to assist other aspiring authors by serving for many years as the director of the Creative Writing Class, a subsidiary of the Twentieth Century Club. She had apt students, they an apt teacher, for together they wrote and presented several drama productions for club programs. Inasmuch as the actresses were members of the class, she occasionally joined them in the performances.

These activities required considerable obligations, but she fulfilled them without reducing the time she felt should be committed to her family. Rarely did she fail to return home before

the first of her children came in from school, and none of them can remember when dinner was not ready when Ray arrived from the office or when fresh clothes were not available for any of them at the start of a new day. Olive carefully managed her time as well as her domestic responsibilities in order that she might comfortably pursue her personal interests—as well as the civic duties she felt all citizens should fulfill.

Busy people, it has been said, are the only individuals who should be entrusted with vital projects. Olive was an energetic and involved woman, and she always found time to be active in church work, not only by preparing special seasonal programs for the Plymouth Congregational Church and contributing to congregational periodicals but also by accepting various officer and committee assignments dealing with other important functions for the Church, including that of Sunday School teacher. In time, she would be tapped to serve at the national level, being appointed as a member of the Board of Home Missions of Congregational Christian Churches and as one of 38 members of the prestigious National Committee of Lay Sponsors of the Congregational Churches.

Incredibly, there was more. Many years when the Wichita Community Chest drive began, Olive could be counted among those most active in the money-raising campaigns, and during World War II, she first served as a door-to-door fund collector and eventually was Colonel of the Women's Division for the Community War Chest. Additionally, she was cited in February of 1946 by the American Red Cross for "meritorious personal service performed in behalf of the nation, her armed forces, and suffering humanity in the Second World War."[5]

Olive grew accustomed to the remark, "You do things so easily," and her pleasant, responsive smile ignored the endless hours she had spent and reinforced her determination to work hard at every project in the most efficient way possible. Through the years, her maturing methodology, already recognizable even when she was a schoolgirl, became the explanation for her mounting achievements. She organizes, plans, and performs tasks—characteristically completing them within a conscious time frame while adjusting to interruptions. When one is finished, she calmly tac-

kles the next one on her unending list of things to do. The secret of her success, as one observer has noted, is "that most people do things three times: (1) they tell you what they are going to do; (2) do it; and (3) tell you what they have done. Olive eliminates (1) and (3) so that no one (friends, family, or colleagues) is aware of her projects unless personally witnessed or told by someone who happened to be an observer."[6]

Despite her obvious busyness, Olive also saw to it that her husband received "equal billing" by being constant in her support of his activities. Ray was exceptionally busy himself after the Garveys moved to Wichita in 1928, often times struggling against declining economic conditions brought on by the Great Depression which forced many of his contemporaries into financial difficulty. Hardships notwithstanding, he was not one to allow them to make him distraught or discouraged, nor did he permit them to change his lifestyle or personal characteristics. His home was his refuge, kept so by a wife who made family relationships her first priority. The girls, whom he called "Toodles" (Ruth) and "Bunny" (Olivia), were his pets; the boys ("Willer" and "Skeet") his playmates.

The dinner table remained the highlight of each day, for it was a social gathering where everyone said what he liked amid a mixture of lighthearted laughter and seriousness. Ray was ever conscious of the children, and if a problem was presented, it was dealt with. With his teacher's instinct, he used these opportunities to lead and instill principles, drawing upon his background for illustrations ranging "from the ridiculous to the sublime."

When Olive and Ray brought their young family to Wichita, they were regarded as affluent but in no means wealthy by classical standards. The time spent in Colby were good crop years, and Ray had accumulated 25,000 tillable acres of wheatlands, a modest chain of independent service stations, and substantial cash reserves which he expected to put to work in testing the economic waters whenever new opportunities arose.

The general prosperity which had prevailed nationwide during the 1920s (in almost every enterprise except farming) still lingered in Wichita, and Garvey decided to put some of his reserves to work in 1929 by creating a financial institution known

as The Amortibanc Investment Company, Inc. By issuing guaranteed first mortgage savings bonds, he was able to attract a host of small investors, and with the funds thus raised, he embarked upon a land purchase/residential construction program in the Meadowlark Addition at Oliver and Mt. Vernon where the city's first all-brick subdivision was developed.

For the next two decades, real estate investment and development became the principal medium for growth of the Garvey enterprises, even though the depression and economic hardships altered Ray's approach to housing during the early 1930s. He entered the low-cost housing field in an effort to provide homes for families having little income, building one-room houses with minimal plumbing at the back of lots subdivided from an extensive parcel of land which he purchased near Wichita State University. By building the small "bungalows," he made it possible for people to have shelter until they could build larger houses at the front of the lots (converting the bungalows to garages)— and, most importantly, they could immediately regard themselves as homeowners. His plan was well received; nevertheless, the downward economic spiral added greater and greater risks to every endeavor in which Ray was involved.

Hardest hit was the Garvey Farms Company. "We made a farming profit in 1930," Ray once remarked, "and did not make another profit until 1940."[7] Although he managed to keep a large part of his wheatlands under cultivation during the first years of the depression, his overall farm operations were plagued by drought as well as economic uncertainty, even after New Deal farm relief and subsidy programs paid farmers for limiting production (a program Ray thought extremely unwise).

Most farmers, including Ray, continued to face difficult times throughout the decade. Many lost their holdings, and Ray was obliged to convert the profits realized from the Colby-based Service Oil Company to help keep the Garvey Farms solvent. Nonetheless, he continued his aggressive acquisition of additional acreages by using Amortibanc as a vehicle for purchasing numerous foreclosed farms from the Federal Farm Credit Administration. And as the decade drew to a close, many of his contemporaries thought that he probably was land poor inas-

much as he also had become a substantial owner of undeveloped real estate in and around Wichita. Although his cash flow was strained at times, Ray managed to keep his resources flexible, and his timely acquisitions positioned him for the long haul.

World War II afforded dramatic opportunties to capitalize on his portfolio of landholdings. As the enormous worldwide demand for food arose, government quotas were discontinued and fullscale production encouraged, thus ending almost two decades of recession for the American agricultural community. Garvey rushed his lands into cultivation and, over time, bought still more acres and put them to the plow, with the result that by 1947, he would produce more than a million bushels of wheat on 70,000 acres under tillage, "which then was the largest harvest by a single operator in the world." That was, however, only half the story of the wartime effects on the utilization of Garvey real estate.[8]

Wichita, already established as a center for airplane production, realized a tremendous growth from the wartime activities at the Boeing, Beech, and Cessna aircraft manufacturing companies. Massive hiring programs which began in 1941 exerted heavy pressure on available housing, and Garvey, rising again to the occasion, was "forced" into forming yet another business, entitled Builders, Inc., through which he built scores of conventional and apartment-style dwellings on the undeveloped properties he held in an effort to accommodate the needs of a "continuing tide of defense industry workers."

Nor did he slow his pace after the war, for returning servicemen bought houses almost as fast as they could be erected. Although the housing industry thereafter suffered periodic downturns, Garvey's construction company eventually would develop 24 subdivisions along with an additional 2000 individual houses, 2300 apartments, four shopping centers in Wichita and countless small homes in some 20 Third World countries.[9]

Olive refuses to accept much credit for his successes. "I was useful as a listening board," she comments, "and we discussed many things, but he arrived at his own conclusions. Had he listened to my advice, we probably would be modestly secure, but would never have achieved what he did. We both grew from our discussions because we respected and occasionally accepted one

another's views and got new ideas. I was supportive in principle, even though we did not agree on some matters, and he taught me to have confidence in my opinion if well researched, regardless of public opinion. I discovered he was right, so I, too, learned to ignore adverse opinions. He also taught me the value of operating on borrowed money and to think in terms of large transactions. In this way he gave me invaluable preparation for the later assumption of operation and responsibility."[10]

At times Ray also invited Ruth, Willard, James, and Olivia to work in the various operations both before and after the war, and they too acquired informed business mentalities. Due to the ownership of land which their father had bought for them as well as their investments in elevators and other properties, they were prepared when the time came and were required to accept responsibility. The master teacher had done his job well.[11]

As the decade of the 1940s drew to a close, the Garvey resources had increased to the point where additional investments not only were possible but also prudent. With almost 100,000 acres of wheatlands in production, Ray entered a new endeavor when the demand for petroleum products soared in the postwar years. He created in 1949 yet another vehicle, which he named Petroleum, Inc., with a subsidiary known as the Garvey Drilling Company, and launched into the oil exploration and production business. To give direction to this new venture, Garvey employed a promising oilman, Eric Jager, and over time Petroleum, Inc., has produced an impressive record. In 1978, on the 50th anniversary of the Garveys' residence in Wichita, the firm reported that it had drilled 2057 wells in Kansas and was producing 2100 barrels of oil and 13 million cubic feet of gas per day in the state alone. It also had operations in eleven other states, Canada, and Turkey and was continuing its quest in other locations.[12]

As successful as he had become by mid-century, there still was another enterprise into which Ray would be "forced," one which would eclipse all previous achievements many times over. The open market system which he so strongly advocated, and to which the agricultural community had returned temporarily, was producing record wheat yields by the end of World War II, as his own 1947 crop of a million bushels would attest. Such yields re-

sulted in large surplusses and storage problems of major proportions. Indeed, it was not uncommon to see huge mounds of grain heaped upon the ground near rail loading stations—which made them subject to the wiles of High Plains weather until they were shipped to processors and other markets.[13]

Congress again took a hand in trying to deal with surplusses by restoring the allotment system and by passing laws in 1949 which sought to encourage the construction of grain storage facilities. The Commodity Credit Corporation was authorized to guarantee partial storage for three years to those who would build elevators. As an added inducement, provisions were made which allowed owners, for tax purposes, to write-off or depreciate most of the costs of the new construction at faster than normal rates. Moreover, the Reconstruction Finance Corporation extended further encouragement by offering assistance loans of up to 50% to builders if they could secure the partial guaranty from Commodity Credit.

Although Ray disdained the government's return to production management, he had too long faced the problem of finding sufficient storage for his own grain to be indifferent to the gigantic national predicament which the new laws sought to address. He was no stranger to the storage business, having acquired elevators in Kansas at Halford and Spica during the twenties and thirties. However, it was not until 1948 that he embarked on a major expansion of his facilities. With his son in-law, Dick Cochener, he constructed elevators for the newer farms in Greeley County, Kansas, and Kiowa County, Colorado. Additionally, with his son James, he built another at Winona, Kansas, and expanded the capacity of existing elevators at Haswell and Brandon, Colorado, as well as at Spica and Halford, Kansas. When completed, their combined capacity still was not great enough to handle Garvey's record-setting crops, and he was obliged to arrange for huge storage space at the Wichita Terminal Elevator Company, paying as much as five cents a bushel over normal storage rates in order to secure the arrangement.[14]

Again, Ray Hugh Garvey would have contended that he had been forced into another business, for the fierce competition for storage clearly indicated that he was not alone in his plight and

that by taking care of his own needs, he also might realize a profit by providing storage for other desperate High Plains wheat growers. Thus, he approached several large-scale farmers in northwest Kansas with a proposal to secure sufficient funding for a cooperative elevator, but the grain men had faced hard times in prior years and felt the venture too risky should the government abandon the subsidy programs.

With Cochener's assistance, he then turned his attention to making proposals to the Commodity Credit Corporation, but after submitting "guaranty applications" for over 40 medium-sized facilities and receiving approval for some 20 of them (including one for three million bushels at Topeka), he encountered much difficulty in securing loans sufficient to begin construction, even from the Reconstruction Finance Corporation which offered a maximum of only 50% financing.

Finally in April of 1950, Ray dropped all of the projects except for Topeka, and after failing to attract outside capital in time to start and complete construction before midsummer harvesting began, he convened a family caucus and determined that a facility with a capacity of one million bushels could be built in Topeka by using only Garvey funds. With Olive, Ruth and Dick Cochener, Olivia, Willard, and James contributing equal shares, a new partnership was formed, entitled C and G (Cochener and Garvey) Grain Company, and "the first million of a long road to two hundred forty millions of bushels of storage space" was begun with a deadline for completion on July 10, 1950. It was a gamble of major proportions, and it succeeded while skeptics watched and waited in anticipation of a colossal failure. On July 10, the Topeka terminal began accepting grain for storage.[15]

It was indeed a long road from one million to two hundred million, especially in view of the fact that Garvey built virtually all of the massive elevators with loans from private banks rather than with loans guaranteed by government-sponsored agencies. The precedent he set in consulting and involving his family in the decision to build the Topeka terminal was repeated without exception when each subsequent elevator project was being considered.

By the mid-1950s, Family Board meetings were held regu-

larly, always with open and free discussions. Inasmuch as the board consisted of six strong-minded people, there were frequent disagreements. Olive considered herself as sergeant-at-arms and tried to help obtain a consensus. Ray's methods with everyone, as in all his business dealings, were gentle, informal, and often whimsical. His firmly-held principles were related with a touch of good will and humor, which removed the sting from their application, and everyone learned without realizing they were being taught. Ultimately, Ray usually made the final decision, and the family had respect for his judgment and complied.

Starting with the Topeka terminal, a total of eleven huge "Castles on the Plains" were constructed within an eight year period, the three largest being at Wichita (a half-mile-long, 44-million-bushel-capacity structure), Topeka (subsequently enlarged from its original size to 41 million bushels), and Salina (at a respectable 34 million bushels). The costs ran to astronomical figures in terms of 1950 dollars, and at one time Ray and Willard were the responsible signatories to over $50 million of borrowed capital.[16]

Raising such a sum was Herculean, inasmuch as none of the Wichita and Topeka banks could handle loans of that magnitude, and most eastern bankers at first showed no interest because they had had little prior experience in making grain storage loans and even less in financing massive elevator construction. Undaunted, Ray made telephone calls to virtually every large financial institution in the nation and dispatched Willard and Oliver Hughes, his nephew, to make personal contacts with eastern financiers. Soon, inquiries about Garvey's operation came from a number of sources, but there still was great reluctance to extend him loans in the amounts he required.

In the end, the financial gap was bridged by Arthur Kincade, President of the Fourth National Bank and Trust Company in Wichita, who was held in high esteem throughout the national banking community and who gave Garvey his unqualified endorsement as well as the maximum line of credit his bank's policies would permit. "Ray Garvey," his standard response to all inquirers began, "will never ask for a loan he can't and won't pay back." Thereafter, the number—and national prestige—of the insurance companies, financial institutions, and banks which

joined the Garvey parade to world prominence in the grain storage business literally boggles the mind—but not more so than Garvey's feat itself.[17]

Construction of ten of his massive elevators followed in planned order, and all arrangements for them were made with verbal guarantees through telephone conversations with Clinton H. Chalmers of the Chalmers and Borton Construction Company of Hutchinson, Kansas. No written contracts ever were executed to authorize the more than $50 million in building costs; in fact, during the eight years Garvey and Chalmers worked together, they met face-to-face only three times, despite the fact that Garvey established three ready-mix cement plants to supply him with most of the concrete for the projects. A man in a hurry to effect a miracle, it would appear, has no time for unproductive conversation.

By the time he completed the last of three seven-million-bushel elevators (at Parnell, Kansas, and at Lincoln and Hastings, Nebraska), he had become in 1959 "the world's largest grain elevator operator" with annual rental payments from the Commodity Credit Corporation alone of more than $20 million, the only direct participation the government had in Garvey's success. Nonetheless, he again was assailed by his critics for capitalizing upon a system which he outspokenly opposed, but his measured response always was, "We operate under this program. We don't set it." And he added, "I quit trying to solve the farm problem 30 years ago. Maybe they should have left farming under free enterprise. But we've been [under price supports and crop controls] so long now, it would be tough if not disastrous for farmers to break away."[18]

Despite his successes, Ray remained virtually unaffected by them. "Wealth," one has remarked, "was not in the forefront of his mind. He didn't emphasize money, and he never took himself seriously. He was humble to the point that few people realized the extent of his wealth." He was known to relish the opportunity to stand in front of the massive Wichita elevator and remark, "She's more beautiful than the Parthenon. The Parthenon has columns, too. But these are taller, there are more of them, and they are full of grain."

Ray was a man of simple tastes whose casual dressing habits, it is said, made it difficult for anyone to pick him out of a crowd of farmers. He drove standard Ford sedans when he could have afforded the most expensive of automobiles, and he and Olive chose to live in modest, if spacious, houses while employing only a minimum of domestic help. Three times he bought new homes after first having rented the North Clifton property: 236 South Terrace Drive, 126 Circle Drive, and finally in 1948, 16 Lakeside Drive, all of which sought to address the family's needs at appropriate stages.[19]

He regarded his home as his refuge; Olive was his anchor in a sea of complicated activities, and his children were his most important responsibility. They enjoyed being at home together, although Ray seldom was inactive when he was there. He seemed never to tire and was constantly on the telephone, for it was through such conversations that he remained in contact with and gave directions to the supervisors of the far-flung elements of his business.

Those conversations, although Olive heard only Ray's part of them, were another vital link in the growth of her business knowledge. What she heard were the words of a strong man who dominated almost every situation in which he was involved, and one who was lucid and direct in sharing his wisdom as well as firm and unemotional in giving instructions on how his decisions were to be carried out. Many times, the topics of discussion involved business activities in which she was an investing partner, adding yet another dimension to her interest in listening to them. Admittedly, such exposure was gratifying but not necessarily of critical importance in her list of personal priorities.

As involved as she had become by the late 1950s, Olive still regarded business activities as Ray's domain. "I was more or less involved in our businesses," she has said, "but mostly from a respectful distance. I thoroughly enjoyed the responsibilities surrounding the domestic and social parts of our lives, but Ray always saw to it that I had a good understanding of the businesses." As the enterprises expanded and required a board of directors, Olive was elected Vice President and always attended the meetings, but her participation, in her words, was "only an extra-curricular

activity," much like the other boards on which she then served. Even though Ray made the final decisions and carried them out, her board experiences nonetheless were valuable and informative.[20]

Shortly after Willard and James had returned from army service and became more active with their father, Ray and Olive began to take some time off for extended vacations, largely because Ray was exhausted and his doctor had cautioned him to take life a bit easier. They spent a part of the winter in Palm Springs in 1946, only to discover upon their return that Ray had diabetes. The following spring, they then spent a month at a lodge in Evergreen, Colorado, and decided to build a cottage there.

From 1949 until 1958, Olive and Ray spent each summer in their mountain retreat, often with their children or other friends and always with Muggs, the family pet. Together they read, played bridge, gin rummy, and Scrabble, and Ray "hacked out" numerous letters on Olive's portable typewriter. For Olive, it was a very hard-working paradise to be joyously shared with her family and a steady stream of visitors, but inasmuch as those eight years coincided with Ray's greatest business gamble, the refreshing summer climate provided a restful change of pace for Ray's tiring body.[21]

Those happy excursions ended in 1958 after Ray suffered a severe heart attack in California as he and Olive were preparing to embark for Hawaii on a brief vacation. Ray battled back to vigorous health but sold the mountain cabin upon the advise of his doctors because they felt the higher altitude in Evergreen was not favorable for heart patients.

Regrettably, Olive and Ray would enjoy less than two more action packed years together, but during that time the Garvey grain storage facilities would reach the unprecedented capacity of more than 200 million bushels. There also were two other elevators under construction at Grand Forks and Jamestown, North Dakota, but Ray's death on June 30, 1959, following an automobile accident near McPherson, Kansas, found them months from completion.[22]

His death shocked his family and stunned citizens throughout

the state and nation. "The fatal injury of Ray Garvey," one jour-
nalist wrote, "removed a fabulous man from the Kansas scene.
A big, hearty man, Mr. Garvey thought in terms to match his
size." The account continued:

> Last year at the 93rd commencement exercises at Washburn,
> Mr. Garvey received an honorary degree. He was cited by his
> alma mater as a "distinguished alumnus, successful attorney,
> prominent leader in business and industry, supporter of many
> and varied causes, and friend of able and worthy men and
> women."...His passing ends a legendary career, the like of which
> is seldom witnessed. He matched big thoughts with big deeds.[23]

There were many, many other tributes in well chosen rhetoric
befitting his accomplishments.

Since his passing, Ray Hugh Garvey's story has been kept vivid
in Kansans' minds because his empire survives with great visi-
bility and because journalists still find the saga of the remarkable
feat of "a man who made it by sheer brains and sound judgment
and heeding the knocks of opportunity" well worth the retell-
ing.[24] However, the memory of Garvey and his achievements,
though they remain bright, are but a part of the legacy he left.
Living on with remarkable effectiveness are his wife, whose smile
and demeanor had so thoroughly captivated him at Washburn
almost a half century earlier, and his four energetic children (and
sons/daughters-in-law), all of whom since his death have shoul-
dered a part of the responsibility of providing intelligent direc-
tion to the businesses he founded—and which have continued
to grow under their prudent and aggressive leadership. Thus
since 1959, the story of the Garvey enterprises no longer is ex-
clusively that of Ray's alone.

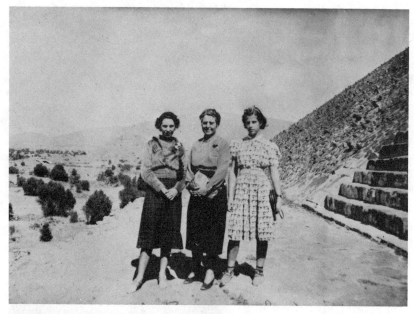

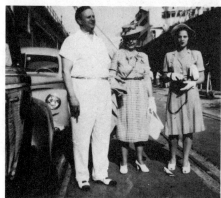

Above: Olive felt her first priority was to her husband and children. Here she, Ruth, and Olivia visit the pyramids near Mexico City in 1938. Left: Ray also was devoted to his family. He is pictured with Olive and Olivia in La Guira, Venezuela, in 1947.

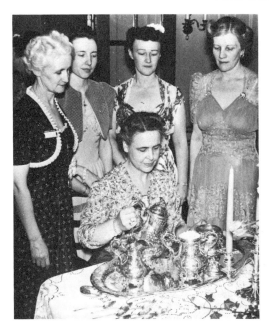

Left: Olive frequently participated in important social events, such as this Installation Tea for Delta Gamma Beta Kappa. Below: The "Book Club," one of Olive's many associations relating to her literary interests.

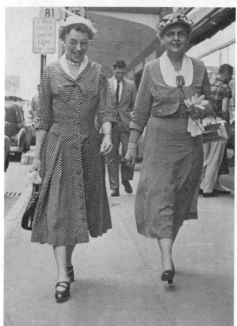

Above: Olive and Ray belonged to "The Bridge Club," a social group which enjoyed home visitations and entertainment. Left: Olive has had many friends, such as Irene Dean, a college classmate with whom she was photographed while shopping in downtown Wichita in 1956.

Above: The Garvey home in Wichita at 236 South Terrace, their home from 1929-1934. Below: They then purchased this lovely home on 126 Circle Drive where they resided from 1934-1948.

Above: Finally, they built this home in 1948 at 16 Lakeside Drive. Left: Garvilla in winter time, the Garveys' Colorado mountain cabin.

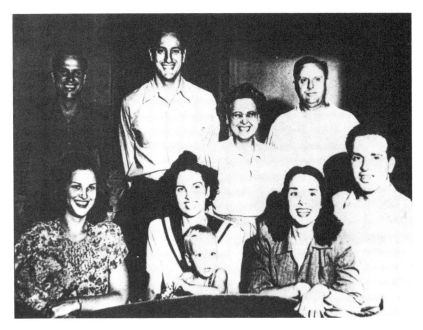

Above: A Garvey family portrait, taken in Green Mountain Falls in 1946.
Below: The Garvey family (including family pet, Muggs McGillicuddy)
at the time of the wedding of James Garvey to Shirley Fox in 1947.

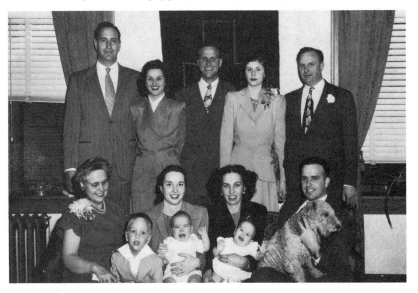

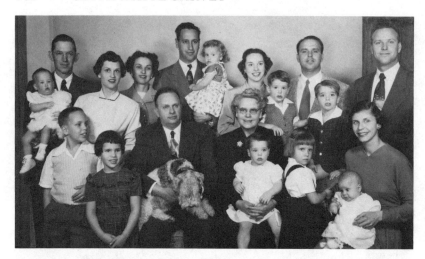

Above: "Cheaper by the dozen, but dearer by the score." A Garvey family portrait in November of 1952. Below: By Thanksgiving Day in 1957, the Garvey family had grown to include 18 grandchildren, all of whom are shown in this photograph.

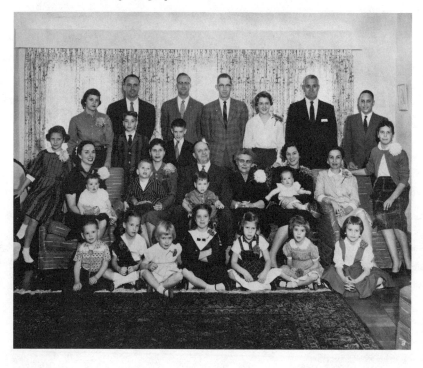

Olive and Ray, shown here in 1954 at their home on Lakeside Drive, enjoyed 30 years together in Wichita.

7

OLIVE'S THIRD ADVENTURE

You will be engaged in several lines of business with broad activities.
Chinese Fortune Cookie
Opened by Olive Garvey

Mrs. Garvey once wrote that her life has fallen into three distinct but interrelated segments: childhood and education; a marriage of almost 43 years which included motherhood and a range of social and civic experiences; and a business career which began at the age most people embark on their retirement years. She might also have included in the second segment her growing involvement in the Garvey enterprises as well as the fact that she already owned considerable property from which she derived a substantial private income. Each of these periods, in her judgment, trained her for the next, and although the last of them was thrust upon her by Ray's death, she definitely was not a stranger to the responsibilities she inherited after June 30, 1959—or devoid of the skills necessary to deal with them.

Whatever else might be said of Ray Hugh Garvey, he was not one to cower in the face of adversity. He had faced difficult situations many times, yet always had summoned inner strength and renewed optimism to emerge from each of them with even greater accomplishments. Olive White Garvey was cut from the same cloth, and once the harshest part of her sadness had softened, she began immediately and confidently to meet her new challenge, not merely because she had to, or because it was expected of her, but also because she had the example of a master teacher who encouraged her through the years to become involved and develop her own business talents.

When she went to Ray's office, she regarded her first duty as

146

that of acknowledging the expressions of sympathy and kindness from countless friends, and with the help of his secretary, she wrote over a thousand personalized notes. During those early weeks, however, business correspondence arrived almost daily with matters needing decisions, considerations which forced her to delve promptly into the records and assess the actions she thought appropriate in each case. At least she had the comfort of knowing that the various subsidiary companies were being managed by competent individuals, and that a tentative plan for leadership of the grain facilities already had been discussed before Ray's death: Willard would remain in Wichita and the Finks in Topeka; James would relocate in Fort Worth; and the Lincolns would move to Lincoln, Nebraska.[1]

Any thought Olive might have had about a temporary assumption of responsibilities faded quickly, for upon examination of the facts, she discovered numerous "loose ends" which required daily management and supervision. Moreover, she realized that every member of the family already was working to capacity and that someone "had to be the catalyst to hold the whole thing together." Olive was the logical person, and she moved without hesitation into the top position of the Garvey enterprises with the full support of her family.[2]

Some of the earliest difficulties she encountered were by-products of Ray's genius. Ray did almost all of his business by telephone, the details of which he kept in his computer-like mind, and most of the written understandings with other firms or individuals were in letters. That there was mutual trust between him and his business associates is evidenced by the fact that he built elevators worth more than $50 million solely upon telephone conversations. Because of his mindset and unusual talents, he remained informal in all aspects of his business dealings, resentful of unnecessary restraints (which he called "red tape"), and impatient with rules of procedure in board-type deliberations.

Blessed with total recall, even intricately related data complete with dates, he also could "correlate in his head all essential financial statistics and production projections with dumbfounding accuracy—to the amazement of everyone he dealt with." He did not want and never kept a large staff, fearing that it would

hinder his ability to act quickly on business decisions. The responsibility for maintaining whatever records were necessary was entrusted to his secretary, and he did not employ a regular bookkeeper until he had been in business for several years. As admirable as his talents were, the net result was that the vital functions of the Garvey enterprises were conducted by Ray Garvey, and much of the overall knowledge of his extensive empire was kept in his head. His death removed that reservoir as well as his leadership.[3]

Thus, those who have assumed that Olive Garvey inherited a well developed and organized company have incorrectly assessed the effects of Ray's operating and management style, successful though it had been for him. And even those who were aware of it at the time and feared that without him the Garvey enterprises might be headed for disaster likewise failed to reckon properly with Olive's basic character, the breadth of her analytical and management talents, or her decisiveness in dealing with difficult situations. Her goal became not just that of conservator for what the family had inherited but also that of synergist for assuring that all the businesses would continue to operate at full potential. It never entered her mind that any one of them could fail, nor did she regard the early problems she faced as being at or near the crisis stage, sensitive though some of them were.[4]

Olive wasted no time in demonstrating her competence as a businesswoman. Very early in her tenure, she convened a meeting of her children and Robert Page in her office and asked them for their assessment of the efficiency of key personnel and what problems needed attention. As a result of their advice, she engaged Oliver Hughes, her nephew, to search the records and get the minutes of each corporation in order. As standard procedure, she continued to consult the children and Page in order to get an accurate picture of every situation and to utilize the best collective thinking available upon which to base her decisions, many of which were made on ideas advanced by them. Some of the decisions she reached in the early months were crucial, but she made them calmly and resolutely in the face of considerable pressure, knowing that "the decks had to be cleared" be-

fore the businesses again could function normally. And significantly, most of them were made not so much with a view toward cost effectiveness but in the interest of conserving time.[5]

Clearing the decks, however, was not without its complications, for at least four major considerations required early analyses and prudent handling. There was, of course, the important matter of probating Ray's Will, but its ultimate settlement was contingent upon yet another problem—a long-standing dispute with the Internal Revenue Service over an alleged tax lien against the Garvey enterprises. Additionally, the matter of operations leadership, both at the central office and divisional levels, needed to be addressed, as did the sizeable short term debt obligations against the grain elevators.[6]

As executrix of Ray's Last Will and Testament, Olive set in motion its probation by assigning the responsibility to two men: Emmett Foley, Garvey's staff attorney who had prior experience in closing estates; and Robert Page, a partner in the certified public accounting firm of Elmer Fox & Company who had worked with Ray in drafting the document. No doubt there were those who felt she should engage one of the major law firms in Wichita to handle an estate of such magnitude and complexity, but she made the decision to remain "in-house" without hesitation, believing not only that Foley and Page were competent to oversee the matter but also that time could be saved in moving the matter to closure.

There was a flurry of apprehension, however, surrounding the filing of Ray's Will. The task of distributing copies of the Will to family members had been entrusted to an employee, and as fate would have it, the only copy of the Will remaining in Ray's safety deposit box was unsigned. Hurried calls went out to the children, to each of whom Ray had directed copies be sent, and "great relief occurred" when James reported that his copy was signed and witnessed. James Garvey took it to an attorney in Colby who secured sworn evidence of its contents. The Will then was placed in a bank safety deposit box until it could be delivered safely to the probate court.

Although actual values were not revealed, the terms of Garvey's Last Will and Testament were made public as early as July

10, 1959. It was an uncomplicated document, fashioned from his heart with generous bequests to his family. Half was left to Olive, along with their home in East Wichita. One percent was assigned to each of his four children, a like amount to each of his 18 grandchildren, and one half of one percent to each of his children-in-law. The balance of the estate was committed to a charity, Garvey Foundation, Inc., with the request that not more than 25% of the income from the trust be spent in the first 100 years following his death.[7]

Some of the Foundation's income was earmarked for 16 specific purposes, seven of which, in one form or another, were for the benefit of Washburn College, Ray's alma mater. One of them, the Olive W. Garvey Award, was a tribute to his wife, whom he had met while they were students there. It provided for an annual award or scholarship to the Washburn junior girl with the most attractive smile. Other scholarships and gifts honored numerous individuals (including his parents and children) and institutions having a special meaning to him. It was a sizable bequest, but nearly three years would pass before the estate was closed and the monies made available for distribution, largely because the IRS tax question remained unsettled.[8]

Another of the matters requiring early attention were the loans Ray had negotiated with eastern financial institutions for the construction of the Garvey grain elevators—some $50 million in short-term debt. Although the repayment schedule always had been kept current, Olive felt it important to reassure the bankers of the family's intent to honor its obligations. Accompanied by Ruth and Bernerd Fink, she traveled in the fall of 1959 to Boston and New York where they paid visits to the executives of each of the banks. It was a wise decision. While in Boston, she learned that a recent visitor from Wichita had cast doubt upon her administration of the estate, but no such doubt remained in the financiers' minds following their discussions. She demonstrated a clear understanding of the financial arrangements, and convinced the bankers of her determination to fulfill all obligations regarding them. She and the Finks were received warmly and treated with great cordiality in both cities, often returning to their hotel rooms to find flowers and theatre tickets awaiting them.[9]

An indication of the lenders' confidence was demonstrated by the fact that none of them filed a claim in the estate proceedings for the loans Ray Garvey had personally guaranteed. Moreover, they were impressed by her decision not to consider requesting a change in the terms of the loans, especially the three-to-five year, short-run repayment schedule. The loans easily could have been spread out and refinanced, thus easing the burden on cash flow during the transition in leadership, but Olive refused to consider the possibility. Even though the last two elevators in North Dakota still were under construction and would require continued funding, she already had determined that the balance between revenues and expenditures, though tight, was favorable for the near term despite the large principal and interest payments. Thus, the loans were repaid precisely when due—without a single extension of time on either principal or interest. It was an important decision and, as time would tell, would have significant influence on future developments.[10]

Ray had been making tentative plans for dividing the administration of the various grain locations into five sections: C-G-F was to assume management of the Topeka (41 million) and Atchison (11 million) elevators; Willard was to manage the Wichita terminal (44 million) which had just been completed; James was to be responsible for Fort Worth (28 million) and Hastings (8 million); George Lincoln would be responsible for the Lincoln (14 millon) and Havelock, Nebraska (8 million), facilities; and Ray would retain the management of the Salina (38 million) and Parnell (8 million) locations for himself. After the completion of Jamestown (1.6 million) and Grand Forks (4 million), the total capacity was 205.6 million bushels. According to the plan, James Garvey's family was scheduled to move to Fort Worth, Texas, and the Lincolns would move to Lincoln, Nebraska.

By mutual consent, Ray's plan for the redistribution of responsibility for the grain locations was implemented almost immediately after his death. James and his family moved to Fort Worth and the Lincolns to Lincoln. Olive assumed the Salina and Parnell assignment and appointed George Stockwell, the executive of The Amortibanc Investment Company, to administer it for her.

The management of the grain facilities was assured, but complicated contracts with the Commodity Credit Corporation affected the whole operation which only Ray had the capacity and experience to supervise. Olive recognized that the absence of a staff person trained to carry on this vital function was a serious void and that the early employment of a skilled general manager/financial director to replace Ray was critical.

Although she had not met Robert A. Page before Ray's death, she frequently consulted with him thereafter, and in a short time, chose him for the position because she knew that he had more overall, complete knowledge about the Garvey businesses than anyone but her husband. And, from the numerous telephone conversations she had overheard between the two men, she was aware that Ray had complete confidence in Bob and often relied extensively upon his advice.

Page, a CPA and graduate of the University of Kansas School of Law, began handling the Garvey account for Elmer Fox & Company (of which he was a partner) in 1954 at a time when an alleged tax deficiency against the Garvey enterprises had become a major concern. The allegations had their origin in the early 1950s when the Internal Revenue Service questioned Ray's practice of dividing ownership of all new ventures with each member of his family. Attractive estate tax benefits accrued to the plan, for it spread ownership (as well as tax bases) among many rather than consolidating all holdings into one giant entity, leaving Ray Garvey as the owner of a large, but nonetheless fractional, part of the businesses under his control. The IRS had raised questions about the practice.

As the two men struggled with the tax issue during the 1950s, Bob became increasingly knowledgeable about all phases of the Garvey businesses and, in time, counseled him on estate planning and the drafting of his Will. The tax case, however, remained unsettled in mid-1959 with no indication of significant progress toward closure. Olive was aware that an unfavorable ruling would mean a tax lien of millions of dollars, and that until the matter was resolved, many questions about the future of the businesses would remain moot.

During the early months following Ray's death, Bob worked

hard at being as helpful as possible to Olive and eventually drafted a letter to her in which he provided a list of active bank accounts and a debt service schedule. He also summarized, as he saw them, the major issues she faced and recommended that she identify and recruit an operations executive to assist her in handling them. The letter was helpful, but Mrs. Garvey already had arrived at her own conclusions about the latter point, and unknown to Bob, she had become convinced that he was the person she needed. Once decided, she lost no time in approaching him.

Page, as a partner at Elmer Fox, had not entertained the thought of changing professions when he received a call from Olive in early December. Nevertheless, it was one of the shortest job interviews in history, lasting hardly more than 45 seconds. As Olive remembers the conversation, "I asked him if he would consider joining the Garvey enterprises and, if so, what financial considerations he might expect. He told me. Then, he asked me what he would be expected to do. I replied that he 'was to sit in his office, assess each enterprise, and tell them what to do.' He responded that he would like that, and I asked when he could come. He said April 1. The matter was settled."[11]

Olive regards the decision as one of the most important she has made since becoming chairman of the board, and her children concur. Bob provided a wealth of background knowledge as well as seasoned technical expertise at a time when it was sorely needed, and he also brought the personality of the consummate corporate operations executive who not only is a good manager but who also recognizes his most important responsibility as that of assembling all information, providing alternatives, and explaining the potential consequences associated with each decision. It has been an ideal relationship. Olive has supplied strong, decisive, and analytical leadership and has proven to be "the glue which holds everything together"; the children have played important roles in causing things to happen; and Bob has furnished the professional advice which has helped all of them achieve their goals with minimum complications.

Prior to Bob's arrival, Mrs. Garvey's management style already had taken form, and as might have been expected, it differed significantly from Ray's. As one who subscribes to the notion that

"if you don't know where you're going, any path will take you there," she is much too organized and methodical to allow the Garvey ship to proceed without a charted course. She initiated family council meetings that met monthly in Wichita during which orderly discussions and consultations took place—complete with prepared agendas, Robert's Rules of Order, and detailed minutes. The meetings oftentimes were lengthy, but Olive thought it wise to cover all subjects thoroughly before decisions were reached and actions taken. Everyone was free, indeed expected, to participate, and the tough problems they faced in the early months conditioned their lively deliberations with a resolve to move with unity toward solving them. As chairman of the board, Olive led the discussions and "refereed the debates," and although she always sought concensus, she nonetheless spoke last and resolutely when decisions were needed.

Bob Page began sitting with the family council at its annual meeting in Las Vegas in February of 1960, and his suggestions thereafter helped shape decisions which provided strength in fiscal management. Citing as a principal weakness the inadequacy of professional personnel in the financial/accounting area, he recommended that Herb Bevan, his associate at Elmer Fox, be brought in to give daily supervision to these activities. The initial steps were taken to systematize processes leading to the present subsidiary corporation, known as SRI, Inc., to train personnel, provide research, and develop standardized procedures for handling all accounting functions.[12]

There were many other issues Olive thought important in setting the house in order, and like a master juggler with several objects in the air at the same time, she made decisions on all of them after they were thoroughly discussed in council meetings. To give greater coordination to their efforts, she directed that the headquarters for the grain operations, then known as Grain Merchants, Inc. (later renamed Garvey, Inc.), be moved from Topeka to Wichita where it was incorporated with the financial department. She asked Clifford Allison, an attorney who had joined the Garvey enterprises shortly before Ray's death, to expand his responsibilities by assuming the supervision of the Garvey Foundation, and Page, along with other functions, was assigned

three key duties: the management of cash flow in order to assure that the large short-term debt could be retired; the continued quest for a reasonable settlement of the long-delayed tax question; and assisting Emmett Foley in handling the settlement of Ray's estate.

Meantime, Olive also proved herself a realist who believes in the theory best expressed in a contemporary colloquialism: "If it ain't broke, don't fix it." When she became chairman of the board, it was obvious to her that many of the various divisions of the businesses were being led by capable people. For example, as Ray himself might have said, Eric Jager of Petroleum Inc., "had paid his tuition" with a decade of experience, loyalty, and successful office and field management, and he knew "the petroleum end of the Garvey game" as no one else did. The same was true for George Stockwell, who also had paid his dues and had proven his worth with effective leadership of Amortibanc for many years and who was carrying on in the Garvey tradition of servicing home and commercial needs for mortgage capital. And there was Henry Dock, an extremely capable and scrupulously honest supervisor of the storage, inspection, and handling of hundreds of millions of bushels of grain each year where any number of potential problems could tip the balance between profit and loss.[13]

Thus, the operations team needed no fixing, and Mrs. Garvey kept it together. In retrospect she has said of them, "There is no way of overestimating the value of these men to our enterprises through the years." But they are quick with accolades of their own, believing that Mrs. Garvey's leadership has been outstanding. "She has faith in people," Jager has said, "and gives them a free hand in carrying out their responsibilities. She always insists on being informed, but she would never interfere unless something needs fixing." Dock, now in retirement, also adds, "She is a gracious person whom everyone enjoyed working for. She was always available and willing to listen to any problem whether it was big or small. When a decision was needed, she gave us one, and it always was the right one."[14]

Of the many decisions Mrs. Garvey made in the early years, none proved more important than her determination to pursue

a realistic settlement in the long-standing tax case, discussions of which already had dragged on for more than five years. Clearing the decks completely could not be effected until the matter was resolved, for additional delays in the decision forced a postponement of progress in other important areas, not the least of which was the settlement of Ray's estate. Moreover, to pursue it unsuccessfully also could mean larger interest penalties on the taxes the IRS felt were due. Nevertheless, in one of the few instances where time was not regarded as the pivotal factor, Olive chose not to abandon the case but to continue the fight, indefinitely if necessary, believing that reason ultimately would prevail and a favorable ruling might be reached.

It was not until 1961 that the corner was turned and Olive's faith vindicated. Fortunately, after lengthy conferences with the IRS, Bob was able to present his arguments successfully and effect a settlement which resulted not in a multi-million dollar tax lien, as once was feared, but ultimately in a half-million dollar tax credit to the Garvey businesses. Thus, this serious bottleneck was removed, and prompt closure followed in the probate action on Ray's estate.[15]

No longer threatened by the tax lien, Mrs. Garvey now found the ability to retire the debts against the grain elevators substantially strengthened. Indeed, the *Southwestern Miller* reported in 1963 that the empire Ray had established "has continued to prosper and expand under the ownership and management of members of his family. In fact, it currently rests upon a foundation that is much more secure than...in the recent past, for it is now approaching the point where the companies he founded will be free of debt."[16]

Such a position truly was remarkable in view of the fact that only a few years earlier, the Garvey indebtedness hovered around $50 million. At the suggestion of Bob Page, Olive confirmed the newly achieved status by writing a clever but heartfelt letter (accompanied by an album containing photographs of the Garvey grain elevators) which she sent in 1963 to all of the principal lenders, among them Arthur Kincade at the Fourth National Bank:

We thought you might be interested in seeing the concrete evidence of your faith in us and our enterprises, so we are presenting you with this pictorial record of the grain elevators which you have helped us build.

I am sure that it is a source of satisfaction to you as well as to us that all the major facilities but one will be debt free this fall. And it is our intention to begin prepaying the indebtedness on the final facility.

We could not have accomplished this without your help. So please accept this album as a token of our sincere appreciation of your many courtesies and services.[17]

A remarkable achievement indeed! But it merely was a reflection of Olive's basic character, of her determination to see a project through to completion, and of remaining consistent with her family's personal pledges as well as her own conservative economic mindset. Years after she wrote the letter to Kincade, she and her family remembered his assistance in a more substantive way, creating in 1976 a $10,000 "Arthur W. Kincade Award" which was given at the Kansas Bankers Association Convention to a Kansas banker who best exemplifies "the policy of extending credit on personal character and performance rather than material collateral."[18]

Thus, the decisions reached between 1959 and 1962 were important and their outcomes crucial to the Garvey enterprises, and Olive's role in them elicited admiration and praise from family, business associates, and the newsmedia. In an article summarizing the first five years of her leadership, the *Topeka Daily Capital* reported, following extensive interviews with numerous individuals, that she had done "an extremely capable job of stabilizing" the businesses and credited her success to "direct and immediate action in everything she does." Her record in determining the proper course of action was acknowledged as virtually flawless.

She was, the account continued, an involved businesswoman who described her position as being "more or less a liaison one of seeing that things are taken care of, giving advice, and helping with coordination" in a daily routine which called for five or six hours in the office, half of which was spent in conferences and

correspondence as a "matter of keeping track of what is going on." She also confessed that there still were so many things to do that she had not found an opportunity to slow down. "Nothing is certain but change," she concluded, "but people who can meet the conditions will adjust to whatever happens. I have always been too busy today to think about what I would do tomorrow."[19]

Although totally dedicated to her business responsibilities, Mrs. Garvey did, however, find time to pursue interests other than business, especially after Bob Page joined the firm and "lifted a great weight" from her shoulders. In the summer of 1960, she attended a highly regarded two-week workshop for writers held annually at the University of Colorado, and that experience was soon followed by an extensive tour of the Far East with a friend from her college days, Irene Dean. Then in 1961, she and Julia Raymond joined the Clarence Vollmers in a six-week Mediterranean tour with stops at numerous ports, including Barcelona, Madeira, Istanbul, Athens, Cairo, and Yalta.[20]

Nor did she neglect her service to various organizations, for her civic service expanding dramatically during the early 1960s. She accepted an appointment to the YMCA Board and also was elected to serve on the Wichita Area Chamber of Commerce Board of Directors along with another outstanding businesswoman, Olive Ann Beech, the first Wichita women to be so recognized. Both also were asked to become members of the Metropolitan Wichita Council, an advisory organization formed to assist in the orderly development of the city. Additionally, Mrs. Garvey became a trustee on the Board of Directors of Friends University and was chosen to serve as a director on the boards of such organizations as the Kansas 4-H Foundation, the Institute of Logopedics, the Wichita Symphony, and the Wichita University Endowment Association.

Olive's involvements broadened as time passed. She became the Kansas representative to the Regional Advisory Council for the Institute of International Education which assisted foreign students desiring to study in the United States, and she was instrumental in the development of the Good Will operation in Wichita, a contributor to the establishment of a Wichita branch of the Urban League, and a supporter of the Music Theatre which

grew out of a movement by James Miller at Friends University to create a summer program in the performing arts. She also was a member of the committee which built the Coliseum and is still a member of its Board.

With a work schedule during the early years of "five to seven hours a day at the office, five, sometimes six, days a week," the scope of Olive's external activities is a source of wonder—how she maintained the pace, summoned the stamina, and kept herself sufficiently informed of the details on each agenda to allow her to perform at the level she always demanded of herself. She expected to shoulder her portion of the responsibilities in each organization she served and was not one to accept an appointment "merely as window dressing."[21]

Thus, the life Mrs. Garvey led after the tragic death of her husband differed only in emphasis from the one she had enjoyed previously. It still was one of total involvement in a range of satisfying activities, both personal and professional, but more and more of the time she normally devoted to maintaining a home was absorbed by business activities. Fortunately, her children now were grown with families of their own, and all were directly involved in the management of the businesses. To free herself from the routine of caring for a house and yard, she searched for a suitable apartment, and finding none available, she decided to build a new highrise complex. At her direction, Builder's Inc., began construction on a luxury apartment building known as Parklane Towers, the first of its kind in Wichita in almost three decades, which was completed in the fall of 1962. Not long after the building was occupied by Mrs. Garvey and others, each of the units was sold to its tenant, thus making Parklane Towers jointly owned by its residents.

In late 1962, Olive reluctantly gave up the lovely home she and Ray had built, and since that time she has made Parklane Towers her residence. It was the last of the "deck clearing" decisions she would make, but there were others of great magnitude yet to follow.

Olive assumed the top leadership role for the Garvey enterprises following her husband's fatal accident.

Robert A. Page, a CPA and graduate of the University of Kansas Law School, was a partner with Elmer Fox & Company before joining the Garvey enterprises in 1960. He now serves as President of Garvey, Inc.

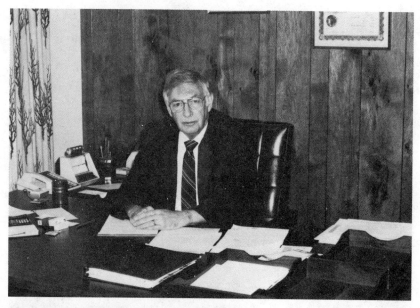

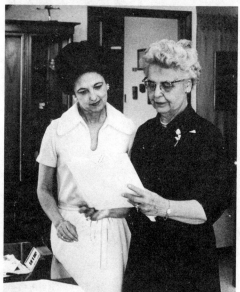

Above: Clifford Allison was a practicing attorney in Wichita before he joined the Garvey enterprises in 1959 just prior to Ray Garvey's death. He now is Executive Vice President of the Garvey Foundation. Left: Mrs. Garvey is ably assisted in office management by Mrs. Edmee Cermak.

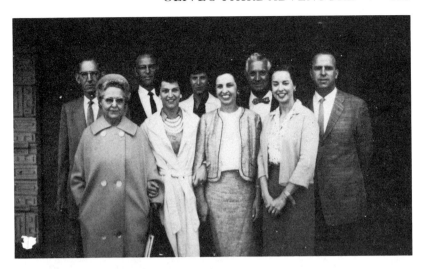

Above: Monthly family council meetings, capped by an annual retreat, were integral to Olive's management philosophy. Pictured at the September, 1961, annual meeting at Colorado Springs are L to R: Olive Garvey, Olivia Garvey Lincoln, Ruth Garvey Fink, Jean Garvey, George Lincoln, James Garvey, Shirley Garvey, Bernerd Fink, Willard Garvey. Left: Annual meetings have continued to the present and combine hard work with periods of relaxation. Here the family gathers around Mrs. Garvey at Lake Tahoe at one of the later meetings.

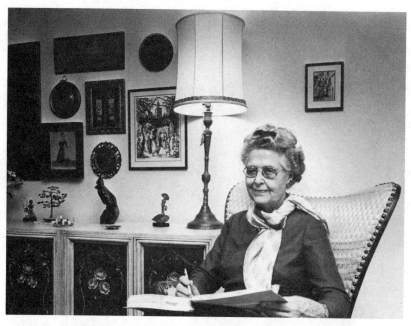

Above: Giving direction to the vast Garvey empire required countless hours of research and preparation, but it has been a happy and fulfilling experience for Olive. Below: The male members of the Garvey management team, L to R: Willard Garvey, George Lincoln, Bernerd Fink, James Garvey, Robert Page. Each holds as a gift from Mrs. Garvey a personal statuette carved by Carl Olander.

Above: Parklane Towers, the high rise condominium structure built at Mrs. Garvey's direction and in which she now resides. Below: Mrs. Garvey on the south balcony of her Parklane Towers condominium overlooking the Parklane Shopping Center, another Garvey project.

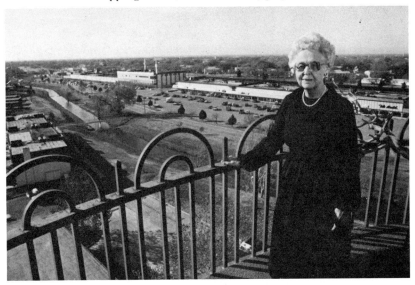

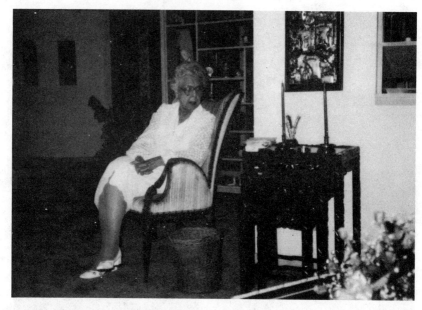

Above: Interior view of the parlor in Mrs. Garvey's spacious condominium showing some of the oriental decor. Left: Birthday parties given by the office staff in Olive's honor have been held annually for the past 25 years, one of which was highlighted with this rendering by cartoonist Charles Schulz.

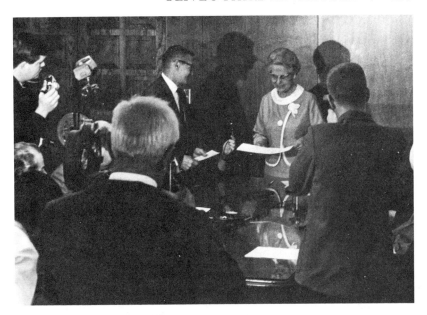

Above: Contract signing for the Urban Renewal lands on which to expand the Garvey Center was conducted with URA officials in the presence of area newsmedia. Below: Dedication ceremonies on July 14, 1971, for the Kiva, the attractive rotunda done in Native American motif which connects the various components of the Garvey Center.

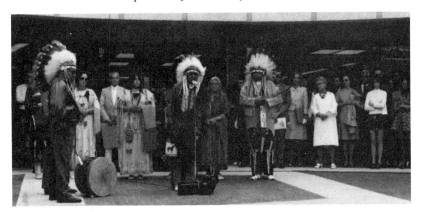

The Garvey Center connects across Douglas Avenue with Century II, Wichita's civic center/city park complex located along the east bank of the Arkansas River. The U-shaped Kiva (center) joins the three highrise structures.

8

POSITIONING FOR THE FUTURE

*If we had no winter, the spring would not be so pleasant;
if we did not sometimes taste of adversity, prosperity
would not be so welcome.*
 Anne Bradstreet (1664)

Settling the tax case, closing Ray's estate, and getting the massive grain elevator debt under control were significant achievements for a short span of three years, given their complexities and obvious interrelatedness. As long as these problems existed, a spirit of extraordinary unity prevailed within the family in seeking the best decision on every issue and seeing that it was executed as planned, but once the tax issue was settled, the two other related matters moved toward resolution "within a miraculously short time," thus opening the door to another major problem of perhaps even greater significance to the future of the Garvey enterprises.

Again, the source of the problem was a by-product of Ray's genius. His practice of spreading ownership in newly acquired properties among members of his family was a brilliant arrangement inasmuch as Ray achieved important objectives without surrendering operating control, and the plan worked well for a person of his wisdom and personality. By the time of his death, he had made more than ample provisions for the security of his family, each of them holding portfolios which included not only individual but also some common ownership of farmland, real estate (both residential and commercial), grain elevators, and oil leases.

Still, a large portion of the Garvey properties was retained by Ray, and he had given little thought to the eventual division of

169

them prior to the automobile accident at McPherson. In fact, in his discussions with Page, he had given consideration only to estate planning, for he held the belief that the strength in his enterprises rested upon their continued consolidation, albeit with diffused operational responsibility.[1]

Grain storage, at the time, was the chief cash generator among the various enterprises, and the implementation of Ray's plan already was in place and proceeding well. Procedurally, assigning the principal responsibility for the major centers was simple enough, but there were conditions which made their orderly operation more difficult than was at first envisioned.

Simply stated, there were more properties in the Garvey inventory than just the elevators, and early efforts to apportion the responsibility for the other assets met with lively debate. Moreover, common ownership in some of these properties existed before Ray's death, and additional shares had been gained through the settlement of his estate. Thus, each of the children, understandably, had a special interest in the ultimate apportionment.

Even as the earlier problems were being resolved, Mrs. Garvey was aware of the conflicts arising from common ownership of operations whose management was the responsibility of one member, for all of the members were serving on each board with full rights to criticism and suggestions of management decisions. At times, their business discussions were strained, and Olive was obliged to make difficult choices between the options which surfaced. For example, all of them owned lands which were operated by Garvey Farms under James' direction, and oftentimes hours were spent at council meetings in debating on matters relating to that operation. When consensus could not be reached, Olive supplied the decisions, and because of their total respect for her, everyone accepted her judgment as final. Nonetheless, council meetings frequently were tense and, viewed realistically, had the potential to destroy the close family relationship the Garveys always have enjoyed.

Little wonder that Mrs. Garvey often has been referred to as the glue which held everything together. As Bob Page has said reflectively, "Through those early years, she was a very strong

leader, completely in charge and always as firm as she felt each situation demanded—but fair and unemotional in every decision she made. She was a model board chairman who had the ability to view everything in long range terms but who sometimes had to function also as the sergeant-at-arms. The children loved her and respected her judgment, and she always regarded whatever sibling rivalry there was as having a positive effect on the outcome of every issue they debated."

The businesses thrived under her leadership, and at no time were their personal relationships affected, despite the frequent strenuous arguments. All of them emerged from the meetings arm-in-arm and ready to have a quiet dinner together—the same happy attitude which always has characterized the Garvey family. Olive was too wise, however, to allow the situation to remain indefinitely as it was, and she took action to remove some of the sources of tension. Knowing that the children at the time were more concerned with operations than ownership, she decided to isolate the authority for each of the units by delegating sole responsibility to the family member assigned to manage it.

In her mind, however, it would be only an interim step. Viewing the matter long range, she recognized that the only way the specter of recurring conflicts could be removed would be to eliminate common ownership, a goal she established despite the fact that she knew it could not be accomplished easily or quickly. Utilizing Page's expertise in such matters, she gave him the responsibility of achieving it. He consolidated all of the Garvey enterprises in 1966 under a new corporate name, Garvey Inc., with Olive serving as chairman of the board, Bob Page as president, and the children as directors. Four first-tier subsidiary companies also were formed with each of the four family groups having responsibility for one of them. They then moved on to the more important issue of eliminating common ownership.

Grain being the largest cash producer, it was logical that discussions initially focussed on grain storage facilities. Because it was difficult to arrive at an equitable value of ownership shares in the various facilities, the Garvey accounting staff spent countless hours over many months in an attempt to establish a basis for a *quid pro quo* exchange. Still, no early blueprint emerged.

Not that such a final plan would be the end of it, for they still faced the problem of obtaining approval of the IRS on the restructured portfolios.

The family council meetings (which by the mid-1960s were being held quarterly rather than monthly) always devoted some time to discussing the matter, and each of the shareholders rigorously debated the appropriateness of every solution proffered. Again Mrs. Garvey was the adhesive which kept everything in perspective. Although she did not seek to limit the discussions unnecessarily, her presence and guiding hand had a stabilizing influence on the ardor of the deliberations, especially after the scope of the property exchanges was broadened to include all commonly held properties except the Garvey Center.

For almost five years, deliberations on the trading of individually owned properties produced no suitable resolution because of differing evaluations of the various holdings. However, it was Bob Page's turn to become a catalyst, and the solution he conceived, significant though it became, arose almost matter-of-factly from an annual routine he followed in reviewing estate tax considerations for each of the family groups.

His chief concern always had been the amount of cash the family could afford to pay in inheritance taxes without disrupting business. While aboard a commercial airliner returning to Wichita one day, he began his routine by approximating the death taxes and thus the possible business contraction which would occur upon the premature demise of Mrs. Garvey or any of her children, something he had done many times. With significantly increasing values, the potential contraction appeared excessive. He then began to make a list of assets not subject to tax at the time of death with a view of potentially converting taxable to nontaxable assets. He first wrote down life insurance, then annuities—and a novel idea struck him: why not annuitize the holdings of the family groups by having them sell their assets to the family companies? Such private annuities would then be based on the actuarial tables of the owners. Mrs. Garvey immediately was impressed with the idea and recommended its consideration by the other family members.

The benefits easily were recognizable. Inasmuch as the trans-

fer of assets was a sales transaction and not a gift, it required no transmission tax and resulted in the creation of what amounted to a standard, single-premium-payment annuity contract, the return on which would be equal to the value of the assets surrendered. Moreover, by vesting asset ownership in the companies, their corporate life could be projected indefinitely by entrusting them in future years to the tender care of professional managers unencumbered by emotional considerations. Even more important, individual judgment would be removed as a factor in determining the value of various assets, inasmuch as each seller would receive precisely 100% of the value of what he or she surrendered.

Although Bob did not anticipate the speed with which the plan was adopted, Mrs. Garvey and the four children promptly endorsed it, and within 90 days, it was done. With values established, property trading became much easier, and Garvey, Inc., thereafter served as a conduit through which many transactions were completed. Finally in 1972, details were completed for a restructuring of all assets in an arrangement which, in effect, inverted the 1966 framework which had provided for Garvey, Inc., and its four subsidiaries. Under the new organization, four separate and independent corporations were created, each headed by one of the family groups. Garvey, Inc., thereafter became a 25% subsidiary of each of the children's companies.

Bob then finalized his recommendations on what he regarded as an appropriate settlement and circulated a draft of it to the family members. Shortly thereafter at a council meeting, Bob's recommendations were put in the form of a motion which was seconded and approved in less than a minute.

Thus, the elimination of common ownership had been achieved after years of trial and effort, but Mrs. Garvey counts it all as gain, believing that only by overcoming difficulties can one fully appreciate achievements. Although Garvey, Inc., no longer serves as the parent company, it continues to provide some services to the four corporations through SRI on a cost-sharing arrangement, such as tax and audit functions, transportation, and securities management. All legal and data-processing functions as well as grain inspection subsequently were provided by the in-

dividual corporations, as have been the training and staffing of their accounting divisions. Garvey, Inc., for which Mrs. Garvey still serves as chairman and Page as president, presently owns the Garvey Center and SRI along with considerable oil properties and other passive investments.

It would be incorrect to assume that finding solutions to the major problems was the only way Mrs. Garvey served the Garvey enterprises. There also was the matter of "business as ususal," and as the larger issues were being resolved, she provided adept leadership in overall direction for the scattered empire. Three other decisions she reached in the early 1960s added significant dimensions to her experiences as well as growth to the businesses, all of which clearly indicated that she was not engaged in holding-action management. For example, the organization of the Parklane National Bank in 1962, the development of which was entrusted to James Clinger, became another successful commercial venture, and Olive's service on the bank's board of directors broadened her knowledge of the financial world and added to her increasing involvement.[2]

A few months later, an opportunity arose to sell the C-G-F elevator in Topeka for almost as much as the entire complex of Garvey grain storage facilities had cost initially. The resulting contract was attractive in many ways: C-G-F continued its operational control over the elevator; options were secured for buying stock in the purchasing company; a substantial down payment provided money for expansion; the balance of payments was spread over a number of years, thus assuring an even greater return because of added interest; and the Garveys were asked to supply a director on the board of the purchasing company.

The venture was significant in another important but unexpected way. It was the first and only departure from a family tradition of entering into business opportunities with less than a majority stockholder's position. Not long after the stock options were exercised, the purchasers suffered serious difficulties, and the Garvey family faced the choice of considering a takeover of the company or of divesting the shares held. The latter alternative was chosen despite a small financial loss and a substantial

diversion of management talent, but Olive counted it as a tolerable, if expensive, educational experience. "It confirmed our faith," she has said, "in the desirability of private business as opposed to public offering."[3]

Notable also during the early 1960s was the decision to construct the R.H. Garvey Building, the first of several buildings which eventually would comprise the present Garvey Center. The main offices at 352 North Broadway had reached their physical limits, and after lengthy discussions, a new office tower was perceived as the best solution to the Garveys' needs. The site selected and purchased was a half block on West Douglas owned by the Missouri-Pacific Railroad which previously had served as the depot for its discontinued passenger service. The location was made even more attractive because the City of Wichita had authorized bonds for the construction of a new auditorium/city park complex on lands just across Douglas Street and facing the east bank of the Arkansas River.[4]

The new structure was designed by S.S. Platt & Associates to accommodate the Garvey's needs and included six additional floors of speculative office-rental space. Opened in May of 1966, the building rapidly filled with new tenants, thanks to the efforts of Jim Clinger, and many others had to be turned away—but only temporarily. Plans were developed almost immediately for the construction of a second office tower east of the R.H. Garvey Building on lands then held by the Urban Renewal Agency, the buildings on which already had been demolished and the property put out for bids. The public offering attracted only two bid proposals, one by the Garveys and another from a New Orleans businessman whose concept of a luxury hotel with "an exotic rotunda" won the approval of the URA.

However, the year's deadline for compliance passed without activity, after which the URA cancelled its initial award and inquired of Mrs. Garvey if she would like to resubmit her proposal. She did so in spite of the costly delay, and plans for the development of the property moved rapidly, including the leasing of a portion of it to Holiday Inns for the construction of a highrise hotel. Within two and a half years, a beautifully coordinated complex of buildings, known as The Garvey Center, was com-

pleted around an attractive Kiva done in Native American or Indian motif. Thereafter, three new multi-story structures graced the Wichita skyline: the original R.H. Garvey Building; the Holiday Inn; and a second office tower which was named the Olive Garvey Building. Also, Page Court (a smaller professional office building), the Fox Garvey Theater, and an enormous parking garage were added to accommodate other needs.

The project was Olive at her best, but there is a little-known anecdote to its success. Shortly after the URA accepted the Garvey proposal, Olive embarked on a European trip. Upon her return, she found that construction had been delayed by an inability to obtain financing. Bob Page had surveyed all potential sources in an extremely tight and expensive loan market and had been forced to mark time until the pressures eased. However, after reviewing the matter, Mrs. Garvey informed him that he had not exhausted *all* his possibilities: "You haven't asked me."[5]

Through a personal loan arrangement, Olive provided the interim financing for the development of the second office building. In retrospect, it was one of her more important decisions. No doubt she was motivated by her commitments to URA and the announced project, but she also was aware of inflationary economic trends, the future prospects for which were no better than they were then. "And, she was just as right as rain," Page reflects, "for construction costs soared out of sight shortly after the complex was completed. Had it not been for her push and willingness to put up her own money, we might not have the Center as we presently know it."

If others are unaware of this fact, the reason is to be found in Olive Garvey's character and style of doing things. Ruth Fink remarked on the eve of the start of the Garvey Center's final stages, "Mother is a woman of tremendous energy and endurance, and she is not a procrastinator. She does what she sets out to do in the quietest, most efficient manner. She doesn't waste time talking about what she does before or after." The results have been Wichita's gain. When completed a full two years ahead of schedule in June of 1971, the Garvey Center complemented the city's new civic center (Century II) and adjoining river front

park area, and helped transform downtown Wichita into a most attractive urban area.[6]

Just as this new dimension was being added to the Garvey businesses, an older one was being phased downward. In 1971 and again in 1972, the Garveys offered to sell in private transactions and public auctions a total of 70,000 of the approximately 120,000 acres of wheat and ranch lands they owned in western Kansas and eastern Colorado. Several factors motivated the divestiture. Much of the land was owned jointly and thus had become a part of the effort to eliminate all commonly held properties and convert their value into separate annuity contracts. However, selling these assets to a corporation posed a special problem in that there was a Kansas statutory provision prohibiting corporate farming.

One factor was paramount: the money derived either from farming the lands or from their sale was vital to the implementation of the plan to annuitize all assets. Thus, the decision to sell the lands outright was made not only to lessen the complications of land management but also to obtain sufficient cash to handle the annuity payments. All of the family except James sold substantially everything they owned, James retaining approximately 40,000 acres which subsequently were reorganized and operated, in partnership with Chuck Fulton of Colby, as the Garvey Farms Management Company.[7]

The strength of Olive's character was at test in this decision, for the farmlands, which had been in the family for so long, had played an important role in the early development of the Garvey enterprises and reflected many happy memories in her life with Ray. Nevertheless, she understood the need and saw no other solution. Her lands were included in the sale.

It stands as a testimonial to her leadership that Olive has not encountered an unresolvable problem, and it was not until the annuity program was implemented and separate corporations formed that any of the Garvey business entities faced a crisis of threatening proportions. However in 1973, one of the four new companies suddenly found itself with a significant bank debt and massive losses, the result of poor judgment on the part of an employee who had been given a second chance during Ray's lifetime. The matter was further compounded by the subsequent

failure of his superior to admit the serious condition facing the firm. When the dilemma finally was discovered by the owners, the multi-million dollar firm was hovering near bankruptcy, and the operating personnel were totally traumatized with indecisiveness.[8]

Mrs. Garvey directed Bob Page to compile all the facts and prepare a list of alternatives for coping with the crisis. The banks, he found, were adamant and demanding payment; thus, the immediate solution became either that of raising working capital by selling some corporate assets or of allowing the company to declare itself bankrupt which would not, under corporate law, jeopardize the private wealth of the owners. When Page reported his findings and presented the two options to Mrs. Garvey, she summarily dismissed the latter choice, stating that "such an alternative is totally unsatisfactory with me." To her, it was a type of moral obligation; a Garvey company could not be allowed to fail when the family had the private resources to prevent it.

Thus, she offered a substantial loan, and each of the stockholders involved joined her. The immediate cash flow necessities thus raised, Bob returned to the bankers and asked for an extension of time "to operate out of the problem" and for a deferral of interest payments. Because of the Garvey reputation for paying its debts and Page's rapport with the financial community, the banks granted the extension. Within six months, the company was on its feet and the debt again manageable, and even today, few individuals other than those directly involved in the crisis are aware of the threatened collapse because the company suffered no interruption in operations and presently returned to a very strong financial position.[9]

Students of business as well as erstwhile management trainees can find a significant message in Mrs. Garvey's ethical standards, a topic on which social analysts of the contemporary marketplace have begun to focus increasingly. It is obvious that she feels the opportunity to share in the rewards of business imposes serious obligations on all participants, and that economic morality derives from basic character and personal integrity—in short, the will to do what is right without regard for the consequences. The only meaningful rewards are those arrived at honestly and hon-

orably, the only lasting satisfactions in overcoming difficulties without violating conscience.

Nowhere are these attributes more in evidence than in the decision she reached recently to close the Fox Garvey Theater. Envisioned for family-type movie entertainment, the Theater in recent years followed the growing trend of presenting programs which have questionable social value. Although the lease provided a substantial income and had years yet to run, she asked Bob Page to negotiate with the leaseholders for its early termination because fiscal considerations were less important to her than matters of personal conscience. She then sought to find other uses for the building and, discovering none suitable, directed that it be razed and the land converted to additional, and much needed, downtown parking spaces.[10]

Throughout the years of her leadership, Olive's personal code of ethics has remained uniformly consistent with her managerial philosophies. "Sometimes," she reflects, "there is nothing to do but to make a change. Some situations are obvious, others not so easily recognizable, but they must be identified and handled promptly and unemotionally. For example, the hardest task any executive has to face is to terminate or demote a faithful employee who is incapable of handling his responsibilities. Yet, to continue his tenure jeopardizes not only the stability of the business but also the jobs of other employees who are dependent upon it. Successful business managers cannot afford to shelter incompetence, and young men and women who aspire to leadership roles must be prepared to make these important personnel decisions, distasteful though they unquestionably are."[11]

Not until the last of the major issues was completed—the elimination of common ownership—did she reduce the number of office hours she kept, but by then she had relinquished to family members most of the responsibility for the various companies. After the division was made, the quarterly family council meetings were discontinued, being replaced by board meetings for the individual corporations.

Each year, however, the family, with Bob Page in attendance, holds an annual meeting where a full agenda of Garvey activities is discussed and appropriate actions taken. There are not fewer

problems, but communications have been markedly improved. Frequent telephonic visits are held, and the Weekly Reports which Olive initiated in 1960 still are compiled by each of the families and sent to Wichita where they are consolidated and returned as a means of providing updated information on all current operations.

Even after her objective was achieved, Olive still remained a shareholder in her children's companies and continued for a time to serve as a director on each of their boards; however, she eventually relinquished her directorships and quietly set about to divest her holdings in all the family corporations, systematically passing along some of her stock in succeeding years to third and fourth generation Garveys. From a tax standpoint, it has been a remarkable achievement, for she has been able to accomplish this goal with a minimum of tax liens. The last of her remaining shares was given to her grandchildren in fiscal 1984, and the value of her gifts to the recipients easily is double what it would have been after inheritance taxes.[12]

Even with this gift program as well as the overall division of Garvey properties with her children, Mrs. Garvey still must be assessed as a person of considerable affluence, although she disdains even the mention of the subject. "Before we begin," she once told an interviewer seeking to write a feature story on her family, "please don't refer to me as wealthy. And don't emphasize our [family's] money. The public believes we only work for money. That's not true. It's only the result of what we do." All too frequently overlooked, she feels, is the fact that the profits they make and spend in the various business endeavors pay the salaries of thousands of employees, create new jobs, provide loans for private homes, construct buildings, operate grain elevators, discover and produce oil—all of which provide stimuli to the economy.[13]

The profits earned, she continues, also pay taxes which support government at every level, provide funding for a host of social services, and enhance countless educational and eleemosynary institutions through private gifts. Lest the point not yet be clear, Mrs. Garvey concludes, such is the essence of the free enterprise system, and economic incentive (the freedom and op-

portunity to risk capital for the sake of profit) is what makes it run.[14]

By the late 1970s, Olive's business goals were comfortably in hand. She had done her work well—as since have her children and children-in-law. As the decade closed, it was reported that Ruth and Bernerd Fink owned the C-G-F Grain Company in Topeka as well as Midwest Industries, an investment company. Willard and Jean Garvey were listed as the owners of Garvey Industries, Builders Inc., Petroleum Inc., Amortibanc Investment Co., Nevada First Corp., Garvey Grain, and Garvey International, all headquartered in Wichita. James and Shirley Garvey were reported as having Garvey Elevators, Garvey Farms, Service Oil Co., Rafter J Ranches, and JaGee Inc., all centered in Fort Worth. And Olivia and George Lincoln were shown to hold Lincoln Industries, Lincoln Grain, The 25 Corp., and the Nebraska Book Co., with corporate offices in Lincoln, Nebraska. All of them have since continued to be aggressive in searching for new investment opportunities.[15]

Although each of the Garveys now "runs his or her own businesses separately," family ties remain strong. Such stability speaks well of Olive and her efforts since 1959. Her older son Willard, perhaps consciously paraphrasing Winston Churchill, put it best when he said, "Never have so many people owed so much to one person. She has been a pillar for all of us to lean on." Moreover, their successes since the division have confirmed her faith in their abilities.[16]

Because the assets of each family are privately held, they are exempt from public disclosure, but newsmedia estimates place the value of the combined assets of all Garvey family enterprises at well past the half billion dollar mark. Such estimates are meaningless and sometimes produce annoyed asides from the various family members, inasmuch as it is not their practice to compile and compare individual or collective assets. They simply are aggressive, individual businessmen and women who are competing only against their own goals, and not with each other. They rejoice at each other's successes but offer counsel only when invited to do so, the only unsolicited counseling prerogative being left to Olive who seldom exercises it. The practice has been re-

markably effective, as have been the performances of the individual owners, for in the mid-1980s the value of any one of the four major Garvey business entities may well be worth several times more than the estate Ray Garvey left in 1959.[17]

Although she is universally applauded for her accomplishments in the business world, some still marvel at them, but only because she has gone about her work unassumingly and with a reluctance to dwell publicly on the reasons for her success. Yet, those who have been close to her know them only too well, for throughout her years as Chairman, she has met business challenges as she encountered them—face to face with her motor revved, full of optimism and faith, and armed with an arsenal of rare talents which she has cultivated since youth including, among many others, a penetrating insight that allows her to identify the source of a problem, the wisdom to conclude what must be done about it, and an unwavering determination to pursue it until accomplished.

Perhaps Bob Page, her closest business associate since 1960, has best summarized her talents.[18] "We all love her for being genuinely honest and sensitive. She is a soft-spoken, mild-mannered, and compassionate individual who just happens to be one of the strongest, toughest, most knowledgeable and perceptive business executives I have ever met. She always gets to the heart of things quickly, then deals directly, fairly, resolutely, and with finality—with no wasted motion. There is absolutely nothing false or misleading about her; she is a person of commanding presence and genteel stature who inspires great respect, trust, and loyalty. I would walk the plank for her."

9

OLIVE IN RECENT YEARS

It is not enough merely to exist. You must do something more.
Seek always to do some good, somewhere.

Albert Schweitzer (1949)

In 1979, Olive Garvey at age 86 received a watch commemo-
rating the completion of 20 years of active service to the Garvey
enterprises. The number more appropriately might have been
40 or even 50 years in terms of continuous service of one type
or another, but she cherishes the recognition accorded her be-
cause she earned it like all Garvey employees do—as John Hou-
seman would say, "the old fashioned way"—through hard work
and under normal company policy. For one of her values, there
is no other way she could have accepted it. "That's just how Mother
is," Olivia Garvey Lincoln has said.[1]

The image and refection of the values Mrs. Garvey has por-
trayed throughout her long life have remained constant and un-
changed. Even though she no doubt has passed the chronological
point in her life where she would be either helped or hindered
by comments others might make, there remains today not even
the hint of a negative assessment about any personal behavior
or professional activity. When one prominent Wichitan heard
she had suggested, "If you want to know what I'm really like, talk
to someone who doesn't like me," he reacted in disbelief and re-
marked, "Well, I don't know who that would be. I don't know of
anyone who doesn't have the highest respect for her, both as a
private citizen and corporate executive."[2]

Although friends and business associates know her in differ-
ent ways, they universally assess Olive White Garvey as a woman
of high integrity, accomplishment, and happiness—and as one

183

who cherishes heritage and family. She is regarded as her own person; as one who makes up her own mind in all matters whether personal or professional; as one who loves her children, their children, and their children's children; and as one who always has a smile on her face, a smile so genuine that Cliff Allison believes it originates in her soul.[3]

She is not viewed as a women's liberationist (because she avows she is not), or as a champion of causes (other than private enterprise, of which she is an outspoken supporter), or as a conspicuous consumer (something she has avoided even from her childhood).[4] She is known to be politically conservative, as one "who cherishes and honors the first 10 amendments to the constitution." In 1971, she was one of several members of the Republican Party who formed the first "professional organization" in Sedgwick County which sought "to strengthen all the wards and precinct people" in an effort to promote greater party unity. The new Sedgwick County GOP group named her to serve in 1971-72 as chairman of a "broad based" finance committee.[5]

Mrs. Garvey always has been regarded as a religious person; however, she prefers the term "faith" to "religion," believing that the latter "connotes formalization which has caused separations, persecutions, and wars." Her philosophies on this subject were expressed candidly in a guest editorial she wrote for the *Wichita Beacon* in 1965:[6]

> My faith is simple. I believe that an omnipresent spirit with an omniscient intelligence created all things; that this spirit dwells deep in every person—"closer than hands and feet"; that it is the choice of each individual if he acknowledges this spirit, cultivates it, consults it, and heeds it; [and] that the degree to which he does these, determines his strength, judgment, attitudes, value to humanity and satisfaction as a person.
>
> It is often ignored that God, even in primitive form, served men for eons before the birth of Christ, and still is the center of the surviving forms. I believe Jesus brought a new and improved interpretation of the laws of God, which we who know them should heed.
>
> In this troubled age it seems to be the universal effort to solve problems en masse. Masses are composed of individuals. I be-

lieve the problems will never be solved until the individuals accept the values—"rebirth"—and follow the dictates of the inner voice.

As previously noted, Mrs. Garvey has resided since the fall of 1962 in Parklane Towers, a Garvey project constructed by Builders, Inc. Olive has retained her tenth-floor apartment because it overlooks yet another Garvey project, the Parklane Shopping Center and, as she has said, "because you can see so much farther"—which undoubtedly is a reference to the view she has of the half-mile-long grain elevator her husband built ten miles southwest of the city.[7]

She has decorated the spacious apartment in an oriental decor and filled it with numerous Chinese and Japanese statuettes and artifacts, many of which were collected during her travels. Some of the furniture dates to the years she shared with her husband. Balconies on two sides, west and south, afford the convenience of refreshing morning breakfasts on shaded patios and a relaxing evening view of the breathtaking High Plains sunsets which engulf the southwestern Kansas horizon—and which have such deep significance to her younger son, James.

A modest assortment of gymnastic equipment provides the means for a controlled program of exercising, and a small library/den area serves as an office as well as a reading room. Framed pictures, thoughtfully spaced, reflect both her taste in art and the respect she has for family and heritage. The overall arrangement motif is one of comfort and convenience for a person who obviously is happy with her life and world—and who enjoys the privacy of a well-secured sanctuary.

As the years progressed, and especially after ownership of the Garvey enterprises was divided among her children, Olive finally found more time to travel, to play a little more bridge, to share a few more activities in her clubs, and to become a weekend painter. She also found time along the way for another long-delayed dream—that of writing a book. That dream is graphically featured on the first page of a scrapbook Olive has kept covering the years from her birth through 1967. A single-panel cartoon, drawn by Franklin Folger and labeled by Olive as "the

story of my life,"pictures a woman in a bookstore and carries the lament: "I've often wanted to run away to some quiet retreat and write a book, but somebody's always putting me on another committee."[8]

Starting in 1968, Olive took the time, without neglecting any of her business or civic responsibilities, to compile, write, and publish with Virgil Quinlisk's assistance, a book entitled, *The Obstacle Race: The Story of Ray Hugh Garvey*. Released in 1970, the book tells the story of her husband's path to success, and of his "drive, foresight, and enterprise not only in business but also in his philanthropies." She wrote it not only as a tribute to Ray's achievements and for her own personal fulfillment—but also, as her older daughter surmises, in the hope that "her grandchildren would know what kind of man their grandfather was."[9]

She also authored a second book in 1977 entitled, *Produce or Starve?* a hard-hitting polemic which mirrors her deep concern for the decline of values and basic freedoms in America. With a look over her shoulder at her heritage, education, and experience, Olive gave her observations and opinions about a host of issues ranging from parental permissiveness, to religious skepticism, to weakening educational standards, and to the widespread ignorance of America's fundamental economic history. She did so, as one reviewer wrote, in the hope of setting "us back on the road to dignified liberty—responsible, practical liberty nurtured by the free enterprise system." And he concluded: "She believes that America lost its way when the basic law of economics was forgotten: produce or starve."[10]

Another reviewer observed, *"Produce or Starve?* is not an easy book to read. Not that it is too complicated to understand. It's the understanding that is painful. It pulls no punches in placing the burden of guilt on society for individually and collectively contributing to the self-destruct condition of family life and the world today." Almost lost to the reader however, because of the intellectual gymnastics they facilitate, are the author's skillful word selection and effective, readable writing style.[11]

Book writing has been a new and challenging medium for one whose previous efforts had been in playwriting and poetry, but she ventured yet a third volume in 1980 entitled *Once Upon a*

Family Tree, an account of "my knowledge of our family to the year 1980,"which she dedicated to "all of my descendants in perpetuity." Using her life story as a narrative, she combines expository and descriptive techniques to identify the roots of her heritage, to express the love she has for her family, and to convey her feelings of concern about changing customs and mores. It is Olive Garvey—youngster, schoolgirl, teacher, wife, mother, businesswoman, sage—at her literary best.[12]

Along with the visibility she has received as an author and as a highly successful business executive, Olive has drawn much recognition for her philanthropy, especially in recent years. In her efforts to be a good steward of the resources she has accumulated, she has sought, in Schweitzer's words, "to do some good, somewhere." Mrs. Garvey has devoted an increasing amount of her time to assessing needs and allocating funds to worthwhile causes.[13]

That practice, however, is not new either for her or the Garvey family, although it was not until the late 1940s that incomes for the various Garvey enterprises became large enough to provide much charitable giving other than a few projects done through Builders, Inc. Under Willard's guidance, the Hutcherson Branch of the YMCA at North Cleveland was built at cost, as was the Mary Talbott Branch of the YWCA on North Water for which Olive and her daughters contributed more than half the costs. Willard also helped the Institute of Logopedics secure a loan under a government program and constructed its physical facilities at cost. Additionally, the Garvey family gave Washburn College an area of four-plexes which later funded the Garvey Competitive Scholarship program.[14]

Charitable giving increased as the businesses grew. In 1949, Ray and Olive formed the Garvey Foundation as a vehicle to receive such family contributions as were allowed under current tax laws, the purpose being to permit the funds to bear interest for growth and to provide a more orderly method of handling gift requests and disbursements. The principal focus, as stated in the corporation charter, would be directed toward educational, religious, and cultural activities. By policy, the Garveys have sought to support programs in localities where they have

business interests or those projects of particular interest to the individual members of the family, especially those which they feel are productive in areas valuable to the future and which have multiplying and on-going usefulness, such as in the training of tomorrow's leaders.

The original contributions to the Foundation were modest but have grown as income increased. As previously detailed, a considerable percentage of the R.H. Garvey Estate was left to the Foundation, and the several prescribed obligations he stipulated made the management of the fund virtually a fulltime responsibility. Then, after the businesses were separated in 1972, the contributions of the various family members were returned to four individual foundations which the children established in connection with their own businesses. Since that time, each unit has made its separate donations according to its own scope of interests. The number and combined value of the gifts and pledges made by the Garvey family through the years have been staggering.[15]

Mrs. Garvey gives thoughtful consideration and direction to the activities of the Garvey Foundation and the Olive W. Garvey Charitable Trusts. With the assistance of Clifford Allison, Executive Vice President of the Garvey Foundation, a thorough job is done in investigating and evaluating the proposals submitted, but once the facts have been assembled and appropriate deliberations are held, Olive normally makes a decision based on the petition's and petitioner's compatibility with her goals, worthiness of the project, evidence of need, and availability of funds. She is not one to prolong the process; in fact, at times the turnaround time can be suprisingly brief.[16]

Allison cites as a case in point a fund request he had researched which had been made by the late Dr. Harold Sponberg, then President of Washburn University. After an interview with Mrs. Garvey which lasted not more than 30 minutes, Sponberg was excused and told that a decision soon would be forthcoming. Because of the brevity of the interview, Sponberg became uneasy about the effectiveness of his presentation, and as he was preparing to leave Wichita that afternoon, he made a last minute telephone call to Cliff seeking some reassurance. "He was utterly

flabbergasted,"Allison recalls, "when I told him that Mrs. Garvey already had decided to honor his grant proposal and that he would be receiving verification in a day or two."

Any attempt to develop a complete listing of the schools, colleges, churches, medical research projects, hospitals, social and cultural agencies, libraries, charities, institutes, patriotic and historical foundations, and the special group of youth-related activities which have been honored by her generosity would prove futile, for it is doubtful that such a compilation could be made without the embarrassing omission of numerous recipients. Some, however, deserve mention because of their special meaning to Olive and because they have insisted upon honoring her when she did not seek or anticipate recognition for the assistance she has given.[17]

Washburn University, which designated both Ray and Olive Garvey as distinguished alumni and awarded them honorary doctorates, has received numerous gifts, among which are: the Elliot Hill White Auditorium in the Garvey Fine Arts Building; the challenge gift for the Women's Athletic Building; the Garvey Competitive Scholarship Fund; the formation of an educational television station KTWU Channel 11 in Topeka; the Free Enterprise Institute which held seminars for teachers and preachers all over Kansas and later became the Kansas Council for Economic Education; and the seed money for the publication of the *Washburn College Bible*, a special project which will be discussed in later detail.[18]

Other colleges and universities also have been aided. Friends University in Wichita has received considerable monetary support in addition to other significant gifts, including the Garvey Center for Athletics and Art; the Alexander Auditorium in the Fine Arts Building; and assistance in the establishment of KSOF radio station. Mrs. Garvey also was a principal donor to Oklahoma Christian College's Enterprise Square, USA, as well as to its Garvey Fine Arts and American Citizenship centers. Both institutions have recognized the significance of her contributions to their programs by awarding her honorary doctorates.

Important donations also have been made to the Wichita State University Endowment Association for the construction of a lab-

oratory facility; to Kansas State University for a significant scientific research project; to Colby Community College in erecting a Fine Arts Building and the endowment of Teacher Benefit and Student Loan funds; and to Fort Hays State University for the relocation of the Wabunsee County Country School.

Washburn owes much to Mrs. Garvey as well as other members of her family who have made sizable gifts for various purposes through the years. Olive and Ruth have served on the College's Board of Trustees. And after a tornado in 1966 which almost demolished several of the buildings on campus, serious questions arose in many minds as to whether the University would survive the disaster until the Garvey family made a challenge gift which led to a fund for the restoration of the buildings as well as normal campus life.[19]

Institutional heads praise Mrs. Garvey's generosity. President Richard Felix of Friends University is candid in assessing the effects of her assistance to his institution. "We were in very difficult financial circumstances in the mid-1970s, with a large debt and little likelihood of retiring it until she became involved in helping us in a special fund-raising campaign." With the assistance of other members of the Board, the debt first was underwritten, and they then joined together to make a schedule for paying it off entirely. Once accomplished, Mrs. Garvey chaired a subsequent drive to create an endowment to help stabilize the institution's finances during the period of rising inflation in the late 1970s.[20]

Since that time, Olive's generosity has been felt many times, not in gifts alone but also through her service on the University's Board of Directors. She served as Board Chairman from 1974 to 1976 and has been elected Honorary Chairman each year thereafter. It is likely that some of Mrs. Garvey's interest stems from her Quaker heritage inasmuch as the institution was founded by the Society in 1898; even more likely, it results, as Dr. Felix notes, "because she feels our mission and her values are on common grounds. But whatever the reason, she has been a precious resource by demonstrating a determination to assist us with our needs for the present as well as to help us chart a course toward

financial independence for the future. I really don't know where Friends University would be without her."[21]

Another of her long associations with a private institution has been with Oklahoma Christian College, an association which began in the late 1950s when Olive helped Chancellor James Baird of OCC secure sponsors for the Free Enterprise Forum which was under the general directorship of President George Benson of Harding College. From the initial contact with Baird, whom she came to regard as a man of strong Christian character, she took note of his institution and became impressed with its efforts to provide students with an education based on values consistent with her own.

Over time, additional contacts with Mrs. Garvey were made by both Chancellor Baird and OCC's President Terry Johnson. Two substantial contributions followed, one to a fine arts center which bears Olive's name and an even larger one to a multi-million dollar building project known as Enterprise Square which combines educational messages with entertaining exhibits around a free enterprise theme. For many years, she has sponsored the three-day seminar of OCC's American Citizenship Center for outstanding high school juniors which has been held at Friends University in Wichita.

Again, it was the compatibility of values which brought donor and educator together, and as Dr. Johnson has observed, "Mrs. Garvey is planting the seeds for the next generation. She realizes that much of what she is planting will not be harvested in her lifetime, but she has the faith that those seeds ultimately will bear fruit in the minds of young people which will lead them into useful lives based on high human principles and good citizenship."[22]

Such is the manner by which some of the larger recipients have viewed Olive's generosity, and although expressions of praise and gratitude are pleasant to her ears, they have never become opiates. She is, as most observers have noted, a person who makes charitable gifts based on principle, not because she feels compassion for an individual, or because she feels pressured to support a particular program, or because there is a pledge of personal recognition in exchange for a gift. Donations are made from her

heart and without strings. But as might be expected, she has been honored many times in many ways by grateful recipients. A partial listing of them may be found in the Appendix.[23]

Although she cannot, and does not, contribute "to everything that comes along," she always is delighted by the opportunity to lend a helping hand to those who need and deserve it. She and her family were instrumental in the establishment of KTPS Channel 8 (the area public television station) and donated its broadcast tower. Additionally, the lands around the tower were donated to the Wichita Zoo for use as a breeding farm.[24]

The Garveys have a long association with the Kansas 4-H Club. The first permanent cottage at the 4-H Ranch at Rock Springs was contributed before Ray's death, a facility he named "The Asa Payne Cottage" in honor of the developer of the summer-fallow method of wheat raising. Mrs. Garvey has continued her assistance to the organization and still serves on its Board of Directors. Additionally, the Garvey family provided funds for the Garvey Activities Building of the Salvation Army on South Hydraulic as well as the challenge gifts for both the Red Cross and Senior Citizen's building campaigns. Considerable assistance also has been directed toward a number of Indian and Black activities.

Significant also was her inauguration of the Herbert Hoover Essay Contest, sponsored in 1974 by the Herbert Hoover Library Association in honor of Hoover's 100th birthday which invited all young scholars under 30 years of age to submit essays on the subject, "Free Enterprise: An Imperative!" The purpose was to encourage young scholars to research the private enterprise concept and so to understand it. Ten winners were chosen that year, and they not only received cash prizes and had their works published but also were awarded trips to the meeting of the Mont Pelerin Society in Brussels, Belgium. In 1982, this project was reinstated as a Biennial Olive W. Garvey Fellowship Contest under the sponsorship of the Mont Pelerin Society. It attracts many entries, and the winners get good reception and gain distinction.[25]

Subsequent to the Essay Contest, Mrs. Garvey was invited to join the Board of Directors of the Herbert Hoover Presidential Library at West Branch, Iowa, and her four children in 1982

endowed the original presidential library in the facility and dedicated it to Ray and Olive Garvey. Ruth Garvey Fink now is a Director also.

Sometimes she joins with one or more of her children to extend assistance to a worthy cause, and she points with pride to a joint effort with Willard in helping the Institute of Logopedics develop its present facilities in northeast Wichita, assistance which included the challenge gift in its $3 million building fund drive. "Willard did most of it originally," she confides. "He helped them prepare their request for federal funding, constructed most of the buildings at cost through Builders Inc., and since has made annual contributions toward the operational costs of the program." The Institute acknowledges both of them as valued friends and supporters.[26]

A project she shared with Ruth arose from a request made to the Washburn University Trustees by Bradbury Thompson, a Washburn alumnus and distinguished graphic designer who has fashioned 80 United States postage stamps and many books and magazines. Some years earlier Thompson had been commissioned by *Field Enterprises* to design and develop a deluxe version of the *Bible*, a project he accepted with enthusiasm and subsequently spent ten years in selecting classic prints, type face, and paper, and in developing a revolutionary design, format, and style—only to learn in 1973 that after an investment of over a half-million dollars, *Field Enterprises* was abandoning the project because surveys found that a recession indicated that such an expensive volume could not be sold rapidly enough to yield the necessary short term return. Thompson, who was a visiting professor at Yale, first turned unsuccessfully to that university for funding, then presented his request to the Washburn College Board of Trustees who asked Ruth Garvey Fink to chair the committee to explore the matter.[27]

Ruth then discussed it with her mother. "When she first told me about it," Olive said, "I thought, that's nice. But when I went up to see it (the design), I was hooked." Through the special handling of a recent commitment by Olive of $500,000 to Washburn, arrangements were made to divert the amount required for the publication of what was to be called the *Washburn College Bible*,

with the understanding that all profits from its sale would reimburse the College with sufficient funds to return Olive's original gift to its intended purpose. The finished product, published in 1979 and retailing at $2500 (later $3500), was hailed worldwide for its magnificence, not only in design but also in the almost poetic readability of the 14-point type, well-spaced format rendering of the King James Version. Sales were gratifying, and both Olive and Ruth now share the joy of knowing that through their efforts, a masterpiece was preserved and that both a native-Kansas graphic designer and Washburn University received the recognition they deserved.[28]

Important in Olive's mind also is the development of Dr. Hugh Riordan's concept of holistic medicine. She first became interested in the concept that nutrition has an effect on mental disorders when she read George Watson's *Nutrition and Your Mind*, and she began a movement to establish a laboratory in Wichita similar to the one Dr. Watson had at the University of Southern California. Coincidentally, Riordan had begun similar studies which had became heightened by his chance meeting with Dr. Carl Pfeiffer of the Bio-Brain Center in Princeton, New Jersey.

Riordan then invited Pfeiffer to Wichita to discuss the development of such a project and, at someone's suggestion, presented a plan to Mrs. Garvey. Because of her prior interest, she subsequently financed a laboratory, and under Dr. Riordan's direction, that small beginning has evolved into a treatment and research center with many programs, all designed to regard the factors—physical, mental, and spiritual—that govern a person's health as being correlated.

Riordan has achieved gratifying (to some, surprising) results by personalizing the discovery and treatment of body deficiencies which contribute to both physical and mental illness, results which Mrs. Garvey finds sufficiently encouraging to warrant her further encouragement of more systematic research. Beginning in 1980, she has provided sufficient funds to ensure the construction of a new multi-million dollar research and treatment facility whose name suggests its primary purpose and honors it principal donor: The Olive W. Garvey Center for the Improvement of Human Functioning. Dedicated on July 15, 1983, Olive's

90th birthday, the venture is a tribute to a physician with a mission and a philanthropist with compassion—both of whom seek to end as much suffering, and to improve the quality of life for as many people, as is humanly possible.[29]

In almost all of the Garveys' philanthropic activities, there is a persistent theme of considering the needs of Wichita and Kansas where they and their ancestors have lived and worked for more than a century. The combined impact of their contributions to numerous Kansas agencies and communities is inestimable. As Bill Ellington, Wichita's City Historian, has remarked with professional vision: "The Garvey family definitely has been a catalyst in Wichita's progress.... Their influence is tremendous, and history books will play up the Garvey family in a strong manner 100 years from now."[30] When the account is written, it will begin with Ray Hugh Garvey, but it will also include Olive's significant contributions as well as those of Ruth, Willard, James, and Olivia (and their progeny), for the time span of their leadership of the ever-expanding Garvey enterprises by then will more than double that of their illustrious founder.

Although Mrs. Garvey noted that her life seems logically to fall into three segments, she easily might have added a fourth, for the years since 1972 have been spent increasingly in directing her resources toward the solution of human needs and problems. But she gives more than her money; she gives unselfishly of Olive Garvey, believing as Emerson wrote that "the only gift is a portion of thyself." She serves on more boards and committees than individuals half her age, and continually searches for fresh ways to encourage others in quest of unfulfilled dreams and goals. Additionally, she finds ways to reward service and loyalty, as in the case of the Christmas gift of $3000 she makes to each Garvey employee who has completed 15 years of service.

In more than a casual way, the fourth segment of Olive's life is a salute to Ray Hugh Garvey, for she never fails to give him credit for making possible everything she and her children have enjoyed or have accomplished both before and after June 30, 1959. And it is in the Garvey name—his name and hers—that her resources are shared with others who need assistance. Ray Garvey lives vividly in her mind, heart, and actions. Her later

years have been a meaningful reflection of Robert Browning's poetic thoughts written in 1845 about another lost leader:

> We that had loved him so, followed him, honored him,
> Lived in his mild and magnificent eye,
> Learned his great language, caught his clear accents,
> Made him our pattern to live and to die!

It is a sensitive and fitting tribute, but when the story of the Garvey enterprises is updated a century from now, as Wichita's City Historian has suggested, a similar and well deserved analogy unquestionably will be drawn on Olive White Garvey's intelligent, highly principled, and successful leadership—as it will on that of other businessmen and women who elect to follow her example.

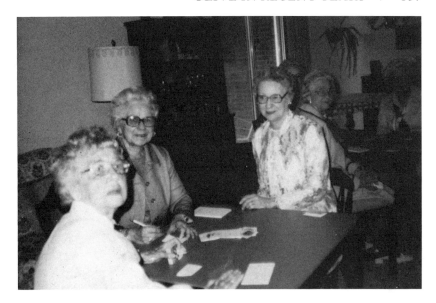

Above: An avid bridge player, Mrs. Garvey frequently joins with other members of the "Bridge Club." Below: The winter months normally are spent in Scottsdale, Arizona, where Mrs. Garvey maintains a condominium. She is shown here with her daughter, Ruth.

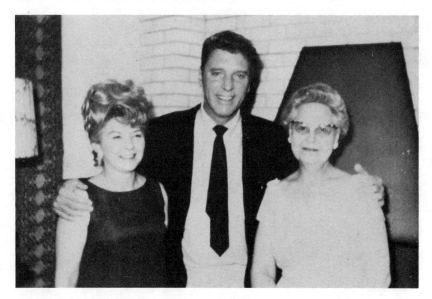

Above: She entertained actor Burt Lancaster in 1968 when he was a guest at Parklane Towers while on location. Pictured also is Gwen Colchin. Below: As a member of the Symphony Board, she helped entertain comedian Bob Hope in 1972. Shown with them is Dale King.

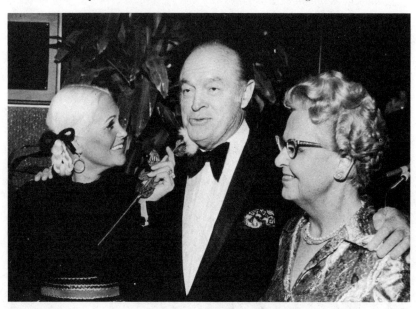

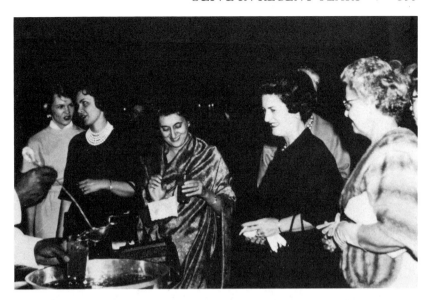

Above: She assisted the Institute of Logopedics in entertaining India's Madam Ghandi in 1962. Below: Madam de Riviera, wife of the President of El Salvador, receives Olive in 1975.

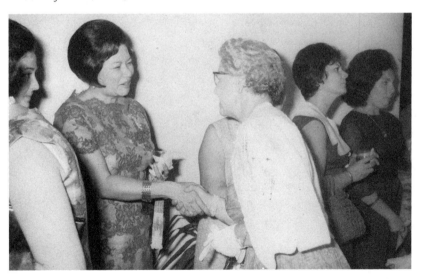

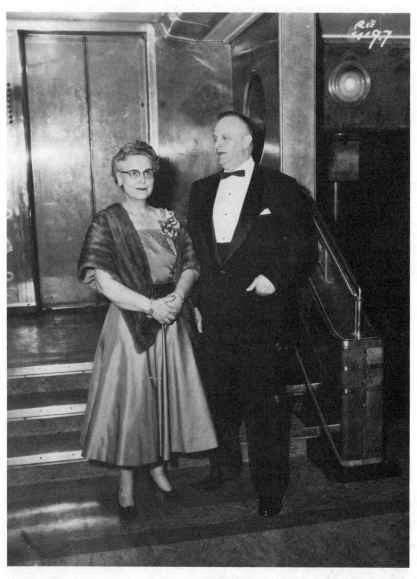

Olive's world travels began with her late husband. Here Mr. and Mrs. Ray Hugh Garvey were photographed on board R.M.S Queen Elizabeth in 1956.

Above: With Taiko Nagasawa (standing first on left) as their guide, Mrs. Garvey and Irene Dean toured the sights of Tokyo in 1960. Later, Olive arranged for Taiko to come to the Institute of Logopedics while studying for her degree. She now is a doctor with the Japanese Health Service. Left: Olive is shown aboard ship shortly before arriving in Honolulu in 1963.

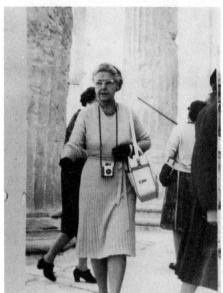

Above: Disembarking during their Mediterranean cruise in 1961, L to R: Mrs. Garvey, Julia Raymond, Dorothy Vollmer, Clarence Vollmer. Left: As a part of the cruise in 1961, Olive enjoyed a visit to the Acropolis in Athens.

Left: Olive is shown in 1971 on a safari at Camp Kilimanjaro in Tanzania, Africa. Below: Strolling through the historic sites of Casablanca in 1972.

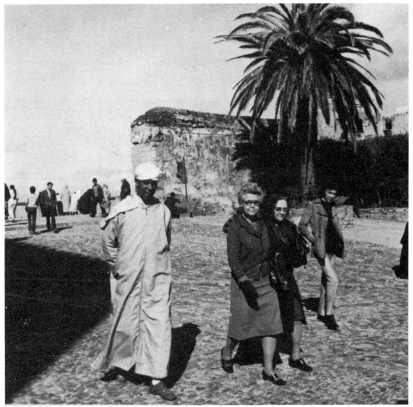

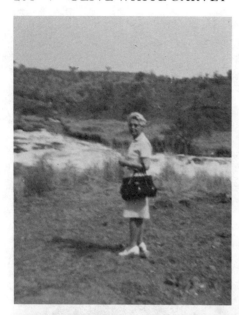

Left: At the Continental Divide in the Canadian Rockies in 1970. Below: Shirley Garvey, Ann Fair, Julia Raymond, and Mrs. Garvey in the lobby of the Hong Kong Sheraton in 1976, preparing to embark on a shopping tour in Hong Kong and Kowloon.

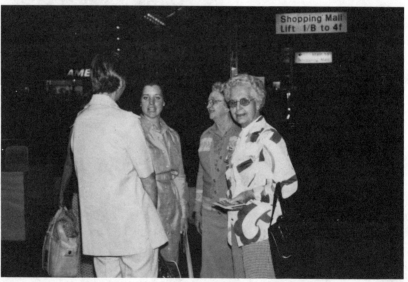

APPENDIX I

OLIVE WHITE GARVEY

PERSONAL:

Born: Arkansas City, Kansas, July 15, 1893
Parents: Oliver Holmes and Caroline Hill White
Education: Topeka Public Schools
 Washburn University (A.B., 1914)
Taught English: Augusta (Kansas) High School 1914-1916
Married: Ray Hugh Garvey (d. 1959), Topeka, Kansas, July 8,
 1916
Children: Ruth Garvey Fink (Mrs. H. Bernerd)
 Willard White Garvey
 James Sutherland Garvey
 Olivia Garvey Lincoln (Mrs. George A.)
 Eighteen Grandchildren
 Thirty-one Great-Grandchildren

BRIEF CAREER SUMMARY
Chairman of the Board & Director:
 Garvey, Inc.
 Garvey Center, Inc.
 SRI, Inc.

President and Trustee:
 Garvey Foundation
 Family Charities Foundation

Trustee:
 Garvey Charitable Trusts One through Ten, inclusive
 Eighteen R.H. Garvey Trusts
 Three R.L. Cochener Trusts

CIVIC, POLITICAL, PHILANTHROPIC, SOCIAL SERVICE ACTIVITIES, ETC.:

Director - Trustee:
 Friends University, Wichita, 1961-1976 (Chairman of the Board, 1974;
Honorary Chairman, 1975-1984)
 Herbert Hoover Presidential Library Association, 1974
 Kansas 4-H Foundation, Wichita, 1960
 Music Theatre of Wichita, Inc., 1973
 Wichita Festival Committee
 Kansas Coliseum Board, 1976

Member:
 National Board of Governors, Institute of Logopedics, 1970
 International Institute of Education (Honorary Member)
 Republican Women
 Wichita Metropolitan Council

Decorations and Awards:
 Phi Kappa Phi (Honorary Scholastic Fraternity)
 Nonoso (Women's Honorary Fraternity at Washburn)

Included in:
 Who's Who of the Midwest
 Who's Who of American Women
 Who's Who of American Women in Business
 2000 Women of Achievement, 1971
 The Writer's Directory, 1971-1973
 Dictionary of International Biography, 1973, 1975, 1976, 1977
 International Who's Who in Community Service, 1975
 Community Leaders of America, 1982
 Who's Who in Kansas, 1975
 Who's Who in the United States, 1975
 The World's Who's Who of Women, 1975, 1977, 1982
 The Registry of American Achievement, 1982
 H.H.D., Washburn University, 1963
 Cited for Service to Business in Wichita, Woman of the Year Contest,
1965
 Cable Award of Delta Gamma Fraternity, 1965
 H.D. in Public Service, Friends University, Wichita, 1966
 H.H.D., Wilson College, Chambersburg, PA, 1967
 Cited for Outstanding Service to 4-H, 1967
 Patron of Kansas Press Women, 1967
 Salesman of the Year by Sales & Management Executives, 1969

Brotherhood Award, NCCJ, 1969
Martin Palmer Humanitarian Award, Institute of Logopedics, 1970
H.D. in Letters, Oklahoma Christian College, Oklahoma City, 1970
4-H Hall of Fame, 1977
Honor Roll, American Society of Colonial Dames, 1979
Distinguished Service Award in Agriculture, Kansas State University, 1971
Honorary Member, Clovia (Kansas State University)
"Over the Years" Award, Wichita Chamber of Commerce, 1971
Uncommon Citizen Award, Wichita Chamber of Commerce, 1975
Rose Award of Delta Gamma Fraternity, 1976
Daughters of American Revolution Medal of Honor, 1983
Distinguished Service Citation, Kansas University, 1983
Kansan of the Year, 1984

OTHER AFFILIATIONS

National League of American Pen Women (State President, 1952)
Kansas Author's Club (District President)
P.E.O.
Delta Gamma Fraternity
National Society of Colonial Dames of America (State President, 1964)
Twentieth Century Club
Jamestown Society
Wichita Art Association
American Association of University Women
Phi Kappa Phi
Daughters of American Revolution
Crestview Country Club
Plymouth Congregational Church

Sponsor of:
Hoover Presidential Library Association Essay Contest, 1973
Mont Pelerin Society Annual Olive W. Garvey Fellowships for Prize Winning Essays, 1982
The Olive W. Garvey Center for the Improvement of Human Functioning, Wichita, 1975

Noteworthy Special Works:
Several published plays, poems, and articles
The Obstacle Race, Biography, Published 1970
Produce or Starve? Commentary, Published 1976
Once Upon a Family Tree, Autobiography, Published 1980

APPENDIX II
HONORS AND PHILANTHROPHY

Above: Four institutions of higher learning have awarded honorary doctorates to Mrs. Garvey. Washburn University President Harold Sponberg reads the citation for the Honorary Doctor of Humanities awarded to Mrs. Garvey in 1963. Below: Friends University conferred an Honorary Doctor in Public Service upon her in 1966. She is shown here with Friends' President Richard Felix during the dedication ceremonies for the Garvey Education Complex in 1984.

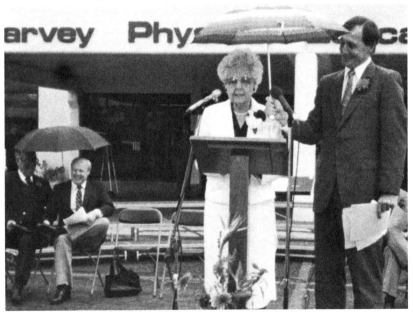

Above: President Havens of Wilson College in Chambersburg, Pennsylvania, awarded her the degree of Honorary Doctor in Humane Letters at the spring commencement in 1967. Pictured also is John Templeton. Below: Chancellor James O. Baird (right) of Oklahoma Christian College congratulates Mrs. Garvey and Leonard Firestone, President of Firestone Tire and Rubber Co., upon receiving Honorary Doctorates in Letters in 1970.

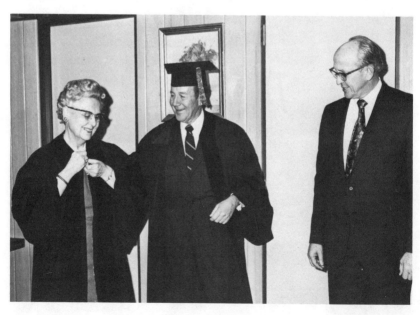

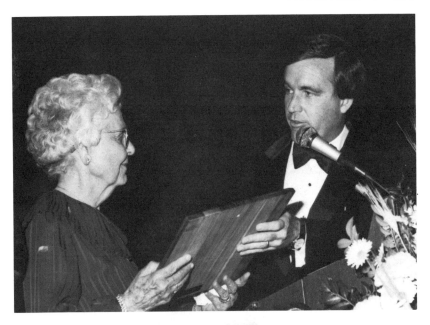

Above: Kansas Governor John Carlin presents Mrs. Garvey with the coveted Kansan of the Year Award in 1984. Left: Plaque given to Mrs. Garvey in 1971 conferring the Wichita Area Chamber of Commerce's "Over the Years Award" for proven dedication to the development of Wichita.

Above: Mrs. Garvey accepting the "Uncommon Citizen Award" given by the Wichita Area Chamber of Commerce in 1975. Below: Robert Langenwalter confers The National Council of Christians and Jews' "Brotherhood Award" upon Olive in 1969.

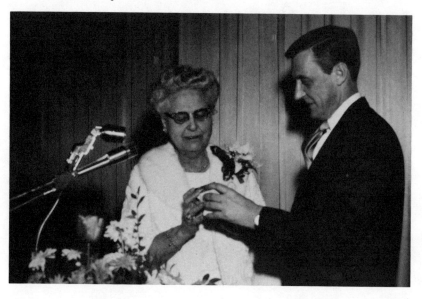

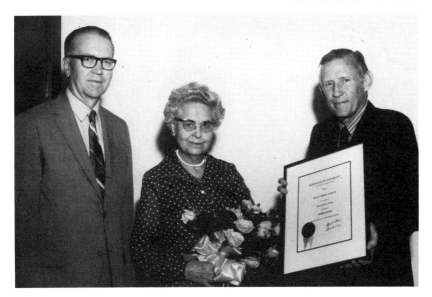

Above: Kansas State University awarded the Distinguished Service Award in Agriculture to her in 1971. L to R: KSU Dr. Glenn H. Beck, Mrs. Garvey, President James A. McCain. Below: Mrs. Garvey presented a plaque for distinguished service to 4-H activities in 1967 to Kansas Governor John Anderson. In 1977, Olive was honored by being inducted into the 4-H Hall of Fame.

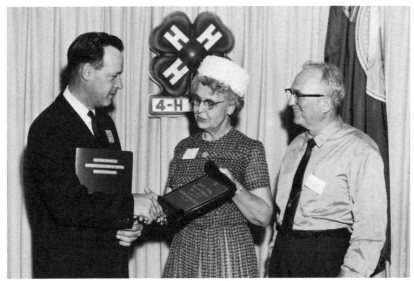

Above: Mrs. Garvey (seated fourth from right) received the Y.W.C.A. Award in 1981 on the 75th Anniversay of the Association. Honored with her (seated third and second from right respectively) were Kansas Senator Nancy Kassebaum and Olive Ann Beech, Chairman of the Board of the Beech Aircraft Company of Wichita. Below: Dr. Hugh D. Riordan, Director of the Olive White Garvey Center for the Improvement of Human Functioning, presents an Award of Appreciation to Mrs. Garvey. Pictured also is Dr. John Ott.

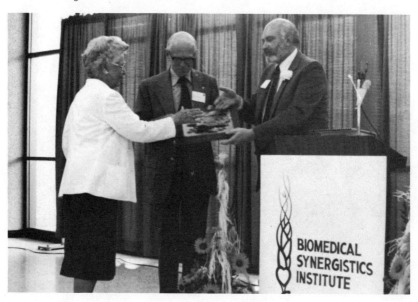

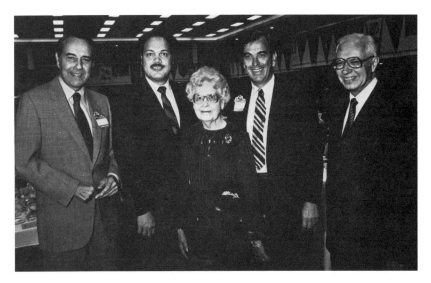

Above: Kansas Senator Bob Dole (left) shared happy moments in 1984 with Mrs. Garvey when she was given The University of Kansas' highest honor, the Distinguished Service Award. Below: Mrs. Garvey is surrounded by family members as she receives the Delta Gamma Rose Award in 1976.

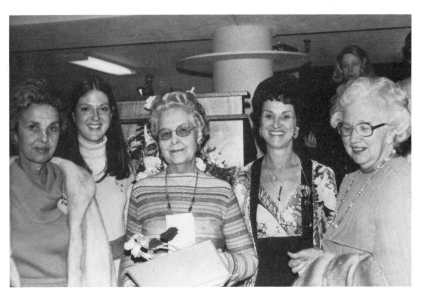

Left: Allen Hoover congratulates Mrs. Garvey upon her address at the dedication of the Herbert Hoover Presidential Library, West Branch, Iowa. Below: The Garvey Presidential Gallery at the Herbert Hoover Library, dedicated to Ray and Olive Garvey by their children.

Above left: The Garvey generosity has been felt in many ways, one of which was the support given to the publication of the Washburn College Bible, designed by Bradbury Thompson. Above right: Mont Pelerin Society Dinner in Brussels honoring Hoover Contest winners in 1974. Mrs. Garvey is seated next to Dr. Shenfield (center) who presided at the function. Below: The tower for Channel 8 ETV, given by the Garvey Foundation, is surrounded by lands donated by the family to the Wichita Zoo for use as a breeding farm.

Above: The Garvey Fine Arts Building at Washburn University. Below: The Asa Payne Cottage, 4-H Camp, Rock Springs Ranch, a Garvey-donated project dedicated to a distinguished agriculturalist and long-time friend of Ray Garvey.

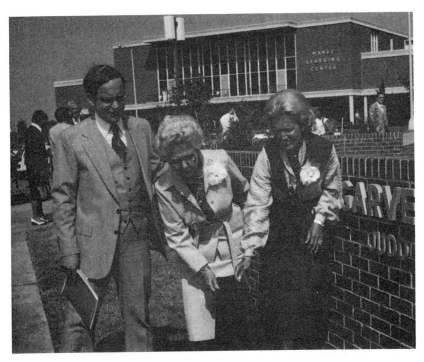

Above: Unveiling of personalized paving tiles at the dedication of the Garvey Fine Arts Building at Oklahoma Christian College. L to R: OCC President Terry Johnson, Mrs. Garvey, Mrs. Quentin Little. Below: The Olive W. Garvey Center for the Improvement of Human Functioning, located in northeast Wichita, only recently has been completed.

APPENDIX III

THE LEGACY OF
RAY HUGH GARVEY

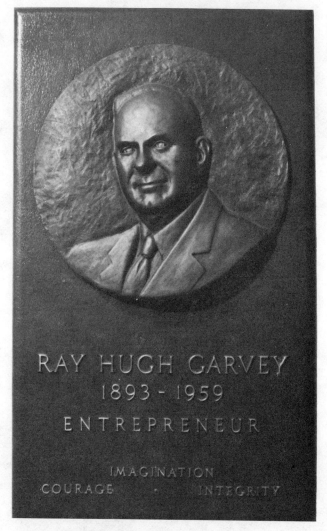

Plaque honoring Ray Hugh Garvey which is affixed to the office tower bearing his name.

Left: Ray's imagination, courage, and integrity led him into many business ventures, first into ownership of farm and ranch lands which ultimately totaled more than 100,000 acres. Here he surveys one portion of his northwest Kansas holdings. Below: In 1924, Ray bought the financially troubled Western Trails Company, renaming its chain of service and supply stations as the Service Oil Company.

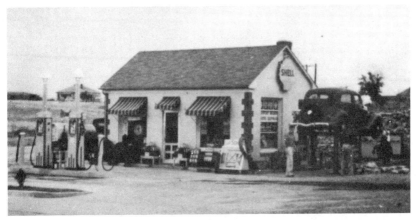

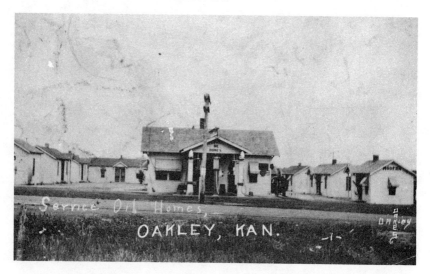

Above: The Oakley, Kansas, branch of Service Oil also included a housing development. Below: By 1947, Ray was farming approximately 70,000 acres and was producing more than one million bushels of wheat by using the most modern farm machinery. Pictured is one of his harvesting operations in Thomas County.

Above: During the 1930s in Wichita, Garvey formed Builders, Inc. He begar constructing FHA financed homes. This photo, reproduced from a local newspaper, shows the first units of a planned 109-house addition for aircraft workers in 1940, located west of Wichita University. Below: To accommodate his harvests, Ray began acquiring small elevators in the 1930s, the Halford Elevator pictured here being the first.

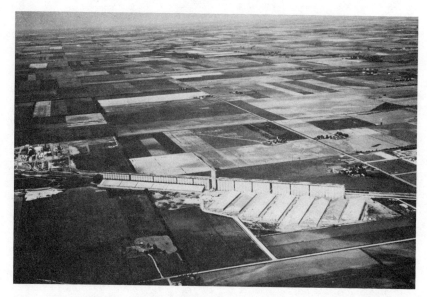

Necessity and opportunity caused Ray to enter the elevator business on a grand scale. Pictured are two of his "Castles on the Plains," the Wichita (above) and Topeka elevators.

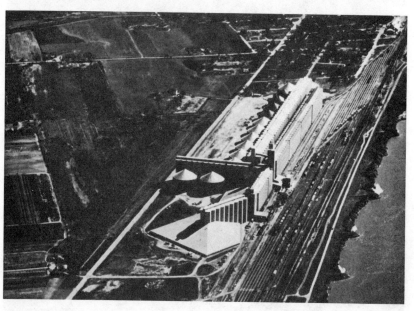

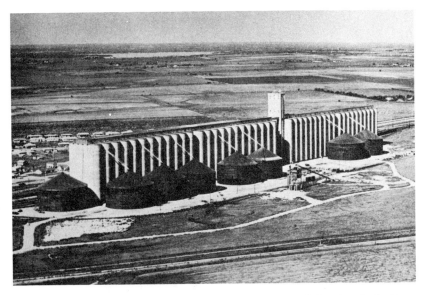

His "Castles" also included the Fort Worth (above) and the Lincoln facilities, all constructed in the 1950s. These formed the nucleus of Ray's vast grain storage complex, which by 1959 had become the world's largest.

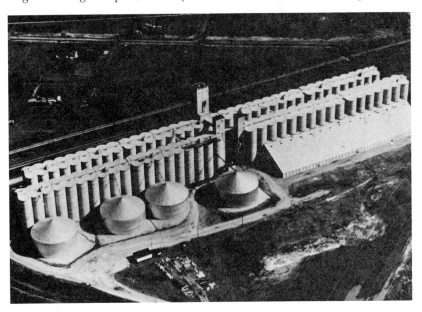

In 1949, Ray also formed Petroleum, Inc., a highly successful oil exploration firm.

NOTES

Chapter 1

[1]*Wichita Eagle and Beacon*, July 16, 1983.
[2]Interview, Hugh Riordan with author, June 6, 1983.
[3]The author was privileged to attend and tape record most of the ceremony.
[4]Ralph Waldo Emerson, "Poems [Merlin]," 1847.
[5]Interview, Ruth Garvey Fink with author, April 21, 1983; Ruth Garvey Fink to author, letters dated June 23, 1983; July 19, 1983.
[6]Interview, Olive Garvey with author, July and August, 1983.
[7]Interview, Willard and Jean Garvey with author, September 15, 1983.
[8]Ironically, during the last six months of Ray Hugh Garvey's life, several summaries of his career were published. See for example: "The World's Largest Grain Elevator Operator...The Story of R.H. Garvey," *Southwestern Miller*, December 9, 1958, pp. 33-34; Fred Kiewit, "His Step-at-a-Time Idea Leads to Huge Business," *Kansas City Star*, February 1, 1959; "Man of Varied Interests Started Career on $500," *Wichita Eagle*, April 8, 1959; Richard Orr, "Wheat Storer Fights to Keep Apace of Glut," *Chicago Daily Tribune*, June 17, 1959.
[9]*Wichita Eagle*, July 1, 1959; Harold Steen, "Garvey Enterprises, Including 210,000,000 Bus of Grain Storage, Farms, Wheat Growing, Oil, Housing, Cattle, Outgrowth of Critical Analysis," *Southwestern Miller*, September 3, 1963, p. 10.
[10]"Woman's Hand Guides Garvey Empire," *Capper's Weekly*, February 23, 1965; "Widow Thriving in World of Business," *Kansas City Times*, February 9, 1965.

Chapter 2

[1]Olive Garvey has spent countless hours delving into the Garvey-White genealogies. A detailed, well-written account of her findings was published in her *Once upon a Family Tree* (Wichita, 1980). The narrative in this chapter follows closely (and it is hoped accurately) the material contained in the first 89 pages of that work. Only supporting references to information obtained from other sources will be footnoted hereafter.
[2]An excellent description of Arkansas City in the late 19th Century may be found in Kathlyn Baldwin, *The 89ers* (Oklahoma City: Western Heritage Books, 1981).
[3]Interview, Olive Garvey with author, July and August, 1983; please refer also to the genealogy in the appendix of Olive Garvey, *Once Upon a Family Tree*.
[4]Interview, Olive Garvey with author, July and August, 1983.
[5]Interview, Olive Garvey with author, July and August, 1983; see also, Olive Garvey, *Once Upon a Family Tree*, pp. 48-49.
[6]Again, please refer to the genealogical charts in the appendix to Olive Garvey, *Once Upon a Family Tree*.
[7]For a brief biographic sketch of Oliver H. White, see: *Topeka Daily Capital*, December 11, 1931.
[8]Baldwin, *The 89ers*, 16-32. See also: D.E. Newsom, *Kicking Bird and the Birth of Oklahoma* (Perkins, Oklahoma: Evans Publications, 1983), 95-111.
[9]The name Newkirk was chosen to distinguish the site from a former stop on the Santa

Fe Railway two miles north known as Kirk. George H. Shirk, *Oklahoma Place Names* (Norman: University of Oklahoma Press, 1965), 149.

[10]For a brief biographical sketch of Mrs. Garvey's mother, see: *Topeka Daily Capital,* September 17, 1943.

[11]Interview, Olive Garvey with author, July and August, 1983.

[12]*Topeka Daily Capital,* December 11, 1937.

[13]The narrative which follows, although enriched by interviews with Olive White Garvey (July and August, 1983) and her brother, Elliot Hill White (July 15, 1983), essentially is adapted from the more detailed account of Mrs. Garvey's formative years as she wrote them in *Once Upon a Family Tree* on pages 93-206.

Chapter 3

[1]*Topeka Daily Capital,* December 11, 1937.

[2]Again, the narrative hereafter is adapted from *Once Upon a Family Tree.*

[3]The Rev. H.A. Maynard was a missionary to Turkey and Russia until 1922, then joined the faculty of the International College of Smyrna, Turkey. Later he became a department head at the American University at Beirut, Lebanon, where he remained until his retirement in 1945. He was made professor emeritus at the American University and missionary emeritus of the American Board of Foreign Missionaries. Mary Maynard, Olive's oldest sister, died in 1967 at her home in Evanston, Illinois, at the age of 84. They had four sons: Robert, Richard, John, and Edward. See the obituary (source unidentified, dated September, 1952), entitled "Rev. H.A. Maynard," and the death notice (source undated and unidentified) entitled "Mary Maynard," in the first of Mrs. Garvey's scrapbooks.

[4]See the biographical sketch of John Hughes in the *Topeka State Journal,* May 25, 1963, and the *El Dorado Times,* May 13, 1967. Mrs. Ione White Hughes, Olive's sister, died in 1967. They had two sons, Carroll and Oliver, and two daughters, Jeannette and Helen. See the *Butler County News,* March 2, 1967, and the *El Dorado Times,* March 2, 1967.

[5]Interview, Elliot Hill White with author, July 15, 1983. Elliot White later entered Washburn where he met his future wife Daphne. He graduated in 1924, after which he attended Harvard University and received the MBA degree in 1925. For approximately five years, Elliot and Daphne lived in Chicago where he worked as a financial analyst for an industrial firm. They had one adopted daughter, Leslie, who died later of kidney failure at the age of 31. In 1930, Elliot returned to Topeka, bought into his father's business, the Topeka Transfer and Storage Company, and remained as its president and principal owner from his father's death in 1931 until 1974 when the business was sold. See for example: *Washburn Alumni,* Summer, 1978, p. 3; *Topeka Daily Capital,* December 11, 1931.

[6]Dr. Stacy Guild, an honored gold medal winner of the American Ontologic Society, was a distinguished professor of otolaryngology at Johns Hopkins University whose research led to a greater understanding of several causes of deafness. He died in 1966 a few years after Florence, Olive's sister, passed away. They had one daughter, Elizabeth, and four sons, Phillip, Thomas, Henley, and Walter. See the *Baltimore Sun,* July 5, 1966.

[7]Olive Garvey to author, April 6, 1984.

[8]Interview, Olive Garvey with author, July and August, 1983.

[9]Interview, Olive Garvey with author, August, 1983.

[10]In her scrapbooks, Mrs. Garvey kept numerous newsclippings (unfortunately sources and dates were not always included) which tell of her activities at Washburn. See in particular the news articles entitled, "Lose First Girls' Debate to Ottawa Friday," and "College Seniors Will Present Play Tonight." There also is a snapshot made of the students who attended the YWCA festivities in Estes Park, Colorado, in the summer of 1913.

[11]See the unidentified newsclipping entitled, "Washburn Societies Show Early Activity." Additionally, Olive and Ray are pictured among the junior class on pages 44 and 47 respectively in *The Kaw,* Washburn's 1913 Yearbook.

[12]For a quick summary of the early days of the oil boom in Augusta and Butler County,

see H. Craig Miner, *The Fire in the Rock: A History of the Oil and Gas Industry in Kansas, 1855-1976* (Newton, Kansas: The Mennonite Press, 1976), 54-68.

[13]In the first of Mrs. Garvey's scrapbooks, an unidentified clipping, presumably from a Butler County newpaper, states that Olive Hill White, "a recent graduate of Washburn College, will have charge of the English department next year."

[14]The story of Ray's entrance into the business world with only $500 to invest is a tale that refuses to die. See for example: "Man of Varied Interest Started Career on $500," *Wichita Eagle*, April 8, 1959, p. 3A; and "Ray Garvey, King of Castles of the Plains," *Capper's Weekly*, June 30, 1970.

[15]Again, the narrative of her marriage and her life in Colby basically follows the material in *One Upon a Family Tree*, 213-239.

[16]Olive Garvey, Colby 1916-1928, copy in possession of the author.

Chapter 4

[1]Ray's genealogy is traced in Olive Garvey and Virgil Quinlisk, *The Obstacle Race* (San Antonio: The Naylor Company, 1970), 13-43.

[2]See for example, *The Kaw* [Washburn's 1913 Yearbook], 105, 110.

[3]Garvey and Quinlisk, *The Obstacle Race*, 58-60.

[4]*Ibid.* The treatment of Ray Garvey's early career in the real estate business and the development of summer-tillage techniques in his custom farm operations is summarized from the more detailed materials found on pages 63-85.

[5]Interview, Olive Garvey with author, July and August, 1983.

[6]Interviews, Ruth Garvey Fink, Olivia Garvey Lincoln, Willard and James Garvey with author, April, July, August, and September, 1983.

[7]Interview, Olive Garvey with author, July and August, 1983.

[8]*Ibid.*

[9]Garvey, *Once Upon a Family Tree*, 234.

[10]Interviews, Ruth Garvey Fink, Willard and James Garvey with author, April, July, and September, 1983.

[11]Interview, Olive Garvey with author, July and August, 1983. See also Garvey, *Once Upon a Family Tree*, 239.

[12]Actually, only Ruth and Willard remember most of these incidents. Interviews, Ruth Garvey Fink and Willard Garvey with author, April and September, 1983.

[13]Interviews, James and Olive Garvey with author, July and August, 1983.

Chapter 5

[1]Glenn W. Miller and Jimmy M. Skaggs (eds.), *Metropolitan Wichita: Past, Present, and Future* (Lawrence: Regents Press of Kansas, 1978), 8-9.

[2]Ruth Garvey Fink to author, April 6, 1984.

[3]Ruth's biographical sketch was obtained essentially from lengthy audiotaped interviews with her and her mother in the spring and summer of 1983.

[4]*Wichita Eagle*, February 18, 1942.

[5]Ruth Garvey Fink to author, April 6, 1984.

[6]*Topeka State Journal*, January 28, 1954.

[7]*Wichita Eagle and Beacon*, December 10, 1978.

[8]Interview, Olive Garvey with author, July and August, 1983.

[9]Willard's biographical sketch was obtained during lengthly interview sessions, all audiotaped, with Willard and Jean Garvey on September 15, 1983, and with Mrs. Garvey in July of 1983.

[10]Mrs. Garvey presented the Eagle Scout Badge to her 14 year old son at a special ceremony during a Rotary luncheon in 1934. See the unidentified clipping detailing this event in the first of Mrs. Garvey's scrapbooks.

[11]Interview, Olive Garvey with author, July and August, 1983.

[12]This somewhat lengthy story is regarded as having had great influence on Willard's

maturation—and the premature greying of Mrs. Garvey's hair. Interviews, Willard and Olive Garvey, July, August, and September, 1983.

¹³Willard's wartime duties were equally influential in his determination to succeed. Interviews, Willard and Jean Garvey with author, September 15, 1983.

¹⁴*Wichita Eagle*, April 19, 1946.

¹⁵See the article in *Wichita Eagle and Beacon*, June 26, 1983.

¹⁶The biographical sketch on James Garvey was obtained during lengthy, audiotaped interview sessions on July 15, 1983, and from those with his mother previously cited.

¹⁷At one swimming meet, James was cited as winning two firsts and Olivia, his sister, a second place ribbon. They represented the College Hill team, and between them garnered 27 points and contributed to an additional 17 in relay events out of a winning total of 88½ points. See the news article (source and date omitted) entitled "Seen and Heard in Wichita," in the first of Mrs. Garvey's scrapbooks.

¹⁸*Wichita Eagle*, November 31, 1947.

¹⁹See for example: *Wichita Eagle and Beacon*, December 10, 1978. James also once opposed Congressman Jim Wright's long hold on the seat representing Fort Worth. *Fort Worth Star Telegram*, May 1, 1977.

²⁰The biographical sketch of Olivia was obtained during lengthy, audiotaped sessions at the home of her daughter in Wichita on September 28, 1983, and from those with her mother previously cited.

²¹Again, see the article "Seen and Heard in Wichita" as cited above.

²²*Wichita Eagle*, November 20, 1949.

²³George Lincoln's biography was obtained in an interview at the dedication ceremonies of the Olive W. Garvey Center for the Improvement of Human Functioning, July 15, 1983.

²⁴Interview, Olivia Garvey Lincoln with author, September 28, 1983.

²⁵Again, see the articles in the *Wichita Eagle and Beacon*, December 10, 1978, and June 26, 1983.

Chapter 6

¹Interview, Olive Garvey with author, May 15, 1984.

²*Wichita Beacon*, May 30, 1937. Two massive scrapbooks, one entitled "Olive White Garvey: Born Arkansas City, Kansas—July 15, 1893," covering the years 1893-1967; and the other labeled "Olive White Garvey: The Second 75 Years," are packed with newsclippings and articles about Mrs. Garvey's activities. The items referenced in this section are to be found in the first of Mrs. Garvey's scrapbooks.

³See for example: *Wichita Eagle*, April 21, 1930; December 12, 1930; October 29, 1934; February 23, 1947.

⁴*Wichita Eagle*, May 11, 1947; National League of American Pen Women, to Olive Garvey, April 30, 1944; Charles Quarles Chandler II, to Olive Garvey, undated Letter in scrapbook #1; Olive Garvey, "Captain Washington," in A.P. Sanford (ed.), *George Washington Plays* (New York: Dodd, Mead and Company, 1931), 169-183.

⁵See for example: *Wichita Eagle*, July 26, 1944; October 14, 1945; March 7, 1949; December 24, 1949; May 15, 1951; May 24, 1953; "[Olive White Garvey]: Writer-Civic Leader," *Anchora of Delta Gamma*, (February, 1953), 3.

⁶Ruth Garvey Fink to author, April 6, 1984.

⁷*Kansas City Star*, February 1, 1959; *Chicago Daily Tribune*, June 17, 1959.

⁸"The World's Largest Grain Elevator Operator...The Story of R.H. Garvey," *Southwestern Miller*, December 9, 1958, pp. 33-34.

⁹*Wichita Eagle and Beacon*, June 26, 1983; *Half-a-Century in Wichita*, 3; *Wichita Eagle*, April 8, 1959.

¹⁰Olive Garvey to author, April 6, 1984.

¹¹Garvey and Quinlisk, *The Obstacle Race*, 154; *Kansas City Star*, February 1, 1959; James and Shirley Garvey to author, April 6, 1984.

¹²*Topeka Daily Capital*, May 22, 1968; *Half-a-Century in Wichita*, 3-4; "Garvey Enterprises," *Southwestern Miller*, September 3, 1963, p. 10.
¹³"The World's Largest Grain Elevator Operator," *Southwestern Miller*, December 9, 1958; *Chicago Daily Tribune*, June 17, 1959.
¹⁴Garvey and Quinlisk, *The Obstacle Race*, 125, 126.
¹⁵*Ibid.*, 136; *Topeka Daily Capital*, July 10, 1950.
¹⁶*Kansas City Star*, February 1, 1959.
¹⁷Interview, Arthur W. Kincade with author, March 9, 1983.
¹⁸"The World's Largest Grain Elevator Operator," *Southwestern Miller*, December 9, 1958; *Chicago Daily Tribune*, June 17, 1959; *Topeka Daily Capital*, July 3, 1959; *Kansas City Star*, February 1, 1959.
¹⁹*Topeka Daily Capital*, June 18, 1970.
²⁰Olive Garvey to author, April 6, 1984.
²¹Olive Garvey, *Once Upon a Family Tree*, 267-268, 272-273.
²²*Wichita Eagle*, July 1, 1959; *Kansas City Times*, July 1, 1959; *Topeka State Journal*, July 1, 1959.
²³*Topeka Daily Capital*, July 2, 1959.
²⁴*Topeka Daily Capital*, July 3, 1959; *Topeka State Journal*, July 1, 1959; "The World's Largest Grain Elevator Operator," *Southwestern Miller*, December 9, 1958, p. 33; *Sedgwick County News*, Vol. III, No. 50, June 30, 1972.

Chapter 7
¹See Mrs. Garvey's account in *Once Upon a Family Tree*, pp. 297-299; see also, *Kansas City Star*, February 1, 1959; *Kansas City Times*, June 1, 1959; *Wichita Eagle and Beacon*, December 10, 1978.
²*Wichita Eagle and Beacon*, December 10, 1978.
³Interviews, Olive Garvey and Robert Page, July and August, 1983.
⁴Olive Garvey, *Once Upon a Family Tree*, p. 298.
⁵Interview, Olive Garvey with author, July and August, 1983.
⁶Interview, Robert Page with author, August 12, 1983.
⁷*Topeka State Journal*, July 10, 1959.
⁸*Wichita Eagle and Beacon*, December 10, 1978.
⁹Interviews, Arthur Kincade and Robert Page with author, March 9, 1983, and August 12, 1983.
¹⁰Interviews, Olive Garvey and Robert Page with author, July and August, 1983.
¹¹Interviews, Olive Garvey and Robert Page with author, July and August, 1983.
¹²Olive Garvey to author, April 6, 1984.
¹³See the advertising supplement to *Wichita Eagle and Beacon*, April 3, 1966; interviews, Olive Garvey and Robert Page with author, July and August, 1983.
¹⁴Interviews, Eric Jager and Henry Dock with author, March 14, 16, 1983.
¹⁵Interviews, Robert Page August 12, 1983.
¹⁶*Wichita Eagle and Beacon*, December 10, 1978; Harold Steen, "Garvey Enterprises, Including 210,000,000 Bus of Grain Storage, Farms, Wheat Growing, Oil, Housing, Cattle, Outgrowth of Critical Analysis," *Southwestern Miller*, September 3, 1963, p. 10.
¹⁷Olive Garvey to Arthur W. Kincade, July 13, 1963.
¹⁸*Wichita Eagle and Beacon*, May 8, 1976; *El Dorado Times*, May 8, 1976; *Capper's Weekly*, May 19, 1976; *Kansas Banker*, Vol. 67, No. 5, June, 1977, pp. 1-2.
¹⁹*Topeka Daily Capital*, February 12, 1965; *Wichita Beacon*, February 11, 1965; *Capper's Weekly*, February 23, 1965.
²⁰Olive Garvey, *Once Upon a Family Tree*, pp. 301-302.

Chapter 8
¹The efforts to effect an equitable division of properties are little known outside the family. The lengthy summary which follows is drawn from the several interviews with

232 / OLIVE WHITE GARVEY

family members, especially Mrs. Garvey, and with Robert Page, all of which have been previously cited.

²Olive Garvey, *Once Upon a Family Tree*, p. 315.

³*Ibid.*, pp. 308-310.

⁴*Wichita Beacon*, November 24, 1964; *Wichita Eagle*, March 24, 1965; *Wichita Eagle and Beacon*, July 22, 1972; *Wichita Eagle and Beacon*, April 3, 1966; December 1, 1968; May 2, 1970; May 17, 1970; *Wichita Eagle*, December 15, 1967; October 23, 1969; January 3, 1970; March 10, 1970; *Wichita Beacon*, September 8, 1969; "Million Dollar Check Changes Hands,"*Spectator*, Vol. 1, No. 27, July 4, 1968, p. 1; "Survey and Planning Phase of Waco-Finn Area Opens,"*Wichita U R A Report*, Vol. 1, No. 2, August, 1968, p. 1.

⁵Interview, Robert Page with author, August 12, 1983.

⁶Peggy Green "Business Success Equaled by Generosity,"*Midway*, December 26, 1975, p. 5; *Wichita Beacon*, June 14, 16, 1971; *Wichita Eagle and Beacon*, June 6, 1971; *Colby Free Press*, June 17, 1971.

⁷*Topeka Capital Journal*, October 1, 1970; *Colby Free Press*, September 4, 1972.

⁸Olive Garvey, *Once Upon a Family Tree*, pp. 310-311.

⁹Interview, Robert Page with author, August 12, 1983.

¹⁰*Wichita Eagle and Beacon*, November 8, 1983.

¹¹Olive Garvey, *Once Upon a Family Tree*, p. 310.

¹²Interview, Robert Page with author, August 12, 1983.

¹³*Wichita Eagle and Beacon*, December 10, 1978; June 26, 1983.

¹⁴Interview, Olive Garvey with author, July and August, 1983; *Wichita Eagle and Beacon*, December 10, 1978.

¹⁵*Wichita Eagle and Beacon*, December 10, 1978; June 26, 1983.

¹⁶Interview, Willard and Jean Garvey with author, September 15, 1983; *Wichita Eagle and Beacon*, June 26, 1983.

¹⁷*Wichita Eagle and Beacon*, December 10, 1978; June 26, 1983.

¹⁸Interview, Robert Page with author, August 12, 1983.

Chapter 9

¹Interviews, Willard Garvey, Olivia Garvey Lincoln, and Robert Page with author, July, August, and September, 1983.

²Interview, Jordan Haines with author, August 16, 1983; Peggy Green, Business Success Equaled by Generosity,"*Midway*, December 26, 1965, p. 5.

³"Woman's Hand Guides Garvey Empire," *Capper's Weekly*, February 23, 1965; interview, Clifford Allison with author, September 25, 1983.

⁴*Topeka Daily Capital*, February 12, 1965; January 24, 25, 1967; *Wichita Eagle and Beacon*, March 28, 1971; Olive Garvey, "The Garvey Gospel," *Wichita Journal*, April 7, 1979, pp. 8-9; *Topeka State Journal*, February 16, 1963.

⁵*Wichita Eagle*, December 12, 1970; January 12, 1971.

⁶*Wichita Beacon*, March 16, 1965.

⁷*Wichita Evening Eagle*, September 12, 1962; *Wichita Eagle*, April 24, 1963; *Topeka Daily Capital*, February 12, 1965; "Need for Second High Rise Meant 'Tower' Development," *Spectator*, Vol. 1, No. 18, May 2, 1968.

⁸See for example: *Honolulu Daily Bulletin*, September 5, 1960; *Topeka Daily Capital*, February 12, 1965; *Wichita Eagle*, February 27, 1963; March 7, 1972; September 24, 1972; *Topeka State Journal*, March 24, 1972; Hon. Robert Dole, "An Outstanding Kansas Lady," *Congressional Record*, April 24, 1968, p. H2979.

⁹*P.E.O. Record*, June, 1971, p. 3; *Topeka Daily Capital*, June 18, 1970; *Kansas City Star*, July 5, 1970; *Wichita Eagle and Beacon*, July 18, 1970; *Southwestern Miller*, July 21, 1970; *Kansas Stockman*, September, 1970, p. 53.

¹⁰*American Future*, No. 12, June 17, 1977; *Anchora of Delta Gamma*, Spring, 1977, p. 4; *Topeka Daily Capital*, November 7, 1976.

¹¹*Wichita Eagle and Beacon*, April 17, 1977.

¹²Olive Garvey, *Once Upon a Family Tree*, dedication page; *Wichita Eagle and Beacon*, June 26, 1983.
¹³"Board Member Is Author, Philanthropist, and Business Woman,"*Kansas 4-H Journal*, January, 1974, p. 1.
¹⁴Olive Garvey to author, April 6, 1984.
¹⁵Peggy Green, "Business Success Equaled By Generosity," *Midway*, December 26, 1965, p. 5.
¹⁶Interview, Clifford Allison with author, September 25, 1983.
¹⁷Again, see *Wichita Eagle and Beacon*, June 26, 1983.
¹⁸*Topeka State Journal*, May 22, 1958; *Wichita Eagle and Beacon*, May 13, 1963; *Topeka Daily Capital*, May 14, 1963; *Kansas City Star*, May 15, 1963; *Wichita Eagle*, May 30, 1966; December 18, 1970; *Oklahoma City Times*, December 14, 1970; *Daily Oklahoman*, December 19, 1970.
¹⁹*Topeka State Journal*, March 3, 1967; July 1, 1968; December 4, 1968; May 13, 1975; *Topeka Daily Capital*, October 11, 1963; April 27, 1965; December 14, 1965; July 13, 15, 1968; October 21, 1968; May 17, 1975; March 7, 1977; *Wichita Eagle and Beacon*, May 26, 1968; August 18, 1968; *Wichita Eagle*, February 2, 1969; *Mason City Globe*, July 21, 1959.
²⁰Interview, Richard Felix with author, August 15, 1983. Mrs. Garvey's long association with Friends University is well documented. See for example: "Board of Directors Introduces New Members for New Year," *University Life* (Friends University), January 10, 1964, p. 1; "Friends Receives $100,000," *Friends University Bulletin*, Vol. LXI, No. 1, October, 1963, p. 1; *Wichita Eagle*, June 14, 1963; *Wichita Beacon*, March 25, 26, 1968; June 14, 1968; "Construction of New Friends Gymnasium Begins," *Friends University Bulletin*, Vol. LXII, No. 2, April, 1969, p. 1; *Wichita Eagle*, March 12, 1969.
²¹"Garvey Elected Board Chairman," *University Life* (Friends University), October 9, 1974, p. 1.
²²Interviews, James Baird and Terry Johnson with author, July 26, 1983; *Oklahoma Journal*, October 21, 1976; Olive Garvey, "The Wholistic Me," commencement address, Oklahoma Christian College, October 18, 1976; *Saturday Oklahoman and Times*, September 30, 1978; *Oklahoma City Times*, September 29, 1978; *Daily Oklahoman*, November 20, 1982; *Sunday Oklahoman*, November 21, 1982.
²³An excellent summary (also listed in the appendix) is found in "Alumni Profile: Olive White Garvey," *Washburn Alumni*, Summer, 1978.
²⁴*Wichita Beacon*, October 23, 1959; *Wichita Eagle*, November 27, 1961; July 9, 1965; June 9, 1966; January 7, 1967; December 26, 1967; *Wichita Eagle and Beacon*, February 5, 1961; *Topeka State Journal*, June 9, 1971; *Kansas 4-H Journal*, April 4, 1968; June 19, 1974; *Sunflower* (Wichita State University Newspaper), January 5, 1968.
²⁵Olive Garvey to author, April 6, 1984.
²⁶Interview, Olive Garvey with author, July and August, 1983; *Institute of Logopedics News, Vol. 2, No., 13, March 31, 1969.*
²⁷*Interviews, Ruth Garvey Fink and Olive Garvey with author, April, July, and August, 1983.*
²⁸"Genesis," *Smithsonian Magazine*, June, 1979, pp. 72-81; *Wichita Eagle and Beacon*, June 10, 1979.
²⁹Interviews, Hugh Riordan, Robert Page, and Olive Garvey with author, June, July, and August, 1983; *Wichita Eagle and Beacon*, July 16, 1983; Olive Garvey, "To Whom It May Concern," letter dated Summer, 1983, copy of letter in possession of author.
³⁰*Wichita Eagle and Beacon*, June 26, 1983.

BIBLIOGRAPHY

OLIVE GARVEY COLLECTION:
Olive White Garvey has compiled an elaborate collection of scrapbooks, photograph albums, family papers, letters, memorabilia, newspapers, periodicals, and books, all related to her rich heritage as the direct descendant of colonial ancestors as well to her own legacy as a wife, mother, author, club worker, civic leader, businesswoman, and philanthropist. The Collection also includes scrapbooks and other similar data detailing her husband's life and accomplishments and those of her children. Fortunately, she has the sensitive judgment of the master historian, seldom discarding even the smallest of items. Much of the material is retained at her home, still more of it at her office in the R.H. Garvey Building in Wichita, Kansas.

CENTER FOR ENTREPRENEURSHIP COLLECTION:
The Center for Entrepreneurship and Small Business Management at Wichita State University maintains significant holdings on subjects relating to the starting and managing of small businesses. The Collection consists of books, periodicals, journals, newspaper files, statistical treatises, and other empirical research data. An important section of the Collection includes audio and video tapes made by or about entrepreneurs who are or have been active in the private business sector. The following audiotaped interviews, all relating to the life and activities of Olive White Garvey, now are a part of the Collection's holdings:

Allison, Cliff, with author, September 25, 1983
Baird, Dr. James, with author, July 26, 1983
Critser, Dale, with author, March 14, 1983
Dock, Henry, with author, March 14, 1983
Felix, Dr. Richard, with author, August 15, 1983
Fink, Ruth Garvey and Bernerd, with author, April 21, 1983
Garvey, James, with author, July 15, 1983
Garvey, Olive White, with author, July, 12, 14, 21, 1983; August 31, 1983; May 20, 1984
Garvey, Willard and Jean, with author, September 15, 1983
Haines, Jordan, with author, August 16, 1983
Hughes, Oliver, with author, July 8, 1983
Jager, Eric, with author, March 16, 1983
Johnson, Dr. Terry, with author, July 26, 1983
Kincade, Arthur, with author, March 9, 1983
Lincoln, George, with author, July 15, 1983
Lincoln, Olivia Garvey, with author, September 28, 1983

Page, Robert, with author, August 12, 1983; May 15, 1984
Riordan, Dr. Hugh, with author, June 6, 1983
White, Elliott, with author, July 15, 1983

NEWSPAPERS AND PERIODICALS:

Selected feature stories drawn from this category about members of the Garvey
family also are listed by author and/or title in the section on Published Materials.

American Future, 1977
Anchora of Delta Gamma, 1977
Baltimore Sun, 1966
Butler County News, 1967
Capper's Weekly, 1965, 1970, 1976
Chicago Daily Tribune, 1959
Chicago World Examiner, 1927
Colby Free Press, 1971, 1972
Congressional Record, 1967, 1968
Daily Oklahoman, 1970, 1978, 1982
El Dorado Times, 1976
Fort Worth Star-Telegram, 1977
Friends University Bulletin, 1963, 1969
Honolulu Daily Bulletin, 1927, 1960
Institute of Logopedics News, 1969
Kansas Banker, 1977
Kansas City Times, 1959, 1965
Kansas City Star, 1959, 1963, 1970
Kansas 4-H Journal, 1968, 1974
Kansas Stockman, 1970
Mason City Globe, 1959
Midway, 1975
New York Times, 1927
Oklahoma City Times, 1970, 1978
Oklahoma Journal, 1976
P.E.O. Record, 1971
Sedgwick County News, 1972
Smithsonian Magazine, 1979
Southwestern Miller, 1953-1963
Spectator, 1968
Sunday Oklahoman, 1982
Sunflower (Wichita State University Newspaper), 1968
Topeka Daily Capital, 1931, 1937, 1943, 1950, 1959, 1963-1970, 1975-1977
Topeka State Journal, 1958-1959, 1963, 1967-1972, 1975
University Life (Friends University), 1964, 1974
Washburn Alumni, 1978
Wichita Beacon, 1937, 1959, 1961-1969, 1971
Wichita Eagle, 1930, 1934, 1944-1945, 1947, 1949-1953, 1959, 1961 1970,
 1972
Wichita Eagle and Beacon, 1961-1978, 1983
Wichita Evening Eagle, 1962

236 / OLIVE WHITE GARVEY

Wichita Journal, 1979
Wichita U R A Report, 1968

UNPUBLISHED MATERIALS:
Garvey, Olive White, A Century in Kansas. 1980.
——————. Colby 1916-1928. 1983.
——————. Garvey Foundation. 1984.
Johnson, Donald E., Dedication of Garvey Presidential Gallery: Herbert Hoover Presidential Library. August 10, 1982.
Skaggs, Jimmy M., Wichita, Kansas: Economic Origins of Economic Development. 1977.

PUBLISHED MATERIALS:
Baldwin, Kathlyn. *The 89ers.* Oklahoma City: Western Heritage Books, 1981.
Bearth, Dan. "Garvey Matriarch Content With All That She Surveys," *Wichita Eagle and Beacon,* December 10, 1978.
"Chairman of the Board [Olive White Garvey]," *Garvey Inc'ling,* March-April, 1971, p. 3.
Free Enterprise—An Imperative! West Branch, Iowa: Privately Printed, 1976.
Find a Need and Fill It. Wichita: Garvey Industries, Inc., 1982.
Garvey, Olive White, "Captain Washington," in A.P. Sanford (ed.), *George Washington Plays.* New York: Dodd, Mead and Company, 1931.
——————. *The Light at the End of the Tunnel.* Wichita: Friends University, 1974.
——————. *Once Upon a Family Tree.* Wichita: Privately Printed, 1980.
——————. *Produce or Starve?* Ottawa, Illinois: Green Hill Publishers, Inc., 1976.
——————. *The Wholistic Me.* Oklahoma City: Oklahoma Christian College, 1976.
——————and Virgil Quinlisk. *The Obstacle Race.* San Antonio: Naylor Company, 1970.
"Garvey Was Millionaire Who Didn't Act Like Tycoon," *Topeka Daily Capital,* July 3, 1959.
Green, Peggy. "Business Success Equaled by Generosity," *Midway,* December 26, 1965, p. M5.
Half-a-Century in Wichita, 1928-1978. Wichita: Garvey, Inc., 1978.
Haystead, Ladd, and Gilbert Fite. *The Agricultural Regions of the United States.* Norman: University of Oklahoma Press, 1953.
Heim, Mike. "Garvey's Daughter Has Warm Memories," *Topeka Daily Capital,* June 18, 1970.
"Homeless Wheat," *Business Week,* April 25, 1942, pp. 811-82.
Isern, Thomas. *Custom Combining on the Great Plains.* Norman: University of Oklahoma Press, 1981.
The Kaw. Topeka: Washburn College, 1913.
Kiewit, Fred. "His Step-at-a-Time Idea Leads to Huge Business," *Kansas City Star,* February 1, 1959, p. F1.
Kraenzel, Karl. *The Great Plains in Transition.* Norman: University of Oklahoma Press, 1955.
McDonald, Marie. "Women Bosses Untypical of Popular Stereotype," *Wichita Eagle and Beacon,* March 28, 1971, p. 1E.

Malin, James C. *Winter Wheat in the Golden Belt of Kansas.* New York: Octagon Books, 1973.
"Man of Varied Interests Started Career on $500," *Wichita Eagle*, April 8, 1959, p. 3A.
Messner, Ann, "Women With Clout," *The Wichitan*, Vol. 2, No. 6, October, 1979, p. 24.
Miller, Glen W., and Jimmy M. Skaggs. *Metropolitan Wichita: Past, Present, and Future.* Lawrence: Regents Press of Kansas, 1978.
"Millionaires Travel Different Roads to Forbes List," *Wichita Eagle and Beacon*, September 29, 1983, p. 1A.
Miner, H. Craig. *The Fire in the Rock: A History of the Oil and Gas Industry in Kansas, 1855-1976.* Newton, Kansas: Mennonite Press, 1976.
Newsom, D.E. *Kicking Bird and the Birth of Oklahoma.* Perkins, Okla.: Evans Publications, 1983.
"Office Building Spotlights Garvey Legend," *Garvey News'n Views*, Vol.2, No. 1, January, 1965, p. 1.
"Olive Garvey, 71, Holds Reins in Broad Business Enterprises," *Topeka Daily Capital*, February 21, 1965.
"Olive White Garvey, DJ, Wichita, Kansas," *P.E.O. Record*, June, 1971, p. 26.
Orr, Richard. "Wheat Storer Fights to Keep Apace of Glut," *Chicago Daily Tribune*, June 17, 1959, p. 10F.
Rae, John B., and Thomas H.D. Mahoney. *The United States in World History.* New York: McGraw-Hill Book Company, 1955.
"Ray Garvey, King of Castles of the Plains," *Capper's Weekly*, June 30, 1970.
"The R.H. Garvey Building, 300 West Douglas," *Wichita Eagle and Beacon*, April 3, 1966, pp. 1H-16H.
"[Ray Hugh Garvey]," *Sedgwick County News*, June 30, 1972, p. 1.
Settle, Brian. "Friends Honors Olive Garvey," *Wichita Eagle and Beacon*, October 30, 1983.
Shirk, George H. *Oklahoma Place Names.* Norman: University of Oklahoma Press, 1965.
Skybreaking '83. Wichita: Olive W. Garvey Center for the Improvement of Human Functioning, 1983.
Thomas, James H. *History of the Fourth National Bank and Trust Company.* Oklahoma City: Western Heritage Books, 1980.
_____. *Arthur W. Kincade: Banker, Civic Leader, and Philanthropist.* Wichita: Center for Entrepreneurship, 1984.
Tompkins, Steve. "Garvey Foundation Donates Millions to Diverse Causes," *Wichita Eagle and Beacon*, June 26, 1983, p. 11A.
_____. "$500 Grew One Million Times for Garvey Family," *Wichita Eagle and Beacon*, June 26, 1983, p. 1A.
Webb, Walter Prescott. *The Great Plains.* Boston: Ginn and Company, 1931.
"Wheat Bonanza," *Business Week*, June 14, 1941, pp. 70-72.
"Widow Thriving in World of Business," *Kansas City Times*, February 9, 1965.
Williams, Janice. "A Downtowner: 'Isolation' of Suburbs Brings Garvey to Seventh Street," *Fort Worth Star-Telegram*, May 1, 1977, p. 1E.
"Woman's Hand Guides Garvey Empire," *Capper's Weekly*, February 23, 1965.
"The World's Largest Grain Elevator Operator...The Story of R.H. Garvey," *Southwestern Miller*, December 9, 1958, pp. 33-34.

INDEX